CULTURAL

STUDIES

Volume 9 Number 3 October 1995

EDITORIAL STATEMENT

ultural Studies seeks to foster more open analytic, critical and political conversations by encouraging people to push the dialogue into fresh, uncharted territory. It is devoted to understanding the specific ways cultural practices operate in everyday life and social formations. But it is also devoted to intervening in the processes by which the existing techniques, institutions and structures of power are reproduced, resisted and transformed. Although focused in some sense on culture, we understand the term inclusively rather than exclusively. We are interested in work that explores the relations between cultural practices and everyday life, economic relations, the material world, the State, and historical forces and contexts. The journal is not committed to any single theoretical or political position; rather, we assume that questions of power organized around differences of race, class, gender, sexuality, age, ethnicity, nationality, colonial relations, etc., are all necessary to an adequate analysis of the contemporary world. We assume as well that different questions, different contexts and different institutional positions may bring with them a wide range of critical practices and theoretical frameworks.

'Cultural studies' as a fluid set of critical practices has moved rapidly into the mainstream of contemporary intellectual and academic life in a variety of political, national and intellectual contexts. Those of us working in cultural studies find ourselves caught between the need to define and defend its specificity and the desire to resist closure of the ongoing history of cultural studies by any such act of definition. We would like to suggest that cultural studies is most vital politically and intellectually when it refuses to construct itself as a fixed or unified theoretical position that can move freely across historical and political contexts. Cultural studies is in fact constantly reconstructing itself in the light of changing historical projects and intellectual resources. It is propelled less by a theoretical agenda than by its desire to construct possibilities, both immediate and imaginary, out of historical circumstances; it seeks to give a better understanding of where we are so that we can create new historical contexts and formations which are based on more just principles of freedom, equality, and the distribution of wealth and power. But it is, at the same time, committed to the importance of the 'detour through theory' as the crucial moment of critical intellectual work. Moreover, cultural studies is always interdisciplinary; it does not seek to explain everything from a cultural point of view or to reduce reality to culture. Rather it attempts to explore the specific effects of cultural practices using whatever resources are intellectually and politically available and/or necessary. This is, of course, always partly determined by the form and place

of its institutionalization. To this end, cultural studies is committed to the radically contextual, historically specific character not only of cultural practices but also of the production of knowledge within cultural studies itself. It assumes that history, including the history of critical thought, is never guaranteed in advance, that the relations and possibilities of social life and power are never necessarily stitched into place, once and for all. Recognizing that 'people make history in conditions not of their own making', it seeks to identify and examine those moments when people are manipulated and deceived as well as those moments when they are active, struggling and even resisting. In that sense cultural studies is committed to the popular as a cultural terrain and a political force.

Cultural Studies will publish essays covering a wide range of topics and styles. We hope to encourage significant intellectual and political experimentation, intervention and dialogue. At least half the issues will focus on special topics, often not traditionally associated with cultural studies. Occasionally, we will make space to present a body of work representing a specific national, ethnic or social tradition. Whenever possible, we intend to represent the truly international nature of contemporary work, without ignoring the significant differences that are the result of speaking from and to specific contexts. We invite articles, reviews, critiques, photographs and other forms of 'artistic' production, and suggestions for special issues. And we invite readers to comment on the strengths and weaknesses, not only of the project and progress of cultural studies, but of the project and progress of *Cultural Studies* as well.

Larry Grossberg
Janice Radway

*　　*　　*

Contributions should be sent to Professor Lawrence Grossberg, Dept. of Communication Studies, CB#3285, 115 Bingham Hall, University of North Carolina at Chapel Hill, Chapel Hill, NC 27599–3285, USA. They should be in triplicate and should conform to the reference system set out in the Notes for Contributors, available from the Editors or Publishers. Submissions undergo blind peer review. The author's name should not appear anywhere in the manuscript except on a detachable cover page along with an address and the title of the piece. Reviews, and books for review, should be sent to Tim O'Sullivan, School of Arts, de Montfort University, The Gateway, Leicester LE1 9BH; or to John Frow, Dept. of English, University of Queensland, St. Lucia, Queensland 4072, Australia; or to Jennifer Daryl Slack, Dept. of Humanities, Michigan Technological University, Houghton, MI 49931, USA.

CONTENTS

▪ ARTICLES ▪

JOHN DOCKER

RETHINKING POSTCOLONIALISM AND MULTICULTURALISM IN THE *FIN DE SIÈCLE*

Abstract

The article argues that terms like 'postcolonialism' and 'multiculturalism' can be totalizing and themselves elide difference. In terms of recent argument in cultural studies in Australia, approaches drawn from postcolonialism referring to Orientalism and race have been contentiously applied to multicultural discourse referring to migration and ethnicity. In such discourse there is a ruling binary distinction between the migrant and Australian society. I seek to complicate the analysis of multiculturalism by pointing to a heterogeneity of shifting centres and margins, for example, between and within ethnic communities, and in diasporic relationships.

Keywords

postcolonialism; multiculturalism; *fin de siècle*

During the 1980s, literary and cultural studies were swept by a powerful movement, in publications, conferences and curricula, centred on the term 'postcolonial'. Postcolonial discourse displaced an older paradigm, influential from the 1950s to the 1970s, focusing on the notion of 'Third World', and associated with anti-colonial nationalist movements. Such older anti-colonial discourse came increasingly to be seen as insisting on fixed, binary, stable distinctions between First and Third Worlds, the colonizer and colonized. Postcolonial theory promised to be more adequate to a postmodern world of contradictions, ambiguities and ambivalences generated by First World–Third World intersections, in particular the experiences of Third World peoples in Western metropolitan centres.

In the *fin de siècle*, however, when, as we might expect, all things are questioned, the term 'postcolonial' is itself being sharply interrogated. The Iraqi–Israeli–American critic Ella Shohat (1992a) argues, for example, that

postcolonial theory, while it has been and continues to be productive, can be deployed in ahistorical and universalizing ways. Shohat sees 'postcolonial' as associated with Third World countries which gained independence after World War II. But, she feels, the term has become increasingly global in its theoretical ambitions, attempting to include and subsume most of the known world. Shohat points, for example, to the introduction of Ashcroft, Griffiths and Tiffin's *The Empire Writes Back: Theory and Practice in Post-Colonial Literatures* (1989), which suggests that the literatures of Africa, Australia, Bangladesh, Canada, the Caribbean, India, Malaysia, Malta, New Zealand, Pakistan, Singapore, South Pacific Island countries, and Sri Lanka are all postcolonial literatures, as is the literature of the United States. Such a formulation, Shohat writes, is problematic in the extreme. It collapses into the one term and history very different national–racial formations, as between settler-colonial societies like the United States, Australia, and Canada, and societies like Nigeria, Jamaica, and India. Situating Australia and India as together postcolonial simply because they were both colonies equates a society dominated by white settlers with a society composed of an ex-colonized indigenous population. Used in this way, 'postcolonial' becomes a totalizing category neutralizing geopolitical differences across the globe.

The term 'postcolonial' is, Shohat feels, not only dubious spatially, but also problematic temporally. It risks reintroducing a new teleology, a unified history, announcing a new epoch, the postcolonial. When, she asks, did this new epoch begin? 'Postcolonial' elides differences between early independence won by settler-colonial societies as in the Americas, Australia, New Zealand, in which Europeans formed their new nation-states in non-European territories at the expense of the indigenous peoples, and nation-states whose indigenous populations struggled for independence against Europe, winning it, for the most part, much more recently with the twentieth-century collapse of European empires. Further, she asks, how does the term apply to situations in the world, as with the Palestinians or indigenous peoples in Australia or the Americas (in the United States in relation to Native Americans), where there are continuing anti-colonial and anti-racist struggles? Are they now to be marginalized by postcolonial theory as pre-postcolonial? As a term, 'postcolonial' reproduces once again, Shohat argues, the centrality of the colonial narrative, a linear narrative of progression in which colonialism remains the central point of reference, in a march of time neatly arranged from the 'pre' to the 'post'. Shohat concludes by suggesting that the term 'postcolonial' should perhaps have more modest ambitions in the world, be deployed more contingently and differentially. It need not be considered the single and primary term of a new epoch and theoretical discourse, but can be used alongside other terms like anti-colonial, neo-colonial, Third World, post-independence, where every term is provisional and ultimately inadequate.

My focus in this essay will be on multiculturalism in Australia in the light of such recent argument (see also McClintock, 1992). Multiculturalism is both a government policy and a debate over the desirability of cultural-

ethnic pluralism, stimulated by post World War II, largely European, immigration. The specificity of Australian migration history is worth establishing here, particularly in relation to US experience. Gary P. Freeman and James Jupp, editors of *Nations of Immigrants*, a volume of essays comparing migration patterns in the United States and Australia, note that immigrants from a wide variety of nations populated North America from the earliest days of European settlement. North America was invaded by a number of European colonial powers: the Dutch, the French, the Spanish, the British. While the British eventually attained dominance over the territory that was to become the United States, by 1790, when the present style of government of the US was established, persons of Anglo-Irish stock made up only 61 per cent of whites. The next largest white ethnic category was German, followed by Dutch, French, and Swedish. The seventy years between 1860 and 1930 saw unprecedented numbers of migrants land on American shores, the majority drawn from nationalities new to the United States, Poles, Czechs, Russian Jews, providing the hands to run the burgeoning industrial machine that was springing up in the East and Midwest. In the 1920s, legislation was passed controlling the numbers of migrants and attempting to favour those from the countries of western and northern Europe that had provided the bulk of immigrants before 1860. During the Depression, World War II and the Cold War, immigration to the US fell dramatically, with accompanying calls for assimilation and Americanization; there was an ageing of the established immigrant communities. Since 1965, however, immigration has resurged, stimulated by the liberalization of refugee laws and reforms attempting to eliminate racial and national discrimination, within an overall commitment to family reunion. Refugees from Hungary, Cuba and Indo-China increased, as did immigration from Latin America, especially Mexico (Freeman and Jupp, 1992).

In contrast, when the Australian island-continent was invaded, from 1788, it was by only one European colonizing power, the British, and the white population of Australia is still drawn predominantly from the British Isles. Compared to the United States, the role of the state in immigration matters has been far more longstanding, extensive and decisive. Convict transportation began in 1788, lasting until 1852 in eastern Australia (until 1868 in Western Australia). The great majority of convicts were English and Irish, although many were sent from throughout the British Empire, including some non-Europeans. From the 1830s, assisted passage was the single most important device for attracting immigrants to a land that was, compared to the United States, while almost equal in size, far less rich in resources, and less hospitable for European-style settlement. From the beginning most people inhabited the eastern seabord cities, Australia now being one of the most highly urbanized countries in the world. Assisted passage was primarily offered to British subjects, although also to Irish people even after independence in 1921. There were some assisted passages to Queensland from the late 1870s for Germans and Scandinavians, looked on favourably as stable, rurally skilled, family-centred and industrious. When southern Europeans became prominent from the late 1880s there was

concern, and quota restrictions were imposed in the 1920s, mainly against southern Europeans who had diverted to Australia after restrictive United States legislation (Freeman and Jupp, 1992).

In the nineteenth century the largest group of non-British migrants arrived as free settlers in the 1850s in response to the gold rushes, the Australian population trebling within a decade, including many Chinese, Americans and a variety of other nationalities. Chinese continued to come in significant numbers until stopped by restrictive measures directed specifically at them, culminating in the 1901 legislation popularly known as the White Australia Policy. In the early decades of this century, non-British migrants were in a minority, coming mainly from Italy, Greece, Yugoslavia, Malta, Poland, Lebanon and Germany. Because of the Depression in the 1930s, immigration in general was very low. After the war, this situation changed dramatically. From 1947, under agreement with the United Nations International Refugee Organization, over 170,000 refugees arrived in the next five years, the largest planned intake of non-British in Australian history. The great majority of these refugees came from eastern European societies, with additional intakes from Hungary in 1956 and Czechoslovakia in 1968. Non-European migrants, effectively excluded since the White Australia Policy at the turn of the century (not officially repudiated until 1973), began to surge from the middle 1960s and especially 1970s, in particular Chinese, Vietnamese, Filipino, Malay and Indonesian (Freeman and Jupp, 1992).

I might make mention here that my mother's family, Anglo-Jews from London's East End (in family lore, Sephardi Jews from Portugal, then Holland, then England), took assisted passage to Australia in the middle 1920s (Docker, 1992–3). Like the rest of the immigrant population, Jews, whose history in the antipodes coincides with the beginning of colonization in 1788, were, until the post World War II period, predominantly from Britain. In the 1920s and 1930s, however, Polish and other Eastern-European, Yiddish-speaking Jews arrived, in part, again, because of American immigration restrictions. As in the United States and Canada, there were in the immediate post World War II period some restrictions on the entry of Jewish refugees and immigrants, so that fewer Jews arrived than might have. Even so, Australia accepted, after Israel, the highest number of survivors of the Holocaust on a pro rata population basis (Rutland, 1988).

Given its history of centralized state supervision and intervention, Australia's immigrant population has been far less heterogeneous than that of the United States (Freeman and Jupp, 1992: 1, 19). Where massive non-British European migration to the United States occurred largely during the late nineteenth and early twentieth centuries, it was introduced in Australia mainly in two periods, during the mid-nineteenth-century gold rushes, and after World War II, which explains some of the post-war intensity of discussion and debate around issues of cultural and ethnic identity. Such intensity of debate over migration and multiculturalism has tended at times to rival the separate debates, sharp and continuing, over white/Aboriginal relationships.

In the 1950s, 1960s and 1970s, the refugees and migrants from Eastern Europe, Italy, Greece and Lebanon, intended as workers for post-war industrializing and development projects, were faced with harsh conditions and inadequate services, and also experienced frequent social hostility, a language of insult edged with racism when applied to migrants from the Mediterranean, considered not quite white. Official government policies were of cultural assimilation to some kind of imagined Australian national way of life. Migrant communities, however, set tenaciously about maintaining what Gill Bottomley calls 'valued traditions' and 'ethnic honour'. Settling mainly in the cities, especially in Sydney and Melbourne, they created large ethnic concentrations and established their own institutions and facilities, in churches, newspapers, radio programmes and cinemas, afternoon schools, clubs, restaurants, cafés, and shops (Bottomley, 1979: ix, 6). Marrickville, in Sydney's inner west, has traditionally been the city's Greek centre, although in the last decade it has also become a locus for Vietnamese shops, cafés and social life; nearby Petersham, where I live, is the Portuguese centre of Sydney, while the next suburb along, Leichhardt, has traditionally been the Italian centre. By the 1990s, Melbourne and Sydney have, compared to a previous Anglo-conformity, become strikingly ethnically heterogeneous. According to the 1991 Census, Sydney has surpassed Melbourne as Australia's 'migrant capital', with 35.7 per cent of Sydney residents born overseas. Sydney, indeed, featured its multi-ethnicity in its successful bid for the year 2000 Olympics.

Particularly from the early 1970s, there was continuous criticism of the authoritarianism of the notion of assimilation. There was recognition of its impossibility in a conflictual society, particularly with longstanding tensions in Australian history between English and Irish, often inflected as tension and dislike between Protestantism and Catholicism. Through tortuous political processes in the 1970s, policies of assimilation and then integration were succeeded by multiculturalism, government and social recognition of the value of a diversity and mixing of cultures. While multiculturalism has become official government policy at federal and state levels, it remains a space of contention and conflict.

From social science to cultural studies

It was primarily sociologists, anthropologists, political economists and demographers, who from the 1960s produced studies of migrants in Australia, deploying a variety of theoretical approaches. Some were influenced by Marxist concerns with class, work and ideology, focusing on exploitation and unequal power relations. Jean I. Martin (1978), was interested in a sociology of knowledge, of how migrants were defined in relation to public policies, organizations and services, concentrating on institutions like education, health and trade unions; Martin called on Foucault's formulation of the concepts of truth and power in his essay 'The political function of the intellectual' (Foucault, 1977). In *After the Odyssey* (1979), her study of Greek Australians drawing on fieldwork with young

Greek women, Gill Bottomley applied a cultural anthropology approach. In 1984 a collection of essays, *Ethnicity, Class and Gender in Australia*, was edited by Gill Bottomley and Marie de Lepervanche. In 1991 Gill Bottomley, Marie de Lepervanche and Jeannie Martin edited a related collection, *Intersexions: Gender/class/culture/ethnicity*. The 1984 volume evoked in particular the migrant experience of Greeks, Italians and Lebanese, theoretically deploying the triad of ethnicity, class and gender. The 1991 collection sought to go beyond what it called this holy trinity, into analyses of cultural representation and construction (far more fluid and ambiguous terms than ideology) in the context of 'postcolonialism'. It also ranged more widely across ethnicity and race, in Asia and the Pacific as well as in Australia, including within the one project study of Aboriginal writings, second-generation Greek Australians, Italian Australians, Latin American Australians, and gender relationships in south India, Bangladesh, Indonesia and Vanuatu.

By the 1980s, the sociologists had been joined by the literary critics. From the early 1980s there was a flourishing of literary studies, inspired by the then Melbourne critic Sneja Gunew, focusing on the new writing that had arisen and become associated with the massive post-war migrations, particularly from Europe. As critics, they insisted on a textual rather than a sociological approach to migrant writing. Such studies constitute what I will refer to in this essay as the literary multicultural discourse. Its chief practitioners include not only Sneja Gunew but also Kateryna O. Longley, Efi Hatzimanolis, and Ivor Indyk, and they focus on writers like Ania Walwicz, Anna Couani, Antigone Kefala, Silvana Gardner, Rosa Cappiello. From the platform provided by such 'high literature' writing, challenging generalizations have been launched, through the 1980s and into the 1990s.

The literary multicultural discourse attempts to apply to 'migrant' writing and notions of multiculturalism what we might call post-Fanon theory, from Edward Said's *Orientalism* to 'postcolonial discourse'. Gunew, the multicultural discourse's leading theorist, has suggested that Said's theory of Orientalism can be applied to the way mainstream society and culture in Australia position and inscribe the migrant as other: 'Edward Said has explored in detail how the Orient becomes an object constructed by the Orientalist. So too the migrant becomes an object constructed by Australian culture', for what happens in Australia is but 'another version' of 'colonialism', of the way, in Said's terms, 'Europe's discourse' encloses Islam and the Arab world within its own terms (Gunew, 1983). Gunew and Kateryna O. Longley argue that in 'literary history' in Australia 'Aborigines and those migrants who have come from places other than England or Ireland' are 'the outsiders, the marginalised' (Gunew and Longley, 1992: xv).

In such discourse, 'migrant' cultures are not simply marginal in the sense that we can safely add them on to the body of Australian literature as an extra ingredient. Rather, migrant writing and culture challenge received Australian literary and cultural histories, diverse and often opposed in other

ways as they may be, revealing how they commonly construct a mainstream Anglo-Celtic position, an excluding centre (Gunew, 1990). The tropes that insistently figure in the literary multicultural discourse, of centre and margin, mainstream and periphery, the dominant and the minority, are reserved with point and passion for the relationship between 'migrant' cultures and an Australian society conceived as a totality, a rounded whole that smothers, others, devalues, excludes, hierarchizes.

These attempted applications of post-Fanon theory can now be seen as highly contentious. When 'the native' becomes 'the migrant', and 'Europe' or 'the West' becomes 'Australian society', something goes askew and awry. A critical discourse and language engaging with (largely European-migrant) ethnicity has been curiously crossed with a critical discourse and language concerned with *race*, the colonized. For 'the migrant', as writer and critic, is predominantly from the First World, not the Third. Aboriginal people have been very concerned to challenge the unifying in multiculturalism generally of the Aboriginal and the migrant into a common non-Anglo-Celtic other, eliding differences and oppositions. For Aboriginal peoples, migrants are another set of invaders, not brothers and sisters on the margins, not the fellow oppressed and dispossessed (Docker, 1991). Migrants in Australia are migrants, they are not the indigenous people, and indeed in relation to Aboriginal dispossession and claims to sovereignty Australia is not a 'postcolonial' society at all (Curthoys, 1993). Post World War II migrants to Australia, whether European or Asian, are always-already empowered as part of a society that continues to be historically advantaged by the brutal dispossession of Aboriginal peoples and countries.

The power of the diaspora

Another difficulty is that the literary multicultural discourse character-istically creates the migrant as a monad. 'The migrant' is centred in a single image. In *Striking Chords*, for example, Ivor Indyk tells us that migrant writing captures experiences of isolation, loneliness, fragmentation, dispos-session, displacement, where the culture of the past comes to reside in only a few surviving objects. For the most part Indyk's essay relies on a rather conventional modernist sociology and aesthetic, where 'the migrant' is subject to anomie, alienation and loss of community. Later in his essay, none the less, Indyk refers to Morris Lurie's *Flying Home* (1978), where the narrator joins a group of American Jews in Israel on a bus tour, and through the shared comedy of defecation they discover a sense of community in their 'spiritual homeland' (Indyk, 1992).

What I will now argue in this essay – and what Ivor Indyk unwittingly argues in his – is that 'the migrant' may also be involved with the continuing collective experiences of migrant communities, themselves usually in diaspora relationships with societies or communities elsewhere. I am helped here by the intersecting rise of another field, the study not of 'high' literature but of migrant folk cultures in Australia. In *The Oxford Companion to Australian Folklore* (1993), Anna Chatzinikolaou and Stathis Gauntlett

argue of Greek-Australian folklore that the metropolitan Greek nation-state has long tried to use songs and dances, traditional and rustic, as a way of consolidating 'national identity', suggesting that the Greek ethnos has a cultural and racial continuity going back to ancient Hellas. They also argue that there is pressure by metropolitan Greek spokespeople that diaspora Greeks maintain a kind of racially pure Hellenic identity. Such pressure runs the danger, Chatzinikolaou and Gauntlett argue, of trying to make diaspora culture 'cringe' to metropolitan models, in a static, cloning, 'deep-frozen' way. The metropolitan centre insists on certain genres as truly Hellenic, like the poetic folk song (*tragoudi*). Such insistence means the marginalizing of comic genres or those with non-classical or 'oriental' affiliations, as in shadow-theatre and fairy-tales enjoyed by mothers, grandmothers, children. Metropolitan pressure also ignores local developments like cultural hybridizing, as in a Melbourne Greek composer fusing bouzouki and didgeridoo music (Davey and Seal 1993: 199–202; Docker, 1993a).

This interesting analysis came as a surprise, since it didn't observe what I took to be the conventions of literary multicultural discourse so solidly established in recent years. In Chatzinikolaou and Gauntlett's argument, edged with passion, metropolitan Greek commentators try to control ('deep-freeze'), channel, manage and police Greek diaspora cultures in Australia, a metropolitan centre attempting to create a cultural hierarchy, with the tragic on top, at the same time devaluing and othering and marginalizing comic, 'oriental', and female-favoured genres.

I began to think that the lines in the sand between centres and margins may be less clear than the binary opposition of 'migrant' and 'Australian society' insisted on by the literary multicultural discourse. The Greek entries in *The Oxford Companion to Australian Folklore* got me thinking anew of the two volume history *The Jews in Australia* (1991), by Hilary L. Rubinstein and W.D. Rubinstein. They construct a species of ethnic history, history as a narrative of progress, achievement, triumph. Because anti-semitism has been relatively mild in Australian history, the main hindrances to progress have, they feel, been within the Jewish community itself. In this narrative, the present greatness of the Australian Jewish community is the result of a post Second World War outlook that is, in W.D. Rubinstein's words, 'non-universalistic', 'distinctively inward looking, intensely Jewish and Zionistic'. The argument, and patterns of language, of metaphor and imagery, in *The Jews in Australia*, systematically doubts and disparages and frequently scorns those Jews who do not reveal or conform to this desired outlook, itself defined in insistently singular terms as the 'central principles' of the 'Jewish consensus'.

My descent group, Anglo-Australian Jews, is derided for not being interested enough in Jewish distinctiveness. Before World War II, many Jews were involved with the left, in the Communist Party or in left-liberal visions of social reform. After World War II, however, left-wing elements were, in the Rubinsteins' words, 'marginalised', 'purged', and 'eliminated' by the now Eastern European-dominated 'roof bodies', who have mercifully

moved the Jewish community towards a proper conservatism in thought and action. Still, for the Rubinsteins, obstacles remain. Sydney Jews are a bit of a problem, always lagging behind Melbourne Jews in proper observance of the desired outlook. Sydney in part has been held back by Central European Jews, German and Hungarian, who were never as intense about Jewish distinctiveness as the Yiddish-centred Polish Jews who settled in Melbourne (Rubinstein, 1991).[1]

Under the gaze of *The Jews in Australia*, it is obviously not that easy to measure up to the criteria of the right and proper Jew. Women find it harder, since, the Rubinsteins admit, men predominate in the key organizations. *The Jews in Australia* also reveals that Soviet and South African Jews face an undertone of criticism that they should have gone to Israel, that Israeli Jews who have migrated to Australia are derided as drop-outs, and that Sephardi Jews, mainly from Egypt and Iraq, resent Ashkenazi control.[2] Any residual left-wing Jews are kept marginal, and anti-Zionist Jews are 'ostracized'. It is indeed difficult for any Jew anywhere in the world to keep up with the standard set by the Australian community. American Jews, for example, still involve themselves in liberal causes, like supporting black rights, whereas post-war Australian Jewry has, W.D. Rubinstein says approvingly, 'purged' any such universalist interest. Even Israeli Jews in Israel fail fully to measure up, their Hebrew, compared to English and Yiddish, being 'blunter and curter', a characteristic 'accentuated by the notably prickly and argumentative temperament of many Israelis'. The Melbourne-led Israel-centred East-European-shaped Australian Jewry is clearly now setting the pace in establishing the right and proper Jew not only for the Diaspora but for Israel as well (Rubinstein, 1991: 5–7, 80–5, 90, 34, 301, 561, 559, 15, 33, 321, 15, 44, 42).

In general, in terms of intellectual method, *The Jews in Australia* offers apologetics for those it agrees with (very few), and abuse for those views and personalities it dislikes.[3] From the evidence of the Rubinsteins' text, it would appear that the curiously named roof bodies of the Jewish community are trying to impose on Australian Jews a logic of authoritarian conformity, an observance of 'central principles' accompanied by the marginalizing, purging, eliminating and ostracizing of those who don't measure up to them. In the *Sydney Morning Herald* of 4 August 1993 a group of Jewish women close to the Sydney Women in Black group placed an advertisement condemning the bombing by Israel of southern Lebanon that had just occurred, the deliberate creation of more than 300,000 refugees, the continuing occupation of Palestinian land, and the appalling human rights abuses against the Palestinian people. They also protested against the claim of the Israeli government to represent Jews worldwide. The following day in the *Sydney Morning Herald* one of the women, Barbara Bloch, said that they placed the advertisement because they felt the significant section of Australia's Jews who opposed such Israeli actions did not have a voice. The *Herald* then asked the opinion of Mr Mark Leibler, president of the Zionist Federation of Australia, who dismissively noted that the women represented the views of a splinter organization which had some sort of axe to grind.

Contrary to the literary multicultural discourse, it is not 'Australian society' (whatever that may be) here imposing a language of centre and margin but a powerful member of a minority community. The multicultural discourse always suggests a unidirectional flow of power, 'Australian society' against 'the migrant'. But what we can infer from the women's intervention is that the roof bodies of the Jewish community clearly exercise significant influence over one part at least of 'Australian society'. News reports of Israeli military activities, especially since the 1982 invasion of Lebanon that involved the Sabra and Shatila massacres, have consistently pointed to Israeli violence. Indeed, the Rubinsteins' *Jews in Australia* tells us that in Jewish day schools the teachers have frequently to rebut the 'growing and unfair media criticism of Israel' (Rubinstein, 1991). Yet the Jewish community's roof bodies are permitted by the media always to present the community as unified around a pro-Israel position, so much so that for Jews to present a dissident and contrary position they have to place a paid advertisement in the papers.

The perplexities of Andrew Riemer

Andrew Riemer's books of memoirs, *Inside Outside* (1992) and *The Habsburg Café* (1993), provide interesting ways of investigating issues of 'Australian society', 'the migrant', and 'the diaspora'. Riemer, a Shakespeare scholar, was a longtime member of the University of Sydney's Department of English. *Inside Outside* evokes the coming of his family to Sydney from Hungary in 1947, where they settle not in the eastern suburbs, along with their compatriots, but in the western and north-western suburbs, indeed Epping, the only migrant family for miles around. When he learnt it, his father's English was never good enough to communicate his 'ironic relish of life', so that his English-speaking acquaintances thought him dull. Much of the narrative is concerned with the young Andrew's desperate comical efforts to conform, particularly after his first experiences of school. He recalls knowing no English, the boys surrounding a creature wearing parrot-coloured clothes, 'a kind of deaf-mute in striped socks'. He was put in the Special Class and spent several months French-knitting. He'd try to talk like the other boys: 'Yeah, my Dad made heaps on the SP last Satdy' (Riemer, 1992: 116, 89–95, 106).

Inside Outside offers a narrative that would not displease the multicultural discourse, the migrant in binary relation to mainstream society. But Riemer in *Inside Outside* is wary of the way the recent multicultural discourse is ever harshly condemning Australian society as if migrants were 'forced by the jackbooted agents of conformism into adopting Australian norms'. In post-war Australia migrants might be called balts, reffos, wogs, but such prejudice, Riemer feels, is often merely ceremonial, 'essentially unmenacing' compared to the nightmarish Europe many such migrants had left behind. In Australia people might be rude or insulting. But they didn't spit at you, didn't hurl bricks through your window. You didn't have to register your every movement with the police, no one stopped you in the

street to demand identity papers, and nobody battered on your front door with heavy fists in the dead of the night. Riemer's parents appreciated the political tolerance of the strange antipodean island-continent they found themselves in (Riemer, 1992: 9, 12–14, 22–3, 205; see also Riemer, 1994). For Riemer and his family, escaping from a Europe ravaged by war, brutality and occupation, such Enlightenment values were what they actively desired, however much they soon became achingly nostalgic for the high culture of Central Europe.

In October 1991, we – Ann Curthoys and I and our son – encountered Andrew Riemer in bizarre circumstances, at a party at the Australian ambassador's residence in Budapest, thrown mainly for visiting NSW TAB businessmen, come to show Hungarians new ways to gamble. We were there to talk about Australian Studies at the university. I hadn't seen Andrew Riemer since he'd taught me first year English at Sydney University in 1963. We arranged to meet the next day, and he showed us something of the city of his boyhood, particularly the hill area of Budapest, with its cobbled streets and Gothic cathedral, overlooking the Danube.

In *The Habsburg Café* Riemer tells of meeting some unnamed Australians, and becoming for them a somewhat bemused tourist guide. Noticing his new companions becoming enchanted by the hill area of Budapest that he takes them to on a beautiful autumn day, he is seized by a desire to make them see the city, and Hungary and Central Europe, as he sees them, returning after so many decades. He tells them that the cathedral they're admiring is really a modern reconstruction, serving the nationalist fantasies of Magyar Hungarians, those who constitute themselves as the true Hungarians and are again becoming racist towards Gypsies and Jews. Walking towards the river, he points to the spot on the embankment where hundreds, perhaps thousands, of people were machine-gunned by the Germans and their Hungarian henchmen in the terrible winter of 1944. He wants them to know that in his memory this city is the place where most of his family were killed, or where they started their journey to death. It was here that he was made to feel that people like himself, Central European Jews, were pariahs, vermin to be exterminated, and that he cannot remember Hungary or, now, visit it without feeling that here is a world poisoned for him forever by the stench of death and hatred (Riemer, 1993: 139–49).

In the narrative of *The Habsburg Café* Riemer returns to Hungary in the latter part of 1991 to teach about Australian literature and culture in Szeged, a provincial town. He lands first in Vienna, which he decides is now a kind of gigantic theme park, its opera, cathedral, palaces, statues mere show-monuments to the memory of the lost glories of the Austro-Hungarian empire. Yet he feels drawn to the allure of this world, or at least to his and his family's dream memories of the old Central Europe, the society where his family felt they first experienced the blessings of 'civilized urban life', in its cafés, its elaborate coffee and cake rituals, its obsession with opera: in the old Vienna and Budapest was fine living at its best, the essence of Europe, of civilization, Mitteleuropa. He also reflects that before World War II, however uneasily, the old Central Europe was a kind of supra-national

entity, where, under the umbrella of empire, diverse nationalities, ethnicities and religions, despite the intense anti-semitism of Catholic Austria and its milder form in Hungary, could coexist in a cosmopolitan society. But that cosmopolitanism and inclusiveness were threatened and then destroyed by Austrian and Hungarian association with Nazi Germany (Riemer, 1993: 9, 15, 32, 45, 52–3, 85–7, 103, 105, 268).

In the climax of the narrative, shortly before leaving Hungary, as winter is sharpening, Riemer is invited by the Australian Embassy to address a reception for a group of Hungarians about to leave for some months' study in Australia. With a bad cold, his voice rasping, he decides to tell his audience of what happened in 1944 to his 'large and on the whole loving family', and hence why he cannot think of himself as a Hungarian and cannot think of Hungary as home. At this point, he is overcome, tearful, and has to stop. He feels ridiculous, a small, squat, bald, middle-aged man blowing his nose. He recovers, he praises Australia for being 'basically healthy and just', despite its 'occasional crassness, intolerance and narrow-mindedness', he comes to a halt, and the Third Secretary says, let's go and eat at a Thai restaurant that's just been opened (Riemer, 1993: 259–61).

Overall the narrative of *The Habsburg Café* enacts a passage from desire and dream of and for Central Europe, carried in potent family memories and myths, to disillusion, bitterness and anger. Yet the narrator can never quite extinguish his nostalgia for the old high culture of Central Europe, its tastes and taste, his sense that this is where Europe and the civilized, cultivated, non-vulgar life truly is, a nostalgia he assuages in Australia by his academic and cultural interests in things British and Continental (Riemer, 1993: 269). The narrator feels his identity inescapably involves such ambiguity and ambivalence, bafflement and confusion – that which we can perhaps refer to as diasporic sensibility, irresistible, inescapable elusive countries of the mind.

There are things I don't quite like about *The Habsburg Café*, apart from it being rather slow and repetitive. There is its modernism, its ever-present sense of cultural hierarchy, particularly in disdain for mass culture and the 'lower female genres', for melodrama and romance. In a bookshop in Vienna he sees 'dumpy ladies' choosing 'cheap little romances' to read, 'Austria's answer to Mills and Boon'. He hasn't read any, but they're 'probably poorly written' and 'escapist', everything in them 'dedicated to feeling, sensation and sentiment' (Riemer, 1993: 21, 37–42). Why do modernists mechanically reproduce the same language and discourse, as if sleep-talking? In *The Habsburg Café* modernism is a home, a centre, a security, an assurance of superior judgement and bearings wherever its narrator is in the world. Strangely, his own confrontation with his audience at the Embassy function about the destruction of his family could well be seen as a crisis-moment of melodrama, melodrama as charged excess, as powerful, moving, disturbing release of the repressed.

Throughout *The Habsburg Café* the narrator tends to refer to 'Australians' as a unity, rather as in the multicultural discourse. At a book launch back in Sydney, Andrew Riemer told me to make sure I read *The Habsburg*

Café, for Ann Curthoys and I were in it, although, he went on, we were submerged as part of a composite portrait with another Australian visitor to Budapest at that time, a comment that, perhaps completely unreasonably, slightly irritated me. When I read *The Habsburg Café*, I could appreciate that we had become part of a specific text, characters, and certainly very kindly and generously treated. No one can quarrel with that. Yet, yet, yet – when the narrator in *The Habsburg Café* refers to how 'eccentric' his own private mythology is that has driven him to come to Hungary, but how representative and characteristic of a certain social grouping in Australia his companions for the day were, I felt like answering back, to protest, to modify.[4]

The narrator writes that his Australian companions' interest in Hungary and Central Europe was 'essentially tourist-like', and again I think how much essentialism suppresses difference, removes idiosyncrasy, divergent purposes, odd interests, fantastical thoughts. We had had to journey to Central Europe over the protests of our mid-teenage-son, not an easy thing to do, who was delighted by Italy's visual excess, and wanted to keep going round the Mediterranean to see the city where the 1992 Olympics were to be held. We obstinately held out for striking north and east. My particular reasons for this interest made no impression on my son at all. I wanted to see Vienna, I'd said, because growing up in the 1950s and 1960s I had registered an intimidatory sense that the café society of Vienna was indeed the high point and place of metropolitanism, world-beating, making Australia contemptible. I was pleased, then, to find Vienna architecturally grey, uniform, limitlessly boring, its food, apart from the coffee and cakes, stodgy and barely edible. (*The Habsburg Café*, I was happy later to notice, refers to Vienna's 'largely indigestible meals' (1993: 35)). I wanted to see Hungary because I'd had a Communist Party childhood, and thought I might get some residual sense of what an Eastern European socialist society might have looked like. We were also supposed to visit Szeged, close to Dracula's Transylvania, which piqued me, fan of Bram Stoker's remarkable Gothic novel from the literary and cultural period which most interests me, 'my' 1890s. I was also far from personally indifferent to the moment of anti-semitism in Central Europe so fateful for Andrew Riemer's family and that had rendered that world so relentlessly monocultural.

For I was also interested in my travels to test out something, to see how multiculturalism in Australia compared to Europe. The results for Europe were not encouraging. In *The Habsburg Café*, Andrew Riemer mentions seeing anti-semitic slogans everywhere, and overhearing anti-semitic comments frequently, including at the Opera (179, 230, 235, 240). A few weeks after leaving Central Europe, I read in Robert Maxwell's newspaper *The European* that Jewish graves had been desecrated in Austria, in a cemetery not far from Vienna, and that Vienna's mayor had dismissed what happened as of little consequence. I found the monoculturalism of Central Europe disturbing and extremely unpleasant, and kept thinking increasingly highly of Australian multiculturalism. In *The Habsburg Café*, Andrew Riemer mentions that 'Szeged's first Chinese restaurant' had just opened (162). As I

read this I thought, God, compare that to the multiethnic riches of cuisine in Australia, including more and more a café life, as if Australia were adopting the best of Central Europe, to add to its proliferating Mediterranean and Asian cuisines and modes. Cuisine in Europe, on the other hand, appears to be used as a competitive marker of regional, national and ethnic difference, hence perhaps a pull to exclude openness to a profusion of cuisines.

Of course, I shouldn't be talking about food. The multicultural discourse has proscribed such mention as trivializing discussion of migrant cultures (see, for example, Hatzimanolis, 1992: 172). Usually, food is classed along with dancing and music as signs of a merely superficial and reductive understanding by Anglo-Celtic Australia of migrant cultures. I don't see anything trivial in talking about food, and one might reflect that the very same people who deride discussion of it very much relish the particular restaurants, cafés, bistros, cuisines, coffees and cakes they choose as excellent. To discuss diaspora experience, its memories and mythologies, might in any case necessarily involve discussion of food. In *The Habsburg Café*, Riemer notes that the social rituals of the old Central Europe were frequently focused on food ceremonies, that his mother always maintained that the *Sachertorte* she made in Sydney was the only genuine version of the celebrated delicacy, and that his own dream memory of Central Europe is associated with images and scents of pungent coffee and sweet vanilla (Riemer, 1993: 15, 61, 12, 18, 57, 278).

Conclusions

While in this essay I have touched on Greek and Jewish diaspora relationships, I don't wish to suggest that there is any single or universal model of diaspora experience in Australia. Rather would there be unpredictable heterogeneity, and there is clearly extensive interaction between ethnic communities, not least from intermarriage, a feature of Australian history.

Nor do I think Australia is unique in its possession of diasporic communities and experience. Postmodernist theory has tended to argue that in the contemporary world identity is multiple, contradictory, fragmented, pluralized. We can see such a characterization at work in that remarkable novel *Satanic Verses*. But such fragmentation and plurality – such hybridity – is in tension with the continuing force and power of collective identities and communities. Their strength and intensity in Britain, for example, may be gauged in the demonstrations against *Satanic Verses*' unfortunate author. In Australia in recent years we have seen enormous demonstrations in Melbourne and Sydney by Greek-Australians over what Eleni Varikas refers to as the 'present nationalist delirium over the Macedonian question', a delirium she suggests is a continuing manifestation of Greek nationalism since early in the nineteenth century, the attempt to conceive and propagate Greece as Western European, to be ever sharply distinguished in its civilization from the Balkans and especially Turkey, remnant and reminder

of the Ottoman Empire, oriental and barbarous. Varikas refers to the nationalist fervour at the end of the nineteenth century favouring the idea of a Great Greece, which involved the irredentist aspiration to reconquer Constantinople and annexation of areas around the Aegean Sea. The civilizing mission of the Greek people would be to spread Western cultural values throughout the Balkans and Orient (Varikas, 1993). (Shades of the Zionist annexionist ideals of Eretz-Israel, I thought, a movement conceived in the 1890s.) Interestingly, in *The Oxford Companion to Australian Folklore*, Anna Chatzinikolaou and Stathis Gauntlett quote from a narrative folk ballad which is highly racist towards Turks (Davey and Seal, 1993) – and Turks are also a sizeable minority community in Australia.

Throughout white Australian history there has been a continuing tension between multiculturality and an insistence on a singular British identity, an insistence particularly marked in the 1920s and 1930s (Fischer, 1989). It is becoming daily clearer that since World War II Australian society has not proven immutable, that there have been innumerable and growing exchanges between margins and centres. Contemporary Australian society has gone into transformation mode, in terms of cosmopolitanism, internationalism, multiculturalism, excitingly so, and migrant or ethnic cultures have been key agents in such transformation. The cosmopolitanism and internationalism of the old Central Europe, the enforced habitus of empire, is, we might say, becoming a phenomenon of Australia, though combined with a political liberalism the Austro-Hungarian Empire itself derided as Western European. The multicultural discourse has never been very interested in Enlightenment values of political tolerance, considering them merely notional, gestural, given how excluded and othered the migrant is: in such discourse the cultural is decisively more important than the political. Perhaps the destruction of Andrew Riemer's family might remind us how important such Enlightenment values can be, the Enlightenment considered not as a necessary totality, the project of modernity, but as desirable aspect of a polity (see Docker, 1991).

Compared to the ugly monoculturalism in so much of Europe, the desire to ethnically exclude or cleanse, evident as much in the racism towards African people in Italy and France (Lloyd and Waters, 1991; Martiniello, 1991) as in the lunar-grey uniformity of Austria, surely multiculturalism is an advantage in the world (see Curthoys and Muecke, 1993; Collins, 1993; and Docker, 1994). Just how powerful the pull of monoculturalism in Europe can be is registered at moments in *The Habsburg Café*, when its narrator encounters in Hungary visiting Germans. Andrew Riemer of course has every reason to despise Nazi Germany. Yet when the narrator refers to German tourists as loud, corpulent, flabby, bulky, gutteral, this reader at least felt uneasy. On one occasion, sitting in the Café Ruszwurm, in the Castle district of Budapest, the narrator feels offended by a group of 'noisy' Germans. They choose to sit nearby, reeking of garlic, then intercept the waitress as she is about to talk to him. Riemer becomes angry, shouts at them, then has a conversation with the young Hungarian waitress who says how terrible the German tourists are, rude and pushy (Riemer, 1993: 151–2,

216, 232). The monoculturalism of Central Europe and Hungary in particular, which elsewhere is his key object of dislike, here emerges as a centring and essentializing of identity around nationality and ethnicity, insidiously invading the text.

When the multicultural discourse argues that 'Australian society' has an excluding Anglo-Celtic centre, we might idly wonder if there is not here a species of reflectionism, a kind of ethnic-aesthetic determinism. The assumption appears to be that because the population in white Australia can be defined as predominantly Anglo-Celtic then it expresses or is only interested in whatever is Anglo-Celtic. Gunew and Longley, for example, refer to the 'English and Irish elements which dominate Australian writing', contrasting such Anglo-Celtic writing with non-Anglo-Celtic texts whose 'allusions may be predominantly to Greek or Italian or European literature' (Gunew and Longley, 1992). Has literary history in Australia really been so intertextually restricted? Have allusions to European literature and culture only appeared since World War II, and only in non-Anglo-Celtic writers? Such claims are preposterous, revealing profound ignorance of Australian 'literary history', the avowed object of Gunew and Longley's critique.

The idea that Australian writing refers and alludes only to English and Irish writing completely forgets that strain in so-called Anglo-Celtic cultural history in Australia that resented perceived (or imagined) imperial English claims to cultural superiority, a resentment often accompanied by a desire for non-English others. In the 1890s *Bulletin* literary editor A.G. Stephens was a Francophile, *Bulletin* editor J.F. Archibald was both Francophile and Judeophile. Poet Christopher Brennan was fascinated by German Romanticism and French Symbolism, in part modelling his *Poems* (1913) on Mallarmé. Even in the more Anglo-conformist 1920s and 1930s, it is worth pondering that the most famous comedian of the time, in vaudeville and radio, was Roy Rene, Mo, white-face Jewish comedian, carnival king, of Dutch-Jewish ancestry, ever outrageously playing with identity. Theatre, vaudeville, radio, television have in Australian cultural history been drawn to American influences as much as British. In post-war Australian literature we can think of Patrick White's Grecophilia, his passionate identification with the Byzantine history of Asia Minor as well as modern Greek irredentist claims to Constantinople (Docker, 1992; 1993b). When a Melbourne Greek composer hybridizes Greek with Aboriginal music, can we speculate on a similar desire in Greek-Australian culture *not* to follow metropolitan Greek culture, a similar desire for and openness to the other?

In the early 1980s, the interventions of Gunew and others were admirable and invaluable in challenging literary culture in Australia to recognize the way it practised exclusions of migrant writing. Criticism in Australia was indeed slow to respond and reflexively consider the new writing. By the middle 1990s, however, the literary multicultural discourse is itself emerging as exclusionary, an orthodoxy, a discourse based on a very small number of 'high literature' writers, producing 'the migrant' as ever marginal, a modernist monad. The multicultural discourse is largely subtended by a dated binarism.

Notes

1 Pages xii, 62, 5, 8, 13, 17, 27, 301, 308, 285, 25, 28, 39, 222, 246, 508, 555, 11, 14, 266, 274, 3, 231, 20.
2 Ella Shohat argues that Israel itself is dominated by European, Ashkenazi, Jews, a minority, who marginalize not only the Palestinians of Israel but the 50 per cent of the population who are Jews of Middle Eastern and North African ancestry. Israeli Jews from the Muslim Arab world experience, she feels, systematic discrimination and institutional suppression of their Middle Eastern history and culture. See Shohat (1992b) and Alcalay (1993).
3 See my review in Docker (1991), an extended version of which appeared as 'Jews in Australia', *Arena* 96, 1991. *Arena* 98, 1992, published a reply by Rubinstein along with my reply to his reply. See also Docker (1986).
4 Bakhtin (1993: 1): 'Aesthetic intuition is unable to apprehend the actual event-ness of the once-occurrent event, for its images or configurations are objectified, that is, with respect to their content, they are placed outside actual once-occurrent becoming – they do not partake in it (they partake in it only as a constituent moment in the alive and living consciousness of a contemplator).'

References

Alcalay, Ammiel (1993) *After Jews and Arabs: Remaking Levantine Culture*, Minneapolis: University of Minnesota Press.
Bakhtin, M. M. (1993) *Towards a Philosophy of the Act*, trans. Vadim Liaponov, Austin: University of Texas Press.
Bottomley, Gillian (1979) *After the Odyssey: A Study of Greek Australians* St. Lucia: University of Queensland Press.
Bottomley, Gillian and de Lepervanche, Marie (1984) editors, *Ethnicity, Class and Gender in Australia* Sydney: George Allen & Unwin.
Bottomley, Gillian, de Lepervanche, Marie and Martin, Jeannie (1991) editors, *Intersexions: Gender/Class/Culture/Ethnicity*, Sydney: Allen & Unwin.
Collins, Richard (1993) 'Post colonial formations: the case of the European Community', paper given to conference on postcolonialism, Griffith University, July.
Curthoys, Ann (1993) 'Identity crisis: colonialism, nation, and gender in Australian history', *Gender and History* 5(2).
Curthoys, Ann and Muecke, Stephen (1993) 'Australia, for example', in Hudson, Wayne and Carter, David (1993) editors, *The Republicanism Debate*, Sydney: New South University Press.
Davey, Gwenda Beed and Seal, Graham (1993) editors, *The Oxford Companion to Australian Folklore*, Melbourne: Oxford University Press.
Docker, John (1986) 'Orientalism and Zionism', *Arena* 75.
—— (1990) 'The temperament of editors and a new multicultural orthodoxy', *Island* 48: 54.
—— (1991) review of *The Jews in Australia*, *Weekend Australian* 22–3 June.
—— (1992) 'Dilemmas of identity: the desire for the Other in colonial and post colonial cultural history', Working Paper, Sir Robert Menzies Centre for Australian Studies, University of London.
—— (1992–3) 'Growing up a Communist–Irish–Anglophilic–Jew in Bondi', *Independent Monthly*, Dec./Jan.
—— (1993a) 'Folklore beyond beards and beads', *Weekend Australian* 24–5 April.

—— (1993b) 'Romanticism, modernism, exoticism: Patrick White in biography and autobiography', Southern Review 26(3).

—— (1994) 'Postnationalism', *Arena Magazine* No. 9, Feb./Mar.

—— (1994) *Postmodernism and Popular Culture: A Cultural History*, Cambridge University Press.

Fischer, Gerhard (1989) *Enemy Aliens*, St Lucia: University of Queensland Press.

—— (1995) ' "Negative integration" and an Australian road to modernity: the Australian homefront experience in World War I', *Australian Historical Studies* 104: 452–75.

Foucault, Michel (1977) 'The political function of the intellectual', *Radical Philosophy* Vol. 17: 12–14.

Freeman, Gary P. and Jupp, James (1992) editors, *Nations of Immigrants: Australia, the United States, and International Migration*, Melbourne: Oxford University Press: ch. 1.

Gunew, Sneja (1983) 'Migrant women writers: who's on whose margins?', *Meanjin* No. 1, reprinted in Lee, Jenny, Mead, Philip and Murnane, Gerald (1990) editors, *The Temperament of Generations: Fifty Years of Writing in Meanjin*, Meanjin/ Melbourne University Press.

—— (1990) 'Denaturalising cultural nationalisms: multicultural readings of "Australia" ', in Bhabha, Homi *Nation and Narration*, London: Routledge.

Gunew, Sneja and Longley, Kateryna O. (1992) editors, *Striking Chords: Multicultural Literary Interpretations*, Sydney: Allen & Unwin.

Hatzimanolis, Efi (1992) 'Speak as you eat: reading migrant writing, naturally' in Gunew and Longley (1992).

Indyk, Ivor (1992) 'The migrant and the comedy of excess in recent Australian writing', in Gunew and Longley (1992): 182–6.

Lloyd, Cathie and Waters, Hazel (1991) 'France: one culture, one people' *Race and Class* 32(3).

McClintock, Anne (1992) 'The angel of progress: pitfalls of the term post-colonialism', *Social text* 31/32.

Martin, Jean I. (1978) *The Migrant Presence: Australian Responses 1947–1977*, Sydney: George Allen & Unwin.

Martiniello, Marco (1991) 'Racism in paradise?', *Race and Class* 32(3).

Riemer, Andrew (1992) *Inside Outside*, Sydney: Angus & Robertson.

—— (1993) *The Habsburg Café*, Sydney: Angus and Robertson.

—— (1994) 'Confessions of a multicultural writer', *Independent Monthly* February.

Rubinstein, W. D. (1991) *The Jews in Australia: A Thematic History*, Melbourne: William Heinemann.

Rutland, S. D. (1988) 'Jewish refugee and post-war immigration', in Jupp, James (1988) editor, *The Australian People: An Encyclopedia of the Nation, Its People and Their Origins*, Sydney: Angus and Robertson: 650.

Shohat, Ella (1992a) 'Notes on the "post-colonial" ', *Social Text* 31/32.

—— (1992b) 'Antinomies of exile: Said at the frontiers of national narrations' in Sprinker, Michael (1992) editor, *Edward Said: A Critical Reader*, Oxford: Blackwell.

Varikas, Eleni (1993) 'Gender and national identity in *fin de siècle* Greece', *Gender and History* 5(2): 270–2.

DIANA GEORGE

WITH SUSAN SANDERS

RECONSTRUCTING TONTO: CULTURAL FORMATIONS AND AMERICAN INDIANS IN 1990s TELEVISION FICTION

Abstract

This article draws on theories of colonial discourse, cultural representation, subjectivity, feminist studies, cultural studies, and historical analysis to examine how the representations of American Indians in 1990s television fiction are constructed, especially in the American television fictions *Northern Exposure, Twin Peaks* and *Paradise*. Central to this analysis is the discussion of colonial discourse and representations of American Indians as Other on popular American television and, more generally, in mainstream American discourse. This examination is set in the context of the issues surrounding the treatment of Indian people in mainstream history, in film, and in contemporary television fiction. It is the authors' position that in the easy acceptance of a stereotyped cultural construction, mainstream America has come to little knowledge or understanding of American Indian nations, their contemporary concerns, or their discrete identities. For the mass market, the Indian *is* either the Vanishing Race of Edward Curtis's photographs or the savage of the captivity narratives, and the process by which that imaginary functions to contain American Indian identity continues in our most popular narrative today: television fiction.

Keywords

postcolonial theory; subjectivity; cultural studies; television fiction; American Indians; stereotyping

In the first part of this century, Edward Curtis set out to capture forever in photographs what had come to be called a Vanishing Race. In his insistence upon erasing all bits of modern life from these gauzy, sepia-toned portraits of the men, women, and children of Indian nations across the North American continent, he set for us an image which became a powerful prototype for non-Indians and Indians alike. It mattered little that these photos were fictions (Hathaway, 1990: 12); they held American Indians and their nations in time and space – historical artifacts which fascinated

Americans then as they continue to today if we are to judge by the number of number of Curtis materials currently available on the mass market. Calendars, cards, and posters reproduce those photos; even the set designers for Kevin Costner's *Dances With Wolves* used Curtis images of prairie encampments as models for that film.

Curtis's photographs, like others of his contemporaries, encased American Indians in the aura of a gentle past, a photographic record of the noble savage – beautiful but gone. That image was certainly in contrast to over two centuries of 'white captivity narratives' detailing the horrors of tribal life (Namias, 1993: 1–17). In these enormously popular scare stories, Iroquois, Apache, Cheyenne – the particular nation mattered little – were more demon than human. Women were beasts of burden: dirty, crass, and cruel to their white slaves. Men were 'savages' who delighted in tortures unimaginable to the so-called 'civilized' world. Savage or saint, these and other popular representations like them worked to construct in our collective imagination something we have come to call 'the American Indian'. In the easy acceptance of that cultural construction, mainstream Americans have come to little knowledge or understanding of American Indian nations, their contemporary concerns, or their discrete identities. For the mass market, the Indian *is* either the Vanishing Race of Edward Curtis's photographs or the savage of the captivity narratives, and the process by which that imaginary functions to contain American Indian identity continues in our most popular narrative today: television fiction.

In the fifties and even through the sixties and seventies, television fiction's most common representation of American Indians was limited to those who appeared in westerns. Most of the Indians *Gunsmoke*'s James Arness or *Wagon Train*'s Ward Bond encountered were hostiles who attacked wagon trains, captured innocent children and beautiful women, and threatened the lives of white settlers. Television did, of course, portray 'good' Indians, as well, but they were of the Tonto variety – the loyal sidekick working for the white man against outlaws and renegades. (Even Cochise of the television version of *Broken Arrow* was identified as good through his willingness to work with white soldiers and settlers.) Negative or positive, both representations can be said to be built upon *inferential racism*, that is they rely upon, in Stuart Hall's words, the 'racist premises and propositions inscribed in them as a set of *unquestioned assumptions*' (1981: 13). Homi K. Bhabha calls this kind of a portrayal 'a fixed reality which is at once an "other" and yet entirely knowable and visible' (1990: 76). Mainstream audiences, then, may recognize the culture portrayed as separate from them/not them, but they recognize it none the less as a distinct 'other', that recognition achieved through repetition and normalization. Through the creation of such fixed realities American Indians became, for early television, little more than feathered warriors on horseback – sometimes friend but more often foe.

Today it is obvious that television has taken us beyond the feathered warrior, but as artist and cultural scholar Coco Fusco points out, that representation is perhaps linked much more closely to profit motive than to any change in the socio-political landscape: 'There is', she tells us, 'a tremendous

amount of multinational corporate investment in multiculturalism in the US, a symptom of political agendas we have not yet fully explored' (1989: 7–9). Fusco calls this phenomenon 'the commodification of ethnicity', and we hope to show that this commodification of ethnicity is exactly what drives a program like *Northern Exposure* and what accounts for the sometimes confused portrayals of American Indians in what might otherwise be considered potentially progressive narratives.

Colonial discourse and the construction of identity

In his work on colonial discourse and the subjection of the 'other', Homi K. Bhabha theorizes how that discourse functions to reproduce and circulate colonial ideology, effectively distributing the notion of the controlled and subjected 'other'. As do Stuart Hall, Edward Said, Trinh-T. Minh-ha, Teresa de Lauretis, and others working in this field, Bhabha insists that in our scholarship, the mere '*identificaton* of images as positive or negative [must shift] to an understanding of the *processes of subjectification* made possible (and plausible) through stereotypical discourse' (Bhabha, 1990: 71).

That shift is especially important in any further study of popular images of American Indians today, for the work of identification has been done thoroughly and frequently (see, for example, Bataille, 1980; Churchill, 1991; Durham, 1992; Stedman, 1980). We do not dismiss it, of course. Without such work, our own would not be possible, but we do mean to take the question of imagery beyond the act of cataloguing, and in so doing we will begin with Bhabha's discussion of colonial discourse and its power to construct and contain or limit the identity of what he calls the subject-race. Such a discussion may help us understand how television fiction serves the function of colonial discourse as it both reproduces and relays the signifier 'American Indian' for a contemporary audience. Because, as Stuart Hall writes, we cannot speak of stereotypes without speaking of ideology, and because 'Ideologies do not consist of isolated and separate concepts, but in the articulation of different elements into a distinctive chain of meanings' (1981: 31), our discussion of television fiction must also reach beyond the medium itself as the sole object of analysis. Instead, we must read televisual images through the 'terrain of past articulations' of such ideological mechanisms as politics, history, and education policies (Hall, 1981: 34).

In order to more fully understand those stereotypes and the ideologies circulated through them, we also turn to T. E. Perkins whose work can be useful for understanding the historical and political complexity of media stereotypes:

First, to have said that it is 'politically' important to understand how stereotypes work implies the possibility of conscious and effective political activity. Secondly, to insist on the complexity and problematic nature of ideology is to presuppose that ideology is never totally effective and indeed cannot be. If protest movements can (sometimes) 'open up'

contradictions then an understanding of stereotypes is crucial, since stereotypes are so often a focal point of activity. Thirdly, if we are to understand how stereotypes function ideologically, we must understand the articulation of both systematic and commonsense levels with relations of production. We cannot do this by looking merely at stereotypes of women or gays in advertisements, books, films or plays, because that will not tell us why and how much stereotypes are effective. We must analyse the other locations of stereotypes as they are constituted.

(Perkins, 1979: 138)

What Perkins suggests here, much in line with Stuart Hall's discussion of articulation theory, is that the stereotypes we see in popular texts make their way ideologically and inconsistently into other forms of cultural production. That is why we must look at the many ways ideology is articulated through stereotyping practices. The language of history books, for example, can function to normalize certain stereotypes as can stated education policies that repeat, reproduce, and thus normalize the same stereotypes we see in network television. We might think, as well, of the 'rediscovery' of American Indian religions and the distortion of those religions in New Age philosophy. Even the popularity of tribal dress as it makes its way through high-fashion clothing and jewelry can serve this same end. As Annishinabe activist Winona LaDuke, speaking to an audience at the 1990 Protect the Earth Festival at the Lac Courtes Oreilles Reservation in Reserve, Wisconsin warned, we cannot rest assured that we understand Indian cultures simply because we wear the current Southwestern Indian fashions, most designed and sold by non-Indians to an élite urban market. Such references to tribal life without an understanding of their relationships to tribal people become commodification of culture pure and simple – that commodification distributing the stereotype ever more widely. What T. E. Perkins further reminds us of, however, is the shifting nature of stereotypes and the fact that ideology is never entirely effective or totalizing. That is, although the colonizing discourse may, indeed, serve to separate and thus subjugate the colonized race, that subjugation is never totally accomplished.

Of course, the contradictory nature alone of many stereotypes does not necessarily undermine the dominant ideology or the colonial discourse through which it is communicated. For example, the Good Indian/Bad Indian contradiction might simply be reformulated into Good Indian/White Man's friend – Bad Indian/White Man's enemy. Clearly, it is quite the same formulation. Perkins reminds us that stereotypes do change, they are modified or reformulated continually (1979: 141). That does not suggest, however, that resistance is impossible within this scheme. What it does suggest is that, even while the colonizing discourse may turn to positive or romanticized stereotypes, that turn alone does not indicate social, political, or even psychological change or resistance. Resistance must be indicated in other, more substantial forms. As bell hooks suggests, marginalized groups must not simply begin telling their own stories and creating their own images of themselves; they must, as well, develop a critical gaze, a way of critiquing

their own discourse within the frame of the colonizer (1993: 36). That call, of course, is much in line with and extends beyond the work of feminist film theorists asking that feminists create their own form of cinematic expression.

In our analysis, we begin with the premise that network television is a prime conveyor of colonial discourse and with the work of Homi K. Bhabha in order to understand how that discourse functions as one strategy of containment. Colonial discourse, Bhabha tells us, 'is constructed around a "boundary dispute"' that is both political and psychoanalytic (1990: 72). It is an 'apparatus of power' the objective of which is 'to construe the colonized as a population of degenerate types on the basis of racial origin, in order to justify conquest and to establish systems of administration and instruction' (75). It is clear, within this framework, that popular images or stereotypes (positive as well as negative) function to, as Stephen Heath tells us, construct a sign system (quoted in Bhabha, 1990: 74), a shorthand for recognizing and reproducing the 'other' thus validating nationalism and denying agency to what Fusco calls the subaltern culture.

The subject-race, according to Bhabha, is constructed by the colonizer as somehow 'abnormal', needing to be civilized, tamed, taught, reworked so that 'normalization' can somehow occur (1990: 76). On the other hand, for the subject-race to remain subjected, that normalization must never be achievable within the colonial system. We might begin to understand how this function of colonial discourse is realized with respect to American Indians and their popular representations by examining the ways in which mainstream America has historically and politically identified Indian people.

Television fiction as colonial discourse

Network television, far from being a trivial pastime in the US, is one of this country's primary forms of colonial discourse because, in any post-industrial society, the media is a powerful tool of ideological containment. Stuart Hall writes:

> Institutions like the media are peculiarly central to the matter [of production, reproduction, and transformation of ideologies] since they are, by definition, part of the dominant means of *ideological* production. What they 'produce' is precisely, representations of the social world, images, descriptions, explanations, and frames for understanding how the world is and why it works as it is said and shown to work.
>
> (Hall, 1981:35)

As the producer, reproducer, and circulator of dominant ideology, the media does function to contain or normalize the colonial narrative. This medium is, in fact, one of the primary educators of young people today.

That American Indians are generally known as stereotyped 'others' is not a remarkable statement, so when Jeffery Hanson and Linda Rouse ran two separate studies of stereotyping and the American Indian with students from Texas, Wisconsin, and North Dakota as their subjects, they discovered what

we might have guessed. These students all engaged in stereotyping activities, and few of them knew any specific details about Indian people, their nations or their contemporary concerns (Hanson and Rouse, 1987; Rouse and Hanson 1991). Regionally, these students differed only with respect to the kind of stereotype they had developed.

These students' familiarity with television fiction cannot, however, explain entirely those regional differences that were noted in the study. As in the nineteenth century when Easterners were beginning to again romanticize Indian people who were no longer a threat to expansion and Westerners were demonizing the same people for standing in the way of 'progress' (Dippie, 1982: 132–3), contemporary attitudes toward Indians are complicated by local politics and competition for resources. For example, in the Rouse and Hanson study, students living in Wisconsin and North Dakota, where American Indians are the most visible minority and where Indians compete with whites for local resources, tended to hold more negative, status-based stereotypes (Perkins, 1979; Rouse and Hanson, 1991) than did students in Arlington, Texas, where that was not the case (Rouse and Hanson, 1991: 1). These findings are certainly in line with Perkins' analysis of stereotyping. 'A stereotype will probably develop about a group because it has [presented], or is presenting, a problem', he writes. 'Consequently most stereotypes do concern oppressed groups because a dominant group's position is relatively stable and unproblematic' (1979: 147–8). Status-based racism is a seriously powerful one because it often appears to be founded more firmly on common sense and experience (inferential racism) than are romanticized stereotypes.

Despite the regional distinctions discovered by Rouse and Hanson in their second study, the vast majority of students from all three sites claimed that they had received most of their information about Indian people from television or movies. Furthermore, according to the work of Sut Jhally and Justin Lewis, who ran a rather large qualitative study on adult viewers of *The Cosby Show*, that belief in the truth of television is broad-based, not simply true for young people alone:

> But surely, it's only television, isn't it? Most people realize that the real world is different, don't they? Well, yes and no. Our study suggests that the line between the TV world and the world beyond the screen has, for most people become exceedingly hazy. We watch at one moment with credulity, at another with disbelief. We mix skepticism with an extraordinary faith in television's capacity to tell us the truth.
>
> (Jhally and Lewis, 1992: 133)

Jean Baudrillard's assertion that the television image *is* the real – that it replaces one reality with a new reality thus becoming the single reality, that it even replaces one version of history with another artificial but highly more memorable version – seems to be played out in these studies (Baudrillard, 1988: 13–23). For our analysis of television's image of Indian people, these findings suggest that, even though contemporary historians may be attempting to write a more thorough history, and even though some scholars

are attempting a more honest portrayal of American Indians and their separate nations, most Americans are learning from television, not from historical scholarship.

Commercial television's need to appeal to a broad audience prohibits questions of difference, especially class and racial difference (Jhally and Lewis, 1992: 132–5). That understanding is an important one for us because racism today is articulated differently than in the early days of television. Jhally and Lewis explain:

> Television, despite the liberal intentions of many of its writers, has pushed our culture backward. White people are not prepared to deal with the problem of racial inequality because they no longer see that there *is* a problem.
>
> (Jhally and Lewis, 1992: 136)

This 'different world' that is no different conveys, then, what Jhally and Lewis call an 'enlightened racism', the 'new, repressed form of racism' suggesting that everyone is, after all, the same. The problems of marginalized groups are not economic or social or political problems but individual failures to act in a system that valorizes individual achievement. Robyn Wiegman calls this attitude 'The conservative retrenchment of the 1980s to produce a vision of cultural relations seemingly unaffected by difference' (1991: 308). What that might suggest for our reading of supposedly progressive televisual representations of Indian people today is that, because multiculturalism has become a major marketing tool, mainstream representations of multiculturalism *must* suggest that difference makes no difference.

Certainly, there are many overt ways in which racism continues to appear in television fiction. According to Gretchen Bataille, Ward Churchill, Jimmie Durham, and other American Indian scholars like them who have catalogued these stereotypes in film and television, American Indians are most commonly depicted as existing only in a particular time (the nineteenth century) and of a particular tribe or place (Plains Indians, primarily Lakota). When, for example, the character Ed Chigliac of *Northern Exposure* receives a visit from an ancestral spirit, that spirit is dressed not in the clothing of inland Alaskan Indians but in the familiar buckskins and beads of plains people because so many non-Indians equate Indianness with the plains people they have seen depicted by Hollywood. Indian people in television fiction are most often unidentified. They appear to have no specific tribal affiliation or they represent 'the last of the tribe' in a peculiar double romance that draws upon both the isolated hero theme of American fiction and the Vanishing Race mythos we've spoken of above. In *Twin Peaks*, for example, Hawk is the carrier of Blackfeet legend but we never know if that is supposed to be his nation or if he simply is knowledgeable of various Indian customs and stories. Television, then, may have gone beyond the feathered warrior, but that medium does still retain the silent, mysterious almost cigar-store Indian – the stoic who seems to know things non-Indians cannot know. Marilyn of *Northern Exposure* and John

Taylor of the now-canceled *Paradise*, effectively represent that stoic Indian speaking rarely and seeming to have insight that others cannot have.

Even television's most positive portrayals of American Indians seem to remain inscribed by historical traces of misinformation, cultural repression, and political domination. Furthermore, as Stuart Hall has suggested, the racism engendered by that complex history is extremely difficult for some to understand because it is unconscious or naturalized racism. That is, one need not be a conscious bigot to engage in unconscious racial stereotyping. The cultural identity suggested by these images is an identity so linked to our cultural construction of 'American Indian' or 'Native American' and one as closely linked to the US history of Indian relations that we rarely even see it as constructed or informed by racism.

The boundary dispute: who gets to tell the story?

Of course, it is the colonizer who has control of the story. That has been painfully true of the history of Indian–White relations since contact. American Indian history written by American Indians came first in the form of autobiographies written by Christianized Indians, the earliest of which was probably that of the Reverend Samson Occom, a Mohegan who wrote his story in 1768 (Swann and Krupat, 1987: ix). Nonchristianized American Indians did not begin telling their stories until the nineteenth century, most after the removal acts, and these in the form of oral histories, most often narrated events linked to westward expansion:

> There was Black Hawk and the Black Hawk War, Wooden Leg and the Custer fight on the Little Bighorn, Yellow Wolf and the Flight of the Nez Perces, Geronimo and the Geronimo campaign. . . . With the 'closing of the frontier' in 1890, however, it was as if the Indian had dropped out of the American historical record.
>
> (Swann and Krupat, 1987: x)

Thus, even those stories told from the 'point of view' of Indian people have most frequently been histories of Indian–White relations and have been prompted by the public's interest in historical events prominent in the colonizer's history.

The problem of who gets to tell the story is surely complicated by the slowness of any academic discipline to change or welcome new approaches. Thus, many American historians continue to be skeptical of the history Indian people value – oral history – stories handed down from generation to generation, many actually recorded through such mnemonic devices as Delaware story sticks (McCutchen, 1993). Alternative histories are certainly being written, but they do not fit easily into American scholarly journals so historians working with oral tradition must contend with tenure and promotion committees that very likely will be judging their work by the measure of more conventional historical scholarship. As well, oral history of Indian nations will not fit nicely into history textbooks or courses designed around the national narrative of the settlement of the West. Finally, many

Indian nations have lost a good portion of their early oral history through centuries of conquest, disease, and assimilationist policies. What that means, of course, is that any history that might purport to represent the story from the point of view of Indian people is one that is rarely taught, slow to be recognized as 'real history', and complicated by the facts of conquest.

Today's television reworking of old stories can certainly seem like an improvement over the old struggling-pioneer-in-the-inhospitable-West plot of a fifties' program like *Death Valley Days*, but, even in texts that appear to validate American Indian cultures, the colonizing discourse still prevails. In *Paradise*, for example, those narratives that center on John Taylor (described in the show as the lone surviving member and last chief of the Paiute nation), might seem a refreshing break from the one-sided history we were told as children. John Taylor is certainly not the feathered warrior. He is a valued friend of the Cord family and obviously serves as 'wise man' or conscience for Ethan and his children, and thus for the majority audience. John Taylor is openly critical of white ways and tells stories of Indian–white history to teach moral lessons, but these stories do not depart radically from the colonizer's familiar account. In an episode entitled 'Burial Ground', for example, John Taylor must first instruct the children about why the Indians 'left their home' and then must tell Ethan, supposedly a valued cavalry scout, the story of an Indian village massacre:

> **John Taylor**: Indian people left their home because the white man wanted their land and made them move.
> **Younger Child**: That's not nice!
> **John Taylor**: Indians didn't think so either, so they decided to fight.
> **Older Child**: But they lost.
> **John Taylor**: You know, the white man's a lot like the giant in your Jack and the Beanstalk. He just takes whatever he wants.
> **Younger Child**: But Jack showed the giant, and won.
> **John Taylor**: Well, that story takes place in England.
> **Older Child**: If the Indians attack, will you join them?
> **John Taylor**: Naw. I'm not a part of that world any more.
> **Younger Child**: Will you fight with the army?
> **John Taylor**: Well, I never was a part of that world!
> **Older Child**: He's a hermit. Remember?
> **Younger Child**: Aren't you lonely?
> **John Taylor**: [Puts his arms around both children to pull them next to him and laughs.] Never!
>
> (*Paradise*, 1990)

Later, in this same episode, John Taylor must instruct Ethan about Ethan's own history. The scene opens with John Taylor looking through a telescope and talking about Galileo and geography in an obvious attempt to avoid the issue at hand – an immanent Indian uprising:

> **Ethan**: What about Black Cloud's village?
> **John Taylor**: You want the truth or what you want to hear?
> **Ethan**: The truth.

John Taylor: You want to believe Colonel Russell. He's your friend.

Ethan: So are you.

John Taylor: Well, the village was attacked. It only took a few minutes, but it took three days to bury the dead.

[Horrified reaction from Ethan as he stands up to face John Taylor.]

John Taylor: Black Cloud's mother, his father, his wife, and three of his four children were killed, and he was one of the lucky ones. At least he still had a son.

Ethan: How? How could he do it? With women and children there? I didn't have anything to do with that. I didn't even know it was happening. If I'd known about it, I might have been able to stop it.

[Cut to John Taylor who looks back at Ethan but does not speak.]

Ethan: I found the camp. Told them where it was. I didn't know he'd attack.

(Paradise, 1990)

There are many ways to read this episode and even these two isolated scenes. One would be to say that, finally, the Indian in the narrative gets to tell the story, and he is not kind in the way he tells it. He says whites were greedy and thoughtless. He reminds us that Indians fought because they were being chased from their homes. He even, in his throw-away line, 'Well, that story took place in England', suggests that America is not likely to change, not likely to give up what it has taken. Thus, we might be able to say that this story represents one way in which the colonized/the subject-race has a voice in the colonial discourse. However, 'one of the ways the mass media operate to support the ruling ideology', Perkins explains, 'is in this re-defining process and in the circulation of new definitions or a range of new definitions. . . . The media respond to what they think the audience want, which includes 'new' or topical series as well as old favourites' (Perkins, 1979: 149). So, for example, the rewriting of American Indian stereotypes is partially in response to a changed audience perception of American Indians. However, those stereotypes still function to flatten reality, and they are produced within the patterns and constraints of overall ideology.

To see how the patterns of overall ideology might constrain a narrative, we can again look at the way Ethan characterizes his role in an historical event. He reminds the audience that the US *cavalry* massacred women and children but the narrative manages to preserve our faith in the US *government* by blaming that massacre on the actions of a single crazy leader, as, say, often happens in history books when a historian reports the Sand Creek Massacre and names Colonel J. M. Chivington, 'a Methodist minister' (Hagan, 1993: 119) the lunatic who is responsible for that action. (See also Whiteman: 'Individuals like John Milton Chivington, a former Methodist minister, had political ambitions' (1987: 168). And, although we should learn to name individuals, the history of too many slaughters (including Custer's attack on a sleeping village) is perhaps too easily attributed to ambitious, crazy individuals. At times the impression seems to be that these individuals are functioning outside the sanction of the US

government, when in fact, although investigations of the Sand Creek Massacre were conducted in Congress, 'and, although Chivington and other officers were found guilty, no one was ever punished' (Whiteman, 1987: 166). As a kind of curious counterpoint, a good many of the standard historical accounts of the Wounded Knee Massacre have, until fairly recently, failed to identify any single insane cavalry officer responsible. Instead, Big Foot is named as a leader of the fated band who left the agency 'despite orders to the contrary', Hagan writes, and were killed when 'A medicine man fomented opposition among a few diehards which brought the entire band under fire' (1993: 150–1). Certainly, there are now better, more thorough accounts, but most non-Indian accounts seem to set this scene of slaughter down to an unfortunate accident.

The boundary dispute, then, is over an ideological boundary. It is about who controls the narrative and who makes the image. In the *Paradise* narrative described above, the white former scout Ethan has now claimed the territory of the victim in his talk with John Taylor. If he had only known, Ethan tells us, he might have stopped the massacre. And although John Taylor throws him a doubtful look, the audience's knowledge of Ethan as a former gunslinger, newly appointed sheriff, and all-round American hero, give to him that credibility. Yes. He might have changed things.

Those scholars who have done work on media stereotypes would pick up on the signifiers of those stereotypes embedded in these two scenes. Typically, the American narrative, as Jimmie Durham tells us, apologizes for the actions of Americans against Indian people without really placing any cultural responsibility on the oppressor. The existing discourse on American Indians has, he explains, 'little intellectual interest in the situation', rather, 'it is always sentimentally moral' (1992: 428). Thus, these narratives present apologies but 'no analysis of the conditions of U.S. society that make [this] apology seem necessary' (428). That is especially true, we would argue, when the narrative sets up the lone, crazed colonel or lieutenant, not the politics of an entire nation, to bear the responsibility for genocide.

In some ways this *Paradise* episode may appear to offer a progressive narrative because it does admit to unjustified murder; the Indians, although their tribe is never named, do have their own language (via subtitles) although that language disappears once Ethan enters the camp; the narrative allows Black Cloud's band to go off on their own at the conclusion of this episode even when the government has said they must return to the reservation; and we have the acknowledgement that what has occurred was a massacre and not a battle. Still, in replacing the racism of a nation with the insanity of a single individual, the narrative undermines any real criticism that it might suggest even as it mystifies the history of Indian–White relations. It certainly would have been highly unlikely that a band of 'renegade' Indians would have been allowed to escape being returned to their assigned reservation. That particular fiction not only valorizes the individual white hero/savior but also rewrites Indian history entirely. Finally, we suspect today's Paiutes would be surprised and shocked to learn that their nation vanished with the cancellation of *Paradise*.

The fixed reality: the Vanishing Race

That the writers of *Paradise* can so easily extinguish the very real existence of an entire Indian nation like the Paiutes may seem remarkable unless we understand how American history has told the story of the decline of Indian nations from first contact through today especially as that story emerges in contemporary political decisions over which tribes are officially recognized and which are declared 'extinct'. Edward Curtis was certainly not the first to identify Indian people as a 'Vanishing Race'. By the time he used that descriptor for the opening image of his twenty-volume pictoral history, *The North American Indian* (1907–30), the idea that Indian nations would inevitably vanish from North America was an old one extending back to the late seventeenth century. As early as the first decade of the nineteenth century, writers, artists, and politicians were predicting the final moments of a civilization past. That prediction was certainly what drove artist George Catlin, photographer Edward Curtis, and others like them out to record the last of what was assumed to be a dying people. In fact, however, already by 1862, many historians and Indian rights activists were arguing that Indian nations were not vanishing/had not become extinct as had been predicted (Dippie, 1982: 123). Still, the myth of the Vanishing Race has been a persistent one and is perhaps one of the primary ways Indian people have been simultaneously romanticized and dismissed.

The extremely popular *Northern Exposure* has actually gone beyond the typical non-Indian apology described above by having Indian people themselves offer forgiveness, thereby releasing all responsibility for the loss of cultural knowledge and the disappearance of many traditional ways. In the 1992 episode from which we take the following scene, Ed Chigliac is making a documentary about a traditional flute maker. The flute maker is (like John Taylor of *Paradise*) the last of his tribe (the Vanishing Race here, as well), and there is no one left to pass his skill on to. Ed follows him, listens, and learns about the flute:

> **Flute Maker:** You know, there's a whole history in the flute. They're very interesting. They were used for courting. The music was supposed to win a girl's heart – even the most reluctant one. Each young man had a song whose melody was transmitted by a guiding spirit – say a roving wolf or a tree or a flower. To find the song, he would go alone in the wilderness and fast until the music came to him in a dream.
> **Ed:** Wow.
> **Flute Maker:** Yeah. That's something, isn't it?
> **Ed:** Um. . . . Doesn't it bother you that – you know – no one else is going to be able to make these flutes once you're gone?
> **Flute Maker:** Naw.
> **Ed:** But then it's all gonna end.
> **Flute Maker:** Listen. It's not so tragic. The world used to be full of things which are no longer: mastodons, sabre-tooth tigers, Indian tribes, herds

of buffalo. Everything gets gone sooner or later. It's the lay of the land. Things become extinct.

<div align="right">(Northern Exposure, 1992)</div>

A generous reading of this dialogue would be to say that the flute maker, like Indian people all over, is simply accepting the fact of change and keeping what he values about his traditions but not making the tradition the whole of his existence. And, certainly, this man represents contemporary Indian accommodation to changing conditions. Still, the final moment of dialogue seems to go far beyond simple accommodation. According to the flute maker's reasoning, the colonizing culture is not at fault because, like animals (mastodons, sabre-tooth tigers, bison) Indian tribes simply became extinct. In this scheme, then, Indian people cannot blame anything but the inevitability of change for the loss of traditions, despite aggressive assimilationist policies aimed at destroying those traditions.

Here we are again reminded of the way in which the national narrative relays a colonial discourse almost without a beat. In history scholarship, for example, this relay can occur at a number of levels. At least one strand of American history seems to have picked up the theme of the inevitability of extinction without at least a conscious reference to the mythology that surely contributes to it. There is an odd echo of 'We didn't actually do as much destruction as you've been led to believe' in the work of historians like Dan Flores who argues that the bison population would have died anyway: 'In a real sense, then, the more familiar events of the 1870s only delivered the *coup de grace* to the free Indian life of the Great Plains', he writes (1991: 485). And, at one point, he even seems to blame the destruction of buffalo herds on Indian religions, suggesting Indians' ways of dealing with nature were superstitious and primitive as opposed, we assume, to the sophisticated and scientific ways in which Anglos have dealt with the natural world:

> Finally, and ironically, it seems that the Indian religions, so effective at calling forth awe and reverence for the natural world, may have inhibited the Plains Indians' understanding of bison ecology and their role in it.
>
> <div align="right">(Flores, 1991: 484)</div>

And certainly, while there are legitimate scholarly reasons for estimating, re-estimating, and arguing over the 'real' number of bison or of (in the case of another popular strand of Indian historical scholarship) the number of Indian people who populated North and Central America before Europeans arrived, one message that research sends is that Anglo-Americans are not nearly as responsible for the destruction of Indian nations as we have been led to believe.

The apparatus of power: kill the Indian; save the man

> The Indian must die as an Indian and live as a man.
> <div align="right">(Richard Henry Pratt, founder of Carlisle Indian School)</div>

Of course, there is destruction and there is destruction. We might think, for example, of the flute maker in that scene from *Northern Exposure* we've described above. He is no old man. He is no Ishi, wandering into a small Alaskan town to be discovered by scientists and anthropologists. No. He is simply 'the last of his tribe'. What tribe? How did he learn the traditions that are, in this story anyway, unique to his people? Where is he from? How does he determine that he is the last? Of course, we do not have answers to those questions. We do have answers, however, to questions of how a people might lose cultural traditions.

As Homi K. Bhabha tells us, the colonizing discourse must make it clear that the subject-race is somehow deficient, somehow in need of civilizing. Between 1887 when the Dawes Act attempted to destroy any system of commonly held Indian lands and 1934 when John Collier came to office to draft a 'New Deal' for American Indians, assimilationist policies aggressively set about to destroy Indian traditions, Indian languages, tribal sovereignty, and tribal affiliations. Perhaps some of the most damaging of those policies were embodied in the Indian Boarding School system through which Indian people were to become 'civilized'. Richard H. Pratt whose philosophy has often been condensed to the succinct 'Kill the Indian; Save the Man' motto we've used above argued forcefully for the necessity of acculturation and assimilation. He was considered a reformer for his time because he did believe that Indian people could be educated and, thereby, civilized, but he was no romantic. In his vigorous argument in favor of allotment and the destruction of the reservation system he wrote:

> I do not care how you go about it. Buffalo Bill does it one way, and Carlisle will do it another way. You may get an Indian into civilization by a great many different roads; but you ought to pull them in, to let them learn to stand alone and be men. . . . I would blow the reservations to pieces. I would not give the Indian an acre of land. When he strikes bottom, he will get up. I never owned an acre of land, and I never expect to own one.
>
> (Pratt, 1973: 276)

The language of the colonizer is an effective apparatus of power because it is the language that is distributed most easily and becomes most easily a part of the culture's ways of understanding itself and other cultures within and outside it. It is the language of the self: 'I never owned an acre of land, and I never expect to own one', Pratt exclaims. His ethnocentricism will not allow him to see any way but one – his own – for people of other cultures.

Pratt early on understood the power of the image to say to a mass audience what the word cannot. Carlisle, Lonna M. Malmsheimer writes, was 'an institutional embodiment of contemporary assimilationist thought' which included the doctrine of acculturation (1987: 26). To convince Congress and donors that Carlisle was doing its job, Pratt had hundreds of 'before and after' photographs taken. They were called 'contrasts' at the time (Malmsheimer, 1987: 25). Children were photographed upon arriving at the school 'letting [them] appear in their wildest and most barbarous costume' (Samuel Chapman to Richard Pratt, 1878; quoted in Malmsheimer,

1987: 25). The contrast would be photographed later when these children were supposedly assimilated. Hair was cut, jewelry gone, all Indian traditional dress eliminated. These, the photos proclaimed, were successes: civilized Indians. As Malmsheimer tells us, the photos are rich in cultural meaning:

> Interpretation will vary accordingly. A viewer who assumes that middle-class life is better than tribal life (in the past or present) remarks the wonderful transformation that has occurred, sees the photographs as a representation of individual (and, perhaps, tribal) progress, and infers that the institutions and processes by which this transformation was accomplished were and are effective and admirable. There may be a bit of nostalgia for the 'noble savage' and the 'vanishing race'. On the other hand, a viewer who takes a dimmer view of the processes which eroded tribal life and transformed North America, particularly emphasizing the social and cultural destruction that came with European dominance, sees the photographs as representative of a tragedy. Here, too, nostalgia for the 'vanishing race'.
>
> (Malmsheimer, 1987: 24–5)

Either way, the colonizing discourse functions to convey the myth of the Vanishing Race, the story of disappearance that can make programs like the disastrous termination policies of the 1950s possible. Through those policies, many Indian nations were essentially cut off from Federal protection and treaties were once again ignored.

Pratt's photographic contrasts might also be understood as an expression of one way the colonizing discourse attempts to create in the subject race the ideal ego. The initial photographs, of untamed, wild Indians were juxtaposed to the civilized, well-dressed, and somehow lighter skinned Americans the photos declared these children had become. As Malmsheimer points out, ' "Wildness" itself was a code term, part of a set of oppositions that invoked a whole series of contemporary meanings, meanings that the photographs were created to represent visually' (1987: 29). The image becomes, then, an image for the subject-race to aspire to, the image of the oppressor is the image of power, the image the colonized cannot have without loss. Thus, our Flute Maker, the last of his tribe, can easily shrug off extinction: 'Everything gets gone sooner or later. It's the lay of the land. Things become extinct' (Northern Exposure, 1992). For the colonizer, the sooner the better. For the colonized, survival can thereby become linked with assimilation. As graduates of Pratt's school often discovered, however, acculturation meant for them a permanent exile. Many who did return to the reservation had forgotten their native languages, languages that had been beaten out of them. They were not often accepted back into the tribe they had been forcefully taken from. Others who attempted to assimilate into the non-Indian world often found themselves ostracized through racism. They had become 'other', both to their own people and to their colonizers (In the White Man's Image, 1991).

The colonial subject and the construction of identity

In her review essay of Spike Lee's *Malcolm X*, bell hooks begins by quoting Civil Rights leader Bayard Rustin who said after the death of Malcolm, 'White America, not the Negro people, will determine Malcolm X's role in history' (hooks, 1993: 36). Later in that same essay, hooks quotes Malcolm himself who warned:

> Never accept images that have been created for you by someone else. It is always better to form the habit of learning how to see things for yourself: then you are in a better position to judge for yourself.
>
> (hooks, 1993: 36)

'Interpreted narrowly', hooks goes on to say, 'this admonition refers only to images of black folks created in the white imagination. Broadly speaking, it urges us to look with a critical eye at all images' (1993: 36). Spike Lee's film, hooks argues, must be read with that critical black gaze. It must be scrutinized in the same way we would scrutinize any other depiction of Black America formed from the predominantly White imagination that is Hollywood.

What hooks is concerned with in her discussion of race and representation is the way in which, as Stuart Hall and Homi K. Bhabha suggest, racial or cultural identity is continually changing, always in the process of formation 'and always constituted within, not outside, representation' (Hall, 1989: 68). In his work on cultural identity and cinematic representation, Hall explains for us the two primary ways of understanding cultural identity. The first is that cultural identity is already formed, historical, consistent, a system of codes that constitutes a group as '"one people", with stable, unchanging and continuous frames of reference and meaning', an identity which, say, television must simply faithfully represent (69). That understanding of cultural identity locks marginalized cultures in an unrecoverable past much in the way Curtis did with his portraits of that Vanishing Race.

Hall does, however, suggest a second way of understanding cultural identity: that it is never historically already formed and static but continually forming, continually changing. This second formulation is, for us, more useful in explaining why televisual representations are such powerful determiners:

> It is only from this second position that we can properly understand the truly traumatic character of 'the colonial experience'. The ways we have been positioned and subject-ed in the dominant regimes of representation were a critical exercise of cultural power and normalisation, precisely because they were not superficial. They had the power to make us see and experience ourselves as 'Other'. Every regime of representation is a regime of power formed, as Foucault reminds us, by the fatal couplet, 'power/knowledge'. And this kind of knowledge is internal, not external. It is one thing to place some person or set of peoples as the Other of a

dominant discourse. It is quite another thing to subject them to that 'knowledge'.

<div align="right">(Hall, 1989: 71)</div>

For Hall, then, as for hooks, Bhabha, and others, cultural identity 'is always constructed through memory, fantasy, narrative and myth. Cultural identities are the points of identification, the unstable points of identification or suture, which are made, within the discourses of history and culture. Not an essence but a *positioning*' (Hall, 1989: 72)

Feminist theory and criticism give us yet another way of understanding and talking about difference that again takes us beyond the simple positive/negative dichotomy we can so easily use to critique popular culture representations. Teresa de Lauretis, for example, tells us that differences are produced through systems of representation. She talks of 'cinematic representation as a mode of production, appropriation, and expropriation of sociosexual [sociocultural] differences' (1990: 7) and of the 'strategies of legitimation and delegitimation in current film'. The success of what Fusco calls subaltern representation, de Lauretis tells us, 'is based not just on presenting acceptable, or positive, images of social groups heretofore underrepresented, but in doing so in cinematic terms that are acceptable, legitimated, by the very apparatus of representation that has excluded them until now – and now appropriates their 'difference' in the service of its unchanged economic and ideological ends' (11). One example of how that might work was vividly shown in the 1990s cinema drama *Dances With Wolves*. While the film did manage to break from traditional ways of depicting Indian tribes with its representation of the Lakota, shown with their own family structures, with their own language, and with their own reasons for acting in the ways they did, the film also recovered the more traditional cinematic representation of 'Indianness' with its depiction of the Pawnee. The Pawnee, always shown in war paint and always acting in malicious, seemingly savage ways, recovered for the audience the notion of Western Indian so common in most of American cinema. The Lakota in this film were represented in ways that were accepted and legitimated, then, only in the classic terms of Good Indian/Bad Indian, with Lieutenant John Dunbar, the white hero, standing at center. This same formation occurs in nineties television fiction, for example, in the way John Taylor (in *Paradise*) is positioned between the renegade Black Cloud band and his new white family of Ethan Cord and children. In other words, many representations, while they are certainly progressive in some ways, are still problematic. We might keep de Lauretis's cautions in mind as we look at images of American Indians, for even the most progressive images can manage to commodify ethnicity and, thus, constrain our understanding of difference.

At the same time that programs like *Northern Exposure* and *Paradise* may seem to validate American Indian cultures, for example, these narratives and visual representations trivialize those cultures and the ways that make them different from the overculture: mainstream American society. Thus, apparently progressive portrayals serve reactionary politics as when the Flute

Maker tells Ed that Indian tribes are like mastodons, their extinction is a part of 'the lay of the land'. In the same way that the conscious strategies of feminist and gay politics are on the one hand appropriated and legitimated and on the other 'preempted of their sociopolitical and subjective power', the commodification of ethnicity also requires this containment (de Lauretis, 1990: 20).

By any measure, US television in the nineties has a much more 'multicultural' look than it has had in its entire history. We suggested earlier that the changed faces in television fiction may have less to do with valuing different cultures than with the changing demography of the middle class, the people who will be buying the products sponsoring network television. Certainly, today more people of color are in the position of the conspicuous consumer. The *appearance*, at least, of multiculturalism is an imperative. And yet, as Jhally and Lewis remind us, 'Television having confused people about class, becomes incomprehensible about race' (1992: 135). Network television simply refuses to grant legitimacy to any but the dominant upscale middle-class culture that is most commonly represented. Jhally and Lewis, for example, discovered that a program like *Roseanne* becomes notable because it defies 'the norm . . . Simply by being working class, she stands out' (1992: 133). A program like *A Different World* works hard to defy its title. It's the same world, only slightly darker, the program seems to say.

How might this formulation work in a program like *Northern Exposure* which clearly attempts the appearance of a multi-ethnic, multi-political world? According to *Northern Exposure* creator Joshua Brand, Cicely is 'a benign universe'. It is a place 'where everybody knows everyone else's business and accepts people for what they are. The town is a non-judgmental place. There's never any attempt to hurt or expose'. Everyone in Cicely is part of one big, albeit quirky, family. Certainly, the portrayal of Indian people on *Northern Exposure* can seem somewhat progressive given television's history of stereotype, misunderstanding, and even outright lie. In Cicely we do have contemporary Indians (their nations went unnamed during the first two seasons) doing everyday things: they work, eat, shop, and dance. And, as Holling found out when he tried to poll Marilyn for whether the Indians would vote for him come election day, these Indians are individuals. 'Some will, some won't,' she answered.

But these seemingly progressive moves are still set within the context of network television, and as such are part of a discourse which in the end tends to serve dominant ideologies. Network images are primarily drawn from the perspective of the colonizer, more specifically the male, white eye. De Lauretis reminds us that men have 'defined the "visible things" of cinema [and] have defined the object and modalities of vision, pleasure, and meaning on the basis of perceptual and conceptual schemata provided by patriarchal ideological and social formations' (1988: 67). It is men who shape and create portrayals of woman in film.

As Stuart Hall reminds us, however, the determining eye is not only male; it is also white. The people of color we see in popular films, read about in mainstream histories and novels, and watch on network television are

constructions made from the observations of a white, patriarchal ideology. This unmarked position from which all these observations are made and from which they make sense is always 'outside the frame – but seeing and positioning everything within it' (1981: 39). Hollywood, as Alile Sharon Larkin (1988) suggests, may have the power to articulate, work on, transform, and elaborate the ideas and representations of race, but such a transformation does not seem to interest Hollywood. According to de Lauretis, 'Hollywood doesn't believe in "others",' even as it gains from and applauds their "portrayal" in motion picture art' (1990: 12). And, we would argue, the television industry believes even less in 'others'.

This television need to make us all the same, to legitimate the overculture, is a primary narrative within even those episodes which seem to focus on questions of non-Indian vs. Indian ways. (Again, the Indian nation is unnamed, so we must be satisfied with generic 'Indian ways', a mythology that further obscures the value and complexities of discrete Indian nations.) When, for example, Ed's Medicine Man uncle is threatened with prostate cancer, he refuses Joel's help, not because he does not believe in white medicine but because going to a white physician would hurt his pride. Joel's visit to Uncle Ancou in his sauna (not sweat lodge which even the creators of popular American television seem to understand would not be a social gathering spot) results in the following exchange:

Ancou: So, you work the crossword puzzles too.
Joel: On occasion.
Ancou: *New York Times*, I presume.
Joel: Of course.
Ancou: Pencil?
Joel: Pen.
Ancou: Wouldn't you be more comfortable naked?
Joel: Um, look. I . . . I know you didn't ask me to come here, and I told myself in no way would I do this again after you gave me the slip but . . . you are going to die if you don't take care of your cancer.
Ancou: We all die.
Joel: Yeah. Yeah. We all die sometime, but you're choosing to die, and I gotta tell you that burns me up because you're a doctor, and you know better.
Ancou: I've been practicing medicine for almost fifty years. I've treated everything under the sun. Most of the time, people got better. Sometimes not. But they always listened to me. Believed in me. And I always treated them my way. I'd rather die than lose face with them.
Joel: What are you talking about? You'd rather die than lose face? No one would rather die. This is stupid. It's nuts. You're either crazy or you are a coward, and we both know you aren't crazy. It's just pride, Ancou. It's just stupid pride.

(*Northern Exposure*, 1992)

Again, this episode might well be read as a contemporary understanding of how many Indian people must function – to balance their traditional ways

with modern, non-traditional knowledge – and that would be a reasonable reading. That reading does not, however, delegitimate this narrative as yet another form of colonial discourse. Viewers discover later in the scene that, in fact, Uncle Ancou has gone to Anchorage for treatment, thus recovering the American Medical Association while not exactly dismissing traditional healing.

Of course, viewers might recall the episode in which Marilyn's cure for the cold (hi-ho-hi-ho-ipsi-ni-ho; or moose shit) is far superior to any medicine Joel can come up with for all of his Columbia University training. And, late in the second season, Joel learned a lesson about humanity from Marilyn's cousin Leonard, a Healer or Medicine Man. Still, the way the show represents Leonard and his holistic method of dealing with patients (listening to them, letting them tell stories, looking into their eyes, learning how they live), reduces his healing strategies to new age therapy, again dismissing the spiritual dimension of the medicine society and thereby reducing all traditional healing to common sense pop psychology or the medicine of seventies television family practitioner Marcus Welby, M.D. whose knowledge of and attention to human nature were his most valuable resources.

The voice of resistance: some of my best friends are white people

It might seem that network television, inscribed by the normalizing forces of commodity culture, can never get beyond the fixed realities we spoke of earlier. Can a basically reactionary medium ever provide a truly progressive narrative? Perhaps not, but television does occasionally allow a few cracks to appear in its otherwise smoothly constructed surface. In *Twin Peaks*, David Lynch and Mark Frost actually did send up the liberal apology we described earlier by giving Hawk the punch line, holding up the weak apologetic discourse so we understand it for what it is. When Lucy and her sister Gwen enter the sheriff's station, Hawk is there to meet them:

> **Gwen**: You must be that native person I've heard so much about – uh . . . Eagle Eye . . . uh
> **Hawk**: Hawk. [Looking at Lucy] Sister.
> **Lucy**: Oh, yeah. This is my sister Gwen. [Turning to Gwen] This is Hawk.
> **Gwen**: It's a pleasure to meet you. God! How you must hate us white people after all we've done to you.
> **Hawk**: Some of my best friends are white people.
>
> (*Twin Peaks*, 1990)

Here, satire, parody, and sarcasm function to provide some promise of progressive politics in popular discourse. Still, the progressivism does not last long. These are jokes, not full-blown satire. They remind us of our own foolishness, but then Lynch and Frost move to the real story, the more important characters within a program that is, at best, problematic in its treatment of women and its obsession with sexual violence.

Within the frame we have discussed here, it might seem likely then that

television can never transcend colonial discourse, that multicultural/multi-ethnic voices and themes are impossible in this medium inscribed as it is by such constraints. Still, even Jhally and Lewis, in their extremely pessimistic reading of network television, claim a change is possible but first we must pay attention to what is really important on television:

> What we are suggesting is that we reconsider the whole notion of media stereotyping by examining the ideological and economic conditions that underpin it. If we do not, we place our culture on a never-ending treadmill of images and attitudes without ever giving ourselves, as a society, the time to think about the consequences of those images. Discussions about television's influence tend to be limited to the effect of its use of sex or violence. If our audience response study tells us anything, it is that we need to be more attentive to the attitudes cultivated by normal, everyday television.
>
> (Jhally and Lewis, 1992: 143)

It is a worthy goal, but how might it be attained? First of all, we must remind ourselves again that, though representations do, as Hall suggests, work partially to construct cultural identity, that ideological construction, that colonizing effort is never totally effective. If it were, we would have no protest movements. The American Indian Movement (AIM) which withstood the siege at Wounded Knee in 1973 would have been impossible, but it wasn't. Radio stations like KILI and WOJB from Indian Country would sound exactly like public radio across the nation, but they don't. Chicago's NAES College would be a continuation of the old Carlisle program, but it isn't. In other words, even within the constraints of colonial discourse, cultural identity is only partially formed.

In his discussion of how the socially constructed subject is constituted, Paul Smith writes:

> Dominated 'subjects' do not maintain the kind of control which the word 'individual' might suggest, but neither do they remain consistent or coherent in the passage of time: both they and the discourses they inhabit have histories and memories which alter in constitution over time. Additionally, the interplay of differing subject-positions will make some appear pleasurable and others less so; thus a tension is produced which compels a person to legislate among them. So, in that light, it can be said that a person is not simply determined and dominated by the ideological pressures of any overarching discourse or ideology but is also the agent of a certain *discernment*. A person is not simply an *actor* who follows ideological scripts, but is also an *agent* who reads them in order to insert him/herself into them – or not.
>
> (Paul Smith, 1988: xxxiv–xxxv)

For some, that agency is achieved through a kind of cultural resistance. John Fiske, for example, argues in many places that audiences never do read the text in the ways that they are meant to (see, for example, Fiske, 1989). Audiences can, as we mentioned above, have varying takes on any one of the

scenes we've discussed, and they can use those readings to assert agency rather than to reinforce the colonized subject-race formation. That Jhally and Lewis's work problematizes that function of viewer response does not entirely dismiss its function.

We might, as well, turn to the work of Trinh T. Minh-ha who insists that, though popular texts do overwhelmingly engage in colonial discourse, the objection of many 'Caucasian critics' that they 'find it difficult to conceive of Black, Chicana, Asian, or Native American women's experiences', for example, is simply a patronizing ' "you-have-to-know-one-to-be-one" strategy' (1991: 231) which works to limit the ways we represent cultures as 'Other'. Instead, we can create multi-ethnic/multi-cultural representations within the overculture. To give one possibility for television, we turn to our neighbors to the north whose history with Indian people is not much better than our own but whose use of television is somewhat different.

By the time the Canadian drama *North of 60* had completed its first season, it was already clear that Canada had managed to produce a program that repositions Indian people (in this case, the Dene of the Northwest Territories) as contemporary Dene people whose lives are important and whose communities have specific needs and raise specific issues. The Dene of *North of 60* do not function, as do the Indian people of *Northern Exposure*, as background, set design, character types. They do not just 'look Indian'. They are real people. The stories center around such issues as tribal government, bootlegging, sovereignty, racism, education, and health care. The Dene are not romanticized in this program and neither are they degraded. The Anglo characters in the show are not always right, and they are not always wrong, either. In an early episode, a Dene woman stood up to the Anglo nurse who wanted her to follow procedure and travel three hundred miles to Yellow Knife to have her third child. If the story had taken place on American television, we suspect the mother would have had complications (as she did in this episode) and the nurse would have had to rush in and save her (as she tried to in this episode only to be turned back by the Dene midwife the mother had chosen). The birth was hard but fine. The breach of trust between the Dene mother and her Anglo friend was obviously not irreparable but was certainly felt in the narrative. That Indian people make up not a small portion of the production staff of *North of 60* certainly makes a difference in the way this program depicts Dene culture.

By contrast in the US, Indian people rarely occupy a central place in television narratives (much less in production staffs), and, in fact, most often simply appear as a part of the texture of any given program. In this way, the narrative actually places contemporary Indian characters back to the level of Tonto, only this Tonto more often dresses like us and even talks like us. Still, our reconstructed Tonto has little more autonomy than did Jay Silverheels. Even those Indian characters who do occupy a central place are often incorporated into the text by way of non-Indian values. Ed's Medicine Man uncle must remind us that white medicine is obviously superior. John Taylor must tell Ethan not to fight his neighbors. Indian people are, in this way, made to be the voice of mainstream American culture. As such, they

reinforce the appearance only of multicultural representation, that appearance being at the base of the commodification of ethnicity.

Writing about African Americans in film, bell hooks tells us that marginalized people in television and film are appropriated as

> colorful exciting backdrop, included in a way that stimulates interest (just seeing all the different black people on the screen is definitely new), yet often their reality is submerged, obscured, deflected away from, so that we will focus our attention even more intensely on the characters whose reality really matters.
>
> (1990: 158)

The same is, of course, true of Indian people in television fiction. Even those programs which attempt sympathetic or multicultural portrayals rely on strategies which ultimately contain difference rather than validate it. In *Northern Exposure*, for example, Indian people most often serve as that set design bell hooks speaks of, moving in the background as non-Indian characters act out their dilemmas: Maggie and Joel; Shelly and Holling; Chris and Maurice are the central figures in Cicely. At times, Ed and Marilyn may have their stories, but, in general, they take their place with the ever-silent Dave who slips in and out of the picture frame to glance upon the action. Writing one of this show's few negative reviews, *Time*'s Richard Zoglin found one positive thing to say: 'The show has some nice touches. Joel's Jewishness is refreshingly up-front, and it's good to see a few Native Americans on TV for a change' (1991: 64). Even so, Zoglin complains that the show's 'patronizing attitude' toward small towners is 'subtle' but 'annoying' (64). We might remind Zoglin that Native Americans have always appeared on television, both identified as such and not, so what Zoglin really is noticing is exactly what bell hooks complains of – something that may be equated with set design or local color – certainly their presence is in response to that commodification of ethnicity we mentioned earlier. The creators of *Northern Exposure*, for example, are also responsible for the problematic *I'll Fly Away*, set in the pre-Civil Rights South, and the banal *Going to Extremes*, a show about US medical students in Jamaica and described by *New York Times* television critic Mark Shapiro as 'first world meets third' (1992: 34), all programs that attempt a portrayal of a multi-ethnic/multi-cultural society but somehow fail to convince us that there is a multi-ethnic/multi-cultural subject position represented therein.

Paradise obviously is the simplest of the programs we have discussed. John Taylor, dressed in his battered white man's clothing, represents all victimized Indians. He lives alone, a hermit, in wise sorrow – the white man's symbol of his own guilt. Yet, he is also there to remind us that the 'good Indian' will no longer fight. He will remain a hermit, the teacher of surprisingly naive white children. Here we have the apology, as Durham says, without the analysis. *Twin Peaks* might offer one possibility for exposing stereotypes and cultural codes with its use of parody and sarcasm but even that happens so quickly that these are often throw-away lines, the lighter moments in a dark text.

Television rarely presents us with the feathered warrior on his horse these days. Tonto has exchanged his stilted English and silent moccasins for an entirely new set of stereotyped signs: the Bingo Hall, leather jackets, cowboy hats with feathers in the band, cowboy boots, long black hair, bandanna-like headbands. As the colonizer's discourse, television has yet to find a way of giving true voice to those identified as Other.

References

Bataille, Gretchen M. and Silet, Charles L. P. (1980) editors, *The Pretend Indians: Images of Native Americans in the Movies*, Ames: Iowa State University Press.

Baudrillard, Jean (1988) *The Evil Demon of Images*, Sydney: Power Institute Publications, No. 3.

Bhabha, Homi K. (1990) 'The "Other" question: the stereotype and colonial discourse', in Ferguson (1990): 71–87.

Billington, Ray A. (1981) *Land of Savagery, Land of Promise: The European Image of the American Frontier in the Nineteenth Century*, New York: W. W. Norton.

Bridges, George and Brunt, Rosalind (1980) editors, *Silver Linings: Some Strategies for the Eighties*, London: Lawrence & Wishart Press.

Chomsky, Noam (1993) *Year 501: The Conquest Continues*, Boston, MA: South End Press.

Churchill, Ward (1991) *Fantasies of the Master Race*, Monroe, Maine: Common Courage Press.

Churchill, Ward, Hill, Norbert and Hill, Mary Ann 'Media stereotyping and Native response: an historical overview', *The Indian Historian* 11(4): 45–56.

Clifton, James (1990) *The Invented Indian: Cultural Fictions and Government Policies*, New Brunswick and London: Transaction Publishers.

De Lauretis, Teresa (1988) 'Aesthetics and feminist theory: rethinking women's cinema', in E. Diedre Pribram (ed.) *Female Spectators: Looking at Film and Television*, London and New York: Verso, 1988.

—— (1990) 'Guerrilla in the midst: women's cinema in the 80s', *Screen* 31(1) Spring: 6–25.

Dent, Gina (1992) editor, *Black Popular Culture*, Seattle: Bay Press.

Dippie, Brian W. (1982) *The Vanishing American: White Attitudes and U.S. Indian Policy*, Connecticut: Wesleyan University Press.

Durham, Jimmie (1992) 'Cowboys and . . . notes on art, literature, and American Indians in the modern American mind', in M. Annette Jaimes (ed.) *The State of Native America: Genocide, Colonization, and Resistance*, Boston, MA: South End Press, 1992.

Ferguson, Russell, Gever, Martha *et al.* (1990) editors, *Out There: Marginalization and Contemporary Cultures*, MIT through The New Museum of Contemporary Art, Cambridge, MA: MIT Press.

Fiske, John (1989) *Reading the Popular*, New York and London: Routledge.

Flores, Dan (1991) 'Bison ecology and bison diplomacy: the Southern Plains from 1800 to 1850', *Journal of American History* September: 465–85.

Francis, Daniel (1992) *The Imaginary Indian: The Image of the Indian in Canadian Culture*, Vancouver: Pulp Press.

Friedman, Lester D. (1991) editor, *Unspeakable Images: Ethnicity and the American Cinema*, Urbana and Chicago: University of Illinois Press.

Fusco, Coco (1989) 'About locating ourselves and our representations', *Framework* 36: 7–15.

Hagan, William T. (1993) *American Indians*, 3rd edition, Chicago and London: University of Chicago Press.

Hall, Stuart (1977) 'Culture, the media and the "ideological effect"', in James Curran, *et al.* (eds), *Mass Communication and Society*, Sevenoaks: Edward Arnold in association with the Open University Press, 1977: 315–48.

—— (1981) 'The whites of their eyes: racist ideologies and the media', in George Bridges and Rosalind Brunt (eds) *Silver Linings: Some Strategies for the 80s*, London: Lawrence & Wishart, 1981: 28–52.

—— (1989) 'Cultural identity and cinematic representation', *Framework* 36: 68–81.

Hanson, Jeffery R. and Rouse, Linda P. (1987) 'Dimensions of Native American stereotyping', *American Indian Culture and Research Journal* 11(4): 33–58.

Hathaway, Nancy (1990) *Native American Portraits: 1862–1918*, San Francisco: Chronicle Books.

Hill, Richard (1991) 'Savage splendor: sex, lies, and stereotypes', *Turtle Quarterly* Spring–Summer: 14–23.

hooks bell (1990) *Yearning: Race, Gender, and Cultural Politics*, Boston, MA: South End Press.

—— (1992) *Black Looks: Race and Representation*, Boston, MA: South End Press.

—— (1993) 'Malcolm X: consumed by images', *Z Magazine* 6(3) March: 36–9.

In The White Man's Image. The American Experience (1991) PBS Video, WGBH-TV Boston.

Jhally, Sut and Lewis, Justin (1992) *Enlightened Racism: The Cosby Show, Audiences, and the Myth of the American Dream*, Boulder, CO: US Westview Press.

Johnston, Claire (1979) 'Women's cinema as counter-cinema', in Patricia Erens (ed.), *Sexual Strategems; The World of Women in Film*, New York: Horizon Press, 1979.

Karp, Stan (1993) 'Trouble over the rainbow', *Z Magazine* 6(3) March: 48–54.

Kasindorf, Jeanie (1991) 'New frontier: how *Northern Exposure* became the spring's hottest TV show', *New York Magazine* 27 May.

Larkin, Alile Sharon (1988) 'Black women film-makers defining ourselves: feminism in our own voice', in E. Diedre Pribram (ed.), *Female Spectators: Looking at Film and Television*, London and New York: Verso, 1988.

Leonard, John (1991) 'Over "Exposure"', *New York Magazine* 28 October: 58–60.

Lipsitz, George (1990) *Time Passages: Collective Memory, and American Popular Culture*, Minneapolis: University of Minnesota Press.

McCutchen, David (1993) translator, *The Red Record: The Wallam Olum, Oldest Native North American History*, New York: Avery Publishing Group.

McWilliams, Michael (1990) '*Northern Exposure* should be elsewhere', *Detroit News* 12 July, C 1: 8.

Malmsheimer, Lonna M. (1987) 'Photographic analysis as ethnohistory: interpretive strategies', Vol. 1 *Visual Anthropology*: 21–36.

Marchetti, Gina (1991) 'Ethnicity, the cinema, and cultural studies', in Friedman (1991).

Minh-ha, Trinh T. (1991) *When the Moon Waxes Red: Representation, Gender, and Cultural Politics*, London and New York: Routledge.

Namias, June (1993) *White Captives: Gender and Ethnicity on the American Frontier*, Chapel Hill, NC: University of North Carolina Press.

Northern Exposure (1991–92) Joshua Brand and John Falsey, producers. Finnegan-Pinchuk Company, Falahey/Austin Street Productions and Cine-Nevada Productions, produced for Universal Television. Aired on CBS in the US.

O'Connor, John J. (1990) 'New doctor adrift in Alaska', *The New York Times*, 'Word and Image', 12 July, C 22.

—— (1991) 'As networks go rural, CBS goes a bit further', *The New York Times*, 22 April, C 16: 1.

Paradise (1990) R. Robert Rosenbaum, producer, Roundelay Productions in association with Lorimar. Aired on CBS in the US.

Perkins, T. E. (1979) 'Rethinking stereotypes', in Michéle Barrett, Philip Corrigan, Annette Kuhn and Janet Wolff (eds) *Ideology and Cultural Production*, New York: St Martin's Press, 1979: 135–59.

Powell, Robin (1993) 'Recycling the redskins', *Turtle Quarterly* Winter: 8–11.

Pratt, Richard H. (1973) 'Remarks on Indian education', in Francis Paul Prucha (ed.) *Americanizing the American Indians: Writings by the 'Friends of the Indian' 1880–1900*, Cambridge, MA: Harvard University Press, 1973: 277–80.

Price, John A. (1973) 'The stereotyping of North American Indians in motion pictures', *Ethnohistory* 20 (Spring): 153–71.

Riley, Glenda (1984) 'European misperceptions of Indian women', *New Mexico Historical Review* 59 (July): 237–66.

Rouse, Linda P. and Hanson, Jeffery R. (1991) 'American Indian stereotyping, resource competition, and status-based prejudice', *American Indian Culture and Research Journal* 15(3): 1–17.

Said, Edward W. (1986) 'Orientalism reconsidered', *Literature, Politics, and Theory; Papers from the Essex Conference 1976–84*, edited by Francis Barker *et al.*, New York and London: Methuen: 210–29.

Shapiro, Mark (1992) 'How a couple of bookish guys made good on TV', *New York Times*, 12 January: 29, 34.

Smith, Paul (1988) *Discerning the Subject*, Minnesota University Press.

Spivak, Gayatri Chakravorty (1988) 'Can the subaltern speak?', *Marxism and the Interpretation of Culture*, edited by Cary Nelson and Lawrence Grossberg, University of Illinois Press: 271–313.

Stedman, Raymond (1980) *Shadows of the Indian: Stereotypes in American Culture* Norman: University of Oklahoma Press.

Swann, Brian and Krupat, Arnold (1987) editors, *I Tell You Now: Autobiographical Essays by Native American Writers*, Lincoln and London: University of Nebraska Press.

Traube, Elizabeth (1992) *Dreaming Identities: Class, Gender, and Generation in 1980s Hollywood Movies*, Boulder, CO: US Westview Press.

Twin Peaks (1990) Mark Frost and David Lynch, executive producers. Lynch/Frost Productions, Inc. Aired on ABC in the US.

West, Cornel (1990) '*The New Cultural Politics of Difference*', in Russell Ferguson, *et al.* (eds) *Out There: Marginalization and Contemporary Cultures*, Cambridge, MA: MIT Press and The New Museum of Contemporary Art, 1990: 19–36.

Whiteman, Henrietta (1987) 'White Buffalo Woman', *The American Indian and the Problem of History*, New York and Oxford: Oxford University Press.

Wiegman, Robyn (1991) 'Black bodies/American commodities: gender, race, and the bourgeois ideal in contemporary film', in Friedman (1991).

Zoglin, Richard (1991) 'A little too flaky in Alaska', *Time Magazine*, 20 May: 64.

STUART TANNOCK

NOSTALGIA CRITIQUE[1]

Abstract

Nostalgia is a widespread structure of feeling in Western modernity. While critique of nostalgia has tended to be hostile and dismissive, associating the phenomenon with dominant and conservative forces in society, this paper argues that nostalgia is a valuable way of approaching the past, important to all social groups. Acknowledging the diversity of personal needs and political desires to which nostalgia is a response, the critique offered here focusses on the limitations that the nostalgic structure of rhetoric may place on effective historical interpretation and action.

Keywords

nostalgia, popular memory, historical consciousness

> In a nostalgic mode . . . the referent is seen 'as an authentic origin or center from which to disparage the degenerate present' . . . Textual feminists subvert 'nostalgic rhetoric' by mining the past to discover play rather than place.
>
> (Greene, 1991: 305)

> Unfortunately, feminist fiction of the sort I have described has passed with the seventies, as white women's fiction has participated in postfeminist retrenchments of the eighties. Lessing, Drabble, and Atwood continue to be concerned with many of the same issues, but they no longer envision the possibility of change.
>
> (Greene, 1991: 320)

In 'Feminist fiction and the uses of memory' (1991), in an argument that many of us will find intuitively convincing, Gayle Greene suggests that an opposition may be constructed between a liberating and progressive 'feminist' memory, on the one hand, and a reactionary and regressive nostalgia on the other. Feminist memory, Greene argues, works to open up, confront, and challenge the voices and institutions of the past, and is therefore central to the projects of the women's movement: nostalgia, which always looks backwards in search of authentic origins and stable meanings, is directly obstructive to these projects. What makes Greene's essay particularly intriguing, then, is that it is itself less an example of the use of critical, playful feminist memory, than it is an example of the use of nostalgia.

Greene sees herself as writing in a period of decline, of 'collective amnesia', and of widespread passivity with respect to the women's movement. She is able to find inspiration by looking back to the feminist fiction of a lost and longed for earlier period – fiction in which (it now seems) the past was put into play, hierarchies were subverted, linguistic, logical, and social codes transgressed. Avoiding any critique or questioning of this literature's asserted aims and effective achievements, Greene is more interested in recuperating the period's activism and sense of possibility. Her rejection of nostalgia in favor of (feminist) memory is thus qualified, to say the least, by the use of her own nostalgia to revive and retrieve the critical playfulness and reflexiveness of that (now lost) feminist memory.

Hostile critiques, such as Greene's, dominate discussions of nostalgia. These critiques associate the phenomenon with dominant and conservative forces in society, and when they are not dismissing nostalgia for its sentimental weaknesses, they are usually attacking it for its distortions and misrepresentations. The inadequacies of such critiques reveal themselves clearly when faced with the actual use and importance of nostalgia in cases such as Greene's own response to a period of stasis and hesitation within the women's movement.

In order to develop more adequate critical discussion of nostalgia, the presence of multiple and different nostalgias among individuals and communities of social groups throughout Western modernity has to be acknowledged. Nostalgia responds to a diversity of personal needs and political desires. Nostalgic narratives may embody any number of different visions, values, and ideals. And, as a cultural resource or strategy, nostalgia may be put to use in a variety of ways. Once such heterogeneity is recognized, critique can then focus on both the openings and the limitations that nostalgia, as a general structure of feeling, may create for effective historical interpretation and action.

Problems of nostalgia critique

Nostalgia, a 'structure of feeling' (in Raymond Williams's sense of the term (Williams, 1977)), invokes a positively evaluated past world in response to a deficient present world. The nostalgic subject turns to the past to find/ construct sources of identity, agency, or community, that are felt to be lacking, blocked, subverted, or threatened in the present. The 'positively evaluated' past is approached as a source for something now perceived to be missing; but it need not be thought of as a time of general happiness, peacefulness, stability, or freedom.[2] Invoking the past, the nostalgic subject may be involved in escaping or evading, in critiquing, or in mobilizing to overcome the present experience of loss of identity, lack of agency, or absence of community. Some of the key tropes central to nostalgic rhetoric are the notion of a Golden Age and a subsequent Fall, the story of the Homecoming, and the pastoral.[3]

This basic value or function of nostalgia remains unacknowledged in much recent criticism of the phenomenon, criticism which tends to operate

under the assumption that nostalgia is pathological, regressive, and delusional. 'The victim of nostalgia', as one critic puts it, 'is worse than a reactionary; he is an incurable sentimentalist' (Lasch, 1984: 65).[4] Hostility towards nostalgia is fuelled in particular by the recurrent cooption of nostalgia by conservative, reactionary politics. Nostalgic invocation of English heritage functions on one level as an 'elitist, escapist perspective' that palliates present inequities and sanctifies traditional privileges (Lowenthal, 1989: 25). Janice Doane and Devon Hodges have examined the ways in which 'nostalgic writers construct their visions of a golden past to authenticate woman's traditional place and to challenge the outspoken feminist criticisms of it' (1987: 3). And James Combs (1993) writes of how Ronald Reagan was able to inspire nostalgic support for the destruction of the welfare state and the construction of a warfare state:

In the former domestic case, the nostalgic model had to be defended against the encroachments of organizational rationality that constitutes state intervention in the province of the personal, and in the latter foreign policy case, the portals of the Town had to be defended against these foreign forces, real or imagined, who would undermine its Edenic grace.

(Combs, 1993: 135)

These critiques are both salutary and valid insofar as nostalgia, as a widespread structure of feeling, has inevitably been appropriated and invested in by reactionary politics. In many ways, nostalgia 'can be used for the political purpose of directing behavior into approved roles and politics into approved ends of power' (Combs, 1993: 28).

The problem with such critiques is that they risk conflating nostalgia with its presence in, and use by, dominant and conservative groups. One has only to recall that nostalgia characterizes politics of both left and right in order to reject such a conflation: British labour invokes its own inheritance of a 'timeless national tradition' of peasant and worker revolt (Lowenthal, 1989: 28); while in the United States, the 'back to nature' and 'back to basics' movements of the 1960s, themselves thoroughly nostalgic, in turn inspire nostalgia among radicals and liberals alike heading into the 1990s (Combs, 1993: 135–43). From the 'seventeenth century Diggers to the Land Chartists and the radical labourers of our own time', writes Raymond Williams, 'the happier past was almost desperately insisted upon, but as an impulse to change rather than to ratify the actual inheritance' (1973: 43).

Nostalgia approaches the past as a stable source of value and meaning; but this desire for a stable source cannot be conflated with the desire for a stable, traditional, and hierarchized society. Nostalgic individuals may (as is the case with the anti-feminist writers studied by Doane and Hodges), in the face of an unstable present, long to return to a stable past – a past in which everything is held in its 'proper' place, where 'men were men, women were women, and reality was real' (Doane and Hodges, 1987: 3).

But nostalgic individuals may equally, in the face of a present that seems overly fixed, static, and monolithic, long for a past in which things could be put into play, opened up, moved about, or simply given a little breathing space.[5] The type of past (open or closed, stable or turbulent, simple or inspired) longed for by the nostalgic subject will depend on her present position in society, on her desires, her fears, and her aspirations.

We need to separate out, in the critique of nostalgia, the critique of the content, author, and audience of a nostalgic narrative – who is nostalgic for what, and in the names of which community – from the critique of the structure of nostalgia itself – the positive evaluation of the past in response to a negatively evaluated present. Contemporary media and political life are saturated by a number of dominant nostalgic narratives (of the Family, of the Nation, of Empire, of the Frontier (see Combs, 1993)) that are deeply alienating to large groups of people: these particular narratives need to be questioned, challenged, and put into place. But there are also other nostalgic narratives which we may wish to view in a positive light, as being progressive or enabling.[6] To understand and evaluate the importance of nostalgia in all of these various narratives, critique needs to move towards an examination of nostalgia as a general structure of feeling, through questions of continuity and discontinuity.[7]

The nostalgic structure of feeling

In his book *Yearning for Yesterday*, sociologist Fred Davis suggests that nostalgia may be seen as 'the search for continuity amid threats of discontinuity' (1979: 35). Nostalgia responds to the experience of discontinuity – to the sense that agency or identity are somehow blocked or threatened, and that this is so because of a separation from an imaginatively remembered past, homeland, family or community. By returning, in text or vision, to these lost pasts, places, and peoples, the nostalgic author asserts a sense of continuity over and above her sense of separation, and from this continuity may be able to replenish a sense of self, of participation, of empowerment, belonging, righteousness or justification, direction.

Nostalgia functions as the search for continuity. Davis's suggestion provides a useful starting point for conceptualizing nostalgia, but it needs to be taken a step further: for discontinuity, far from being simply experienced by the nostalgic subject, and far from being simply the engendering condition of nostalgia, is also and always at the same time a discontinuity posited by the nostalgic subject. 'Nostalgia', as Doane and Hodges emphasize, 'is not just a sentiment but also a rhetorical practice' (1987: 3); and the positing of discontinuity is as central to this rhetorical practice as any assertion of continuity.

Nostalgia works, in other words, as a periodizing emotion: that was then, and this is now. In the rhetoric of nostalgia, one invariably finds three key ideas: first, that of a prelapsarian world (the Golden Age, the childhood Home, the Country); second, that of a 'lapse' (a cut, a Catastrophe, a separation or sundering, the Fall); and third, that of the

present, postlapsarian world (a world felt in some way to be lacking, deficient, or oppressive). The 'lapse' or 'cut' need not be imagined as a vertical chop slicing across a continuous line of time, but may just as often be thought of as a horizontal separation, as the running into the ground of the past by the present. That is, the prelapsarian world may be felt, at times, to run very close to the surface of the postlapsarian world: but there is always and everywhere, for nostalgia to logically exist, a positing of discontinuity. A critical reading of the nostalgic structure of rhetoric should focus, then, on the construction of a prelapsarian world, but also on the continuity asserted, and the discontinuity posited, between a prelapsarian past and a postlapsarian present.

The nostalgic past

To read, value, and critique the nostalgic production of a prelapsarian world is a relatively straightforward matter. In turning to the past to find sources of, or even spaces for, agency, identity, or community, the nostalgic author will inevitably gloss over contradictory or negative components that compromise the sense of possibility found in such spaces and in such sources. In our reading – a reading which may well be undertaken by the nostalgic subject himself – we may wish to preserve the sense of source found in the nostalgic narrative. We may consider the extent to which the nostalgic text is taken to be prescriptive for an historical future, as opposed to being descriptive of an historical past. And we may also recognize the way in which the search for possibility has enabled the nostalgic author to read the past in new and productive ways, or has facilitated the recuperation of previously overlooked historical materials and practices. But our necessary critique will center essentially on what has been edited out of the nostalgic text – on the conflicts of interest and differences of position that are occluded, on the social groups and relations that are cut out of the picture, on the hidden values that may, intentionally or not, be in the process of being legitimated.

Continuity

Reading and evaluating the nostalgic text, however, in terms of the continuity it asserts between pre- and post-lapsarian worlds becomes more difficult, and much more ambiguous. To what degree is the continuity asserted by the nostalgic vision one of retreat, and to what degree is it a continuity of retrieval? Are the sources of identity, community, agency which are found/constructed by the nostalgic vision in the past posited as being located irretrievably in that past, as being accessible only as objects of a private and insular reflection and retrospect? Or are such sources retrievable as resources, as supports for community and identity-building projects in the present? Does the nostalgic text provide a relief from, or a

resource for confronting the sources of the anxieties, fears, and frustrations to which nostalgia is a response?

The ever-present danger in locating sources of community, identity, and agency in the past, as nostalgia does, lies in the underlying suggestion that such sources are not available in the present. What may start out, in the nostalgic response, as a form of incipient social protest – despair over the unhappiness, poverty, cruelty, alienation of the present – is repeatedly undercut by a mounting indifference or self-isolation from contemporary struggles; critique is replaced by retrospect, by a private 'withdrawal into "nature", into the "Eden" of the heart, and into a lonely, resigned, and contemplative love of men' (Williams, 1973: 140). When the present, with all of its suffering and protest against suffering – political unrest, social turmoil, moral crisis – is 'mediated by reference to a lost condition which is better than both [suffering and protest] and which can place both', then, as Raymond Williams points out:

> The real step that has been taken is withdrawal from any full response to an existing society. Value is in the past, as a general retrospective condition, and is in the present only as a particular and private sensibility, the individual moral action.
>
> (Williams, 1973: 140)

In the sometimes desperate quest for community and continuity by the nostalgic subject, living community and historical continuity may paradoxically be given up for lost, as the nostalgic turns to the 'finally negative images of an empty nature and the tribal past . . . where the single observer, at least, could feel a direct flow of knowledge' (Williams, 1973: 211).

But nostalgia does not necessarily entail retreat; it can equally function as retrieval. Thus Williams contrasts the above withdrawals into individual subjectivity with the movements out into community that one may find in the work of a writer such as Grassic Gibbon. The decisive difference here, writes Williams, is that:

> The spiritual feeling for land and for labour, the 'pagan' emphasis which is always latent in the imagery of the earth . . . is made available and is stressed in the new struggles: through the General Strike, in the period of *Cloud Howe*, to the time of the hunger marches in the period of *Grey Granite*. Even the legends sustain the transition, for their spiritual emphasis makes it possible to reject a Church that has openly sided with property and oppression. More historically and more convincingly, the radical independence of the small farmers, the craftsmen and the labourers is seen as transitional to the militancy of the industrial workers. The shape of a whole history is then decisively changed.
>
> (Williams, 1973: 270)

This return to the past to read a historical continuity of struggle, identity, and community, this determination to comb the past for every sense of possibility and destiny it might contain – digging around central structures to find the breathing-spaces of the margins, spinning up old sources into

tales of gargantuan epic – is a resource and strategy central to the struggles of all subaltern cultural and social groups. Nostalgia here works to retrieve the past for support in building the future.

Retreat and retrieval should not, however, be regarded unequivocally as constituting the negative and positive poles of possibility of the nostalgic response. Retrieval, for one, can be put to use by reactionary and revolutionary, dominant and subordinate groups alike. And the possibility of retreat, of a 'time-out', can be critical for the survival of shattered selves, hopes, communities, and confidences – a time-out without which some individuals, or some communities, might never even get to the stage where it becomes possible to respond effectively to the sources of present hurts. Furthermore, retreat and retrieval are never entirely separate, there being an element of each in every nostalgic vision – the possibility of a second world invoked by nostalgia produces, after all, at one and the same time, both a deferral of, and an alternative to, the first, everyday world of the present.

This ambivalence is worth keeping in mind when considering the many ways in which nostalgia has been institutionalized in Western societies. The spaces (time-outs) within our social systems that have been set aside for nostalgia – holidays and weekends to return to the family and home, suburban gardens to recreate personal pastoral visions, not to mention the endless stream of media-produced substitutes for happy families, rosy pasts, and closeknit communities – may seem to work only to reinforce social roles and structures, diffusing discontent with sentiment. Fred Davis suggests that nostalgia functions in modern society as an 'outlet' or 'safety valve' (1979: 110). Nostalgia, by sanctioning soothing and utopian images of the past, lets people adapt both to rapid social change and to changes in individual life histories – changes, in the latter case, that may well lead into social roles and positions (of adolescence, adulthood, old age) in which individual agency, sense of identity, and participation in community are severely restricted. Davis's analysis, insofar as it refers to institutionalized spaces for nostalgia, has to be taken seriously; but, if the nostalgic retreat always comprises both critique and alternative, then these officially sanctioned spaces may well, at certain points in history, provide sites, materials, and inspiration for meaningful social change.

Discontinuity

The third 'production' or 'movement' of nostalgia which must be considered by critique is the positing of discontinuity. One does not, of course, need to deny that nostalgia is a response to the experience of real and abrupt discontinuities; rather, one wants to raise the question of how these discontinuities are interpreted, of how they are given meaning in the structure of nostalgic rhetoric. Some of the problems here revolve around the question of where the 'cut' comes down, of how a discontinuity is placed between past and present. By placing certain voices, places, or cultural institutions in a receding past – voices of the country in pastoral literature, voices of indigenous peoples in pastoral ethnography (Williams, 1973;

Clifford, 1986; Rosaldo, 1989) – one assumes that these voices have no place in the present, that they are transient, doomed to extinction, salvageable only in the nostalgic pen of poet and ethnographer. 'The common idea of a lost rural world', writes Williams, by no means a harmless abstraction, can create fundamental misunderstandings with potentially disastrous consequences:

> It [the idea of a lost rural world] is in direct contradiction to any effective shape of our future, in which work on the land will have to become more rather than less important and central. It is one of the most striking deformations of industrial capitalism that one of our most central and urgent and necessary activities should have been so placed, in space or in time or in both, that it can be plausibly associated only with the past or with distant lands.
>
> (Williams, 1973: 300)

Similarly, by placing indigenous voices and cultural institutions in an ethnographic past, the ethnographer denies the fact that these voices represent alternative cultural futures, futures which are struggling to find a place within the structures and movements of the contemporary world system.

The placing of a cut between pre- and post-lapsarian worlds may also work in the opposite direction, by legitimating all that went before the 'fatal fall'. Williams, for example, shows how, in a pattern that has repeated itself for the last four hundred or so years of British history, the greed and ruthlessness of the latest batch of new landowners has given rise to a longing for the previous, traditional rural order. Attacking this 'deep and persistent illusion' that confers a sense of greater innocence on older and established proprietors, Williams points out that:

> Very few titles to property could bear humane investigation, in the long process of conquest, theft, political intrigue, courtiership, extortion, and the power of money. . . . The 'ancient stocks' to which we are senti-mentally referred, are ordinarily only those families who had been pressing and exploiting their neighbours rather longer.
>
> (Williams, 1973: 50)

The 'new men' are often only intensifying, and not themselves changing in any fundamental way, a system of land control that has been long established and long developing.

This brings up one of the most problematic limitations to historical understanding and action that the rhetoric of nostalgia may create. The nostalgic structure of Golden Age and Fall contains the implicit assumption that decline to the present is caused by forces external to a previously stable and utopian system; the nostalgic subject or author, after all, returns to the past to find sources of identity and community, not sources of alienation and oppression. Decline, naturally, must come after, from elsewhere, from the 'cut' or the Catastrophe. The nostalgic structure of feeling may thus mystify or displace the extent to which decline – that is, the changes that are

interpreted as decline – is caused by pressures and forces internal to the past, utopian world itself.

The isolation of parliamentary enclosures as the main cause of landlessness and poverty in late-eighteenth-century and nineteenth-century England, and the rhetorical opposition of communal pre-enclosure and alienated post-enclosure villages, provides a classic example of such a displacement. While enormous losses and changes unquestionably took place during the period of parliamentary enclosures, Williams points out that this was no break-up of an 'organic' or 'natural' society, but was rather the intensification of an 'economic system of landlord, tenant, and labourer, which had been extending its hold since the sixteenth century' (1973: 107). Processes internal to a developing agrarian capitalism – land improvements, changes in methods of production, and concentration of landholding – had, over a long period of time, been creating both vastly increased levels of productivity, as well as widespread unemployment and displacements of populations. By isolating enclosure from this complex of change as a single main cause, or by seeing enclosure as a fundamental turning-point, one mystifies the larger structures and forces involved (Williams, 1973: 96–107).

This displacement, or mystification, that the rhetoric of nostalgia may cause in transferring origin of change from a prelapsarian world to an external and intrusive 'cut', leads back, of course, to critique of how the image of a prelapsarian world is constructed by nostalgia. Likewise, reading the continuities asserted and the discontinuities posited by nostalgia – what gets placed in the past and what gets brought into the present – is in some sense the reading of two sides of the same coin. For in the end, the productions and movements of nostalgia work together to form a single structure of rhetoric, and in many cases, we will find it difficult to separate constructions from assertions from positions. But by artificially separating out some of the issues and dynamics involved in the rhetoric of nostalgia, one can hope to arrive at a critique that moves beyond the simple division of the subject into good and bad nostalgias, or worse, the outright dismissal of the phenomenon as a reactionary and sentimental illusion.

Nostalgia should unquestionably be challenged and critiqued for the distortions, misunderstandings, and limitations it may place on effective historical interpretation and action; but, in the modern West at least, nostalgia should equally be recognized as a valid way of constructing and approaching the past – recognized, that is, as a general structure of feeling, present in, and important to individuals and communities of all social groups.

Reading: a two-world condition

Critique finds its rationale in the extent to which it aids, clarifies, or directs interpretation and action: it is appropriate, therefore, to conclude with the reading of a particular nostalgic text. To this end, Mikhail Bakhtin's *Rabelais and His World* (1984) presents a relevant example, not least for the

fact that the 'two world condition' of carnival and officialdom through which Bakhtin reads Rabelais may serve as a parallel for the 'two world condition' of prelapsarian past and postlapsarian present through which we must read Bakhtin.

A classic example of a nostalgic text, Bakhtin's *Rabelais and His World* presents a lost world of popular carnival, a world of utopian hope, freedom, and laughter that directly confronts and subverts the hierarchies and ideologies of Renaissance officialdom. Almost from the start of Bakhtin's commentary, however, this laughing and delirious world is precipitated into an inevitable process of decline: carnival spirit is transformed into 'mere holiday mood' (1984: 33); popular laughter disintegrates, leaving only today's 'genres of reduced laughter – humour, irony, sarcasm' (1984: 120). In the traditions we have inherited from this lost era, there 'slumbers' only 'a vague memory of past carnival liberties and carnival truth' (1984: 28).

Like all nostalgic visions of the past, Bakhtin's utopian celebration of carnival ignores its contradictory and negative aspects. Carnival was licensed and sanctioned by the very authorities that, according to Bakhtin, it was supposed to have opposed, and cannot therefore be treated simply as an unmediated popular challenge to hegemony. Carnival, as Peter Stallybrass and Allon White (1986) point out, 'often violently abuses and demonizes weaker, not stronger, social groups – women, ethnic and religious minorities, those who "don't belong"' (19). The fair, which Bakhtin sees as being 'necessarily opposed' to official culture, 'itself played a crucial part in the formation and transformation of local socio-economic relations and the State' (Stallybrass and White, 1986: 35). And, in contradiction of Bakhtin's narrative of decline, in which the 'traditional' fair gradually disappears, there was instead a 'massive explosion of new fairs' in nineteenth-century Europe (Stallybrass and White, 1986: 34).

To critique Bakhtin's nostalgic vision, however, is not to reject it; his focus on carnival as a mode of understanding or as a cultural analytic remains today widely accepted as a tool of considerable use for humanistic studies across the board. Indeed, one might argue that Bakhtin's very success in introducing carnival to contemporary cultural and literary study is inseparable from his nostalgic (utopian, lyrical) impulse. Bakhtin's nostalgia, whatever its distortions of history may be, has achieved the concrete result of opening up a space in the historical record, of recuperating a set of practices and discourses, within which we can now read formerly illegible activities and potentialities of resistance.[8] To acknowledge and fully understand the nature of this achievement, to avoid facile rejections or full-scale endorsements of Bakhtin's arguments, we must be able to read, value, and critique *Rabelais and His World* through the structuring two-world condition within which it was written. We must be able to read *Rabelais and His World* as a nostalgic text.

Notes

1 I would like to thank Shirley Brice Heath for her suggestions and comments on this paper.

2 One may, for example, be nostalgic for a sense of comradeship experienced during wartime, a sense of community experienced in a state of poverty or oppression, a sense of purpose and self experienced during a time in jail.

3 While such tropes have been present throughout European history – the pastoral, the Golden Age, and the Fall begin with the Garden of Eden, and the return home receives its paradigmatic telling in Homer's *Odyssey* – nostalgia becomes a widespread, general structure of feeling only with the massive dislocations of peoples in the modern period. It is the distinctly modern sense of a radical separation of past from present, of people from place, and of person from people that nostalgia functions to mediate, as it spins out its endless tales of return.

4 For other hostile critiques of nostalgia, see Stewart (1984); Doane and Hodges (1987); Brown (1989); Greene (1991); Combs (1993). Assumptions of the pathological nature of nostalgia stem from the term's origins; the word was coined in 1688 as a medical diagnosis of the extreme homesickness suffered by Swiss mercenary soldiers fighting abroad. Nostalgia was considered in Europe to be a potentially fatal condition through to the middle of the nineteenth century; see Starobinski (1966) and Zwingmann (1959) for discussion of the early history of the concept of nostalgia.

5 Examples include Gayle Green's nostalgia for the feminist writing of the 1970s (Greene, 1991), as seen above, and Mikhail Bakhtin's nostalgic evocation of carnival in *Rabelais and His World* (1984), to be discussed below. I do not wish to suggest that longing for a stable and traditional past is inherently reactionary, or that longing for a dynamic and open past is always progressive; the terms could easily be reversed.

6 Due to the negative connotations of nostalgia, nostalgic narratives viewed as progressive or enabling tend not to be called nostalgic; they may be considered as examples of popular memory or historical consciousness instead. The notion of a 'critical' or 'revisionary' nostalgia has been around for some time (see Jameson, 1969; Clifford, 1986; Upton, 1986). Alice Reckley has written of the importance of nostalgia in the recent Mexican novel (Reckley, 1985), and Ramon Saldivar has spoken of the critical nostalgia of Americo Paredes's early poetry (Western Humanities Conference, Stanford University, 16 October 1993).

7 My analysis of nostalgia in the following pages draws on a reading of Raymond Williams's discussion of the pastoral in *The Country and the City* (1973).

8 Bakhtin's work also functions as an interpretation of its historical present: many interpreters now accept that *Rabelais and His World*, written during the 1930s and 1940s, functions on one level as an anti-Stalinist allegory. By returning (nostalgically) to Rabelais and the Renaissance, Bakhtin opens a space for coded political critique of Stalinist authoritarianism.

References

Bakhtin, Mikhail (1984) *Rabelais and His World*, translated by Helene Iswolsky, Bloomington: Indiana University Press.

Brown, Teresa (1989) 'Rewriting the nostalgic story: women, desire, narrative', Ph.D. dissertation, University of Florida.

Clifford, James (1986) 'On ethnographic allegory', in Clifford and Marcus (1986): 98–121.

Clifford, James and Marcus, George (1986) editors, *Writing Culture*, Berkeley, University of California Press.

Combs, James (1993) *The Reagan Range: The Nostalgic Myth in American Politics*, Bowling Green: Bowling Green State University Popular Press.

Davis, Fred (1979) *Yearning for Yesterday: A Sociology of Nostalgia*, New York: Free Press.

Doane, Janice and Hodges, Devon (1987) *Nostalgia and Sexual Difference*, New York: Methuen.

Greene, Gayle (1991) 'Feminist fiction and the uses of memory', *Signs* 16(2): 290–321.

Jameson, Fredric (1969) 'Walter Benjamin, or nostalgia', *Salmagundi* 10: 52–68.

Lasch, Christopher (1984) 'The politics of nostalgia', *Harper's* (November): 65–70.

Lowenthal, David (1989) 'Nostalgia tells it like it wasn't', in Shaw and Chase (1989): 18–32.

Reckley, Alice (1985) 'Looking ahead through the past: nostalgia in the recent Mexican novel', Ph.D. dissertation, University of Kansas.

Rosaldo, Renato (1989) 'Imperialist nostalgia', *Representations* 26: 107–22.

Shaw, Christopher and Chase, Malcolm (1989) *The Imagined Past*, Manchester: Manchester University Press.

Stallybrass, Peter and White, Allon (1986) *The Politics and Poetics of Transgression*, Ithaca: Cornell.

Starobinski, Jean (1966) 'The idea of nostalgia', *Diogenes* 54: 81–103.

Stewart, Susan (1984) *On Longing: Narratives of the Miniature, the Gigantic, the Souvenir, the Collection*, Baltimore: Johns Hopkins University Press.

Upton, Lee (1989) ' "Changing the past: Alice Adams" revisionary nostalgia', *Studies in Short Fiction* 26 (Winter): 33–41.

Williams, Raymond (1973) *The Country and the City*, New York: Oxford University Press.

—— (1977) *Marxism and Literature*, Oxford: Oxford University Press.

Zwingmann, Charles A. (1959) ' "Heimweh" or "nostalgic reaction": a conceptual analysis and interpretation of a medico-psychological phenomenon', Ph.D. dissertation, Stanford University.

RICHARD MIDDLETON

AUTHORSHIP, GENDER AND THE CONSTRUCTION OF MEANING IN THE EURYTHMICS' HIT RECORDINGS[1]

Abstract

Pop songs are often interpreted, by fans, critics and even academic analysts, in relation to traditional notions of 'authorship'. But in recent pop, such as the Eurythmics' hits, these notions are at the very least in tension with a more fragmented construction of subjectivity. This article seeks to develop a method for analysing such constructions, both generally and in specific Eurythmics songs.

The method draws on Mikhail Bakhtin's *dialogic* theory of subjectivity and meaning, presenting the various parts of songs (i.e., both textural lines and structural sections) as interactive 'voices', each with its characteristic style-features. Such features are always culturally marked, through their multiple associations and their different positionings within various discursive domains. It is possible, therefore, to locate the styles, their features and their interrelations on a range of discursive axes (gender, ethnicity, etc.), making up a 'map' of the musico-discursive terrain, then to place the 'dialogue' constructed in a specific song in relation to these axes, this map.

For the Eurythmics, the *gender* axis is the most (though not the only) important one. It functions through the differential positioning of constituent styles (pop, blues, soul, disco, ballad, etc.) on this axis; in relation to other axes of meaning; through articulation in the specific socio-historical context of 1980s British pop; and via interaction with visual images (e.g., on accompanying videos).

After an analysis of eight songs, the article concludes with some implications of the method for the interpretation of gender – and more generally of the construction of subjectivity – in music.

Keywords
popular song; Eurythmics; gender; dialogics

Authorship or agency?

It may seem perverse, in a 'postmodern' world, to approach musical meaning from the perspective of 'authorship'. But if cultural studies no longer takes this romantic myth at face value, it is by no means clear that the popular music culture itself has followed suit. Journalistic criticism no less

© 1995 Routledge 0950-2386

than fan discourse still very often speaks the language of 'originality', 'self-expression' and 'authenticity';[2] and, as Frith (1992), Cohen (1991) and Finnegan (1989) all make clear, this ideology remains at the heart of rock production. Even in the supposedly postmodern sphere of sampling technology, romantic claims of authorship survive (Goodwin, 1990). There are good reasons, then, to interrogate these claims.

In the tradition of Western art music, the individual composer so to speak 'signs' the work as his (or hers), and this 'sign' points to a unique creative source. The work joins others in a repertory, marked by genre, medium, style and function, so that, certainly up to the twentieth century, a fairly clear image of audience location is usually available as well. Of course, things are not quite so simple as this. Sometimes celebrated performers have a role in a work's genesis. Sometimes arrangers, orchestrators or editors muddy the waters. Sometimes composers imitate other composers, pastiche existing styles or borrow material. Increasingly works migrate between audiences and the boundaries of repertories crumble. Nevertheless, I think I describe accurately enough the paradigm case in this tradition. Of course, it is a tradition rooted in a much wider cultural history (see Stallybrass, 1992), and, in music as in other signifying practices, this relationship between 'authorship' and 'individuality' has strong implications for interpretation of style and meaning: it suggests who is speaking and in what context.

This is much less clear in the case of folk music and many other orally and electronically transmitted musics – even though bourgeois folk revivalists have tended to inaugurate a new definition of 'creative authenticity', attaching it to the 'unique identity' felt to be reflected in genuine 'folk' performance. In many non-Western traditions, the originators of pieces are unknown or mythical. Pre-revival 'folk' musicians generally worked with collectively owned material, and have rarely claimed much individual creative status. In twentieth-century popular music, increasing division of labour has turned production into a collective job, shared between performers, producer, sound engineer, and star singer (maybe) as well as writers. For the listener, the 'composition' is most likely to be the recording, and the ontological disjunction between this moment and any previous 'compositional' work merely dramatizes what is a general characteristic of electronically mediated dissemination: pieces refuse to sit still, generically, stylistically, socially; they are always sliding off the edge of one cultural site into another.

However, in the sixties, in rock, *auteur* theory reappeared. In part it drew on the folk revival ideology of 'authenticity', founded on 'truth to experience'; in part it tapped into the ideology of bourgeois art, especially as mediated by various kinds of bohemianism. Many rock performers composed their own songs. Often they got involved in production too. Stylistic originality and self-expression became the guidelines. There was an attempt to mark off a repertory – described as 'genuine' rock – and the rock audience thought of itself as quite tightly defined (even though this had little sociological solidity).

The Eurythmics had nineteen Top Forty hits in Britain between 1983 and 1990, about half of them reaching the Top Ten. While all of them appeared also on albums, their presentation and success as singles gives them the appearance of a coherent repertory, which could be defined by genre (chart pop), medium (amplified rock instruments, synthesised sound, multi-track recording studio), audience and function. At first glance, there seems to be a good case for describing their production in terms of 'authorship' and organizing our interpretation of them around this. The music and lyrics of all the songs were written by Dave Stewart and Annie Lennox, who together made up the Eurythmics. Other performers were brought in as necessary to do specific tasks on specific records. Both participated fully in the recording, mixing and production processes, and Stewart became a highly regarded producer. They deliberately organized their career so as to maximize their own control, forming their own publishing and management company, and insisting, as far as possible, on setting their own artistic agenda (see O'Brien, 1991: 88, 91; Waller and Rapport, 1985: 68, 73–4). Stewart's career began in folk clubs and a folk-rock band; Lennox was a student at the Royal College of Music in London when they met. Both backgrounds could have contributed elements of an ideology of authorship and authenticity. Female song-writers are unusual in popular music – except in the 'singer-songwriter' category, exemplified by Joni Mitchell – and Lennox's status as composer may have brought with it the connotations of 'confession' and autobiography which accompany that genre. She claimed to have been influenced by Mitchell. In the early years of her association with Stewart, their relationship was personal as well as musical. Given that virtually all the songs are about sexual relationships, it is hard not to read autobiographical elements into them.

This is certainly the line taken in many contemporary record reviews and in other journalistic comment (e.g. Sutcliffe, 1988; McNeill, 1983; Fitzgerald, 1983; Waller and Rapport, 1985: 84–5; O'Brien, 1991: 67, 75, 130–2; for instance: 'Annie's strength lies in her ability to channel this pain [arising from the break-up of her personal relationship with Stewart] into her song-writing': O'Brien, 1991: 75). Even a 'knowing' critic like Dave Hill links the self-managed, self-directed quality of the Lennox–Stewart career and the ups-and-downs of their relationship with the emotions and images portrayed in the music, and connects both to a wider 'rise and rise of the cult of the individual' (Hill, 1986: 35). Similarly, at the academic end of the spectrum of response, Wilfrid Mellers relates the songs to 'personal experience . . . a process of discovery' (Mellers, 1986: 226, 227). Lennox herself, in many interviews, goes along with this. 'A lot of the writing is introspective. It expresses how I feel myself' (Waller and Rapport, 1985: 98). 'I don't have much of an objectifying capacity as a composer' (O'Brien, 1991: 130); rather, she writes songs 'just to articulate how I feel' (Du Noyer, 1984: 7), and when she performs, she says, 'I'm showing myself through them' (Jackson, 1987: 26). 'If you have some degree of integrity', she insists, 'it's unbearable to live with an identity that's just slapped on you by someone else and isn't really representative of you' (Jackson, 1987: 26).

In a revealing joint interview, both Lennox and Stewart react violently to a New York dance re-mix of tracks from their *Touch* album: 'It was nothing to do with us', says Stewart; 'I can't stand the principle of it. It's songs that I've already recorded and mixed to the best of my ability' (Du Noyer, 1984: 6). The songs, it seems, are personal possessions.

Despite all this, to link the music's meaning to authorial experience and intention in any direct way is misguided. Just as the lyrics tell many different stories from many different points of view, so the music draws on a far greater variety of styles than could easily be taken to represent any unified perspective. Some might want to play down the significance of this. When musicians acquire a succession of styles, this is often treated as reflecting increasing technical mastery or artistic maturity. But more, always, is involved than this, for styles carry their own discursive baggage with them. A style offers a voice or voices, it makes available perspectives on the world, positions for listening subjects; it locates them socially. However, in the Eurythmics' case, there is a historically specific aspect to this as well. The stylistic allusions display a persistent sense of irony, and sometimes this reaches the level of pastiche. The visual image of the band was presented in a similarly shifting and ironic way, as we shall see later. The styles used summon up images of their own stereotypic audiences, and it seems likely that the market for the records was a very composite one. With so many differing allusions and markers, the music was from the start always seeping outside the boundaries of the chart pop repertory.

A moment's historical contextualization helps us to understand this. In the 1970s, as Frith (1989) explains, David Bowie, by literally and self-consciously 'inventing' himself through the construction of a succession of dramatic personae, had cracked open the rock myth of expressive honesty and subjective integrity. The 'new pop' of the early eighties was founded on the idea of the 'pose': ironic play with both musical and visual style. The new pop criticism which grew out of this moment celebrated 'postmodern' irony as an antidote to rock subjectivity. The rise of 'indie' music in the mid-eighties, as Reynolds (1989) makes clear, further complicated the situation, standing against both rock's straightforward commitment and the equally simple address to adolescent pleasures of typical chart pop. By this time, both critics and musicians were, consciously or unconsciously, often drawing on the language of poststructuralism to explain their strategies. To some extent, the Eurythmics' multifaceted style can be regarded as a microcosm of wider developments.

That this was a deliberate strategy is clear from statements by Annie Lennox herself. Confusingly mixed with claims to expressive authenticity are descriptions of how she played with 'artificial identities' (Du Noyer, 1984: 51); in particular, 'I played with my sexuality' (through manipulating androgynous and contradictory visual images and gestures). This sort of manipulation is related to a certain ambivalence about the self: 'sometimes I'm not too sure just how much is me and how much is someone else's story' (Jackson, 1987: 26); 'There's fifteen thousand different Annies. Within the one person there are a million types of . . . personas according to the

environment you're in' (O'Brien, 1991: 100). But this is subsumed back into autobiography, as Lennox describes her inventions of, and identifications with, a multiplicity of roles virtually as a response to adolescent alienation: 'I didn't belong. I didn't know what role to take on. I didn't know who I was' (Irwin, 1986: 24). The 'unitary subject' is cracking – but reluctantly.

This subject had been exposed as a fiction some time before the poststructuralist assault. But what the poststructuralist critique has done is to make clearer some of the ways in which subjectivity, far from being an a priori experiential ground, is constructed in discourse – particularly language, but also other cultural practices (such as musical styles). One way of putting this, which I want to pursue, is that associated with Mikhail Bakhtin.

For Bakhtin, 'there is no experience outside its embodiment in signs' (quoted in Todorov, 1984: 43). Since signs are social products – that is, discourse is always 'inter-textual', always and unavoidably referring to previous discourse – subjectivity is created in dialogue with other subjects, other discourses. Thus 'the self . . . is not a presence wherein is lodged the ultimate privilege of the real, the source of sovereign intention and guarantor of unified meaning' (Clark and Holquist, 1984: 65); 'the self must be thought of as a project' (72), and 'the reason for the invisibility of the author is the same as that for the invisibility of the self: the author is not a single, fixed entity so much as a capacity, an energy' (88). We can say that 'the self is an act of grace, a gift of the other' (68); hence, while 'the author is profoundly active . . . his activity is of a . . . dialogical nature' (Bakhtin quoted in Clark and Holquist, 1984: 244).

This approach to creativity enables us to retain a concept of agency, in a particular, closely qualified sense, while refusing the mystifications of traditional notions of authorship. This is important, because the active contribution of Annie Lennox to the production process of Eurythmics songs itself creates meaning, especially for feminists. As Susan McClary writes in relation to Madonna, for a woman to insist on taking her representation into her own hands already constitutes a powerful act of meaning production (McClary, 1991: 149–50).

Style, voice and polyphony

The Bakhtinian concept of the 'dialogic subject' seems tailor-made for the Eurythmics' multi-styled repertory. They draw on styles from (at least) rock, chart pop, disco, the synthesizer or 'techno-pop' of the early 1980s, blues, soul, and ballad – and possibly 'classical' and 'folk' as well. And these are not just stocked up, one after the other, as if to demonstrate expertise, but are interplayed, interworked, in ways that relate to lyric themes. In the light of this, we can go further than just picturing the Eurythmics as a microcosm of the stylistic diversity of popular music in the 1980s. On the level of style-ideologies, the image of 'authorship' which they themselves present is not monolithic, but seems to vary in accordance

with the associations attached to the different styles. Thus the irony of 'new pop' bounces off the unitary certainties of rock expression, or the antiphonal collective subject of soul ideology; synthesizer pop tends to write the subject out in favour of the machine; ballads allude to a tradition in which singers often transform already existing songs, obliterating the 'author', against a lavishly 'produced' and knowingly 'artificial' instrumental background. In a sense, then, the Eurythmics are playing with the conventions of various styles as these touch on ideologies of authorship. From the very start, we are confronted with the question, 'Who is this?'; 'Who is speaking here?'

Mainstream music semiology might classify the various style-features as 'topics' (see e.g., Agawu, 1991). But this somehow fails to catch the way that, in popular music anyway, styles are intersected by multiple discourses, so that they stand at the conjunction of a variety of axes of social meaning. Nor does it deal adequately with the fact that, often, in actual textures, manifestations of the styles overlap and coincide, so that they have the character of interacting 'points of view'. Given that these songs, judging by their lyrics, are little narratives or at least 'discursive tableaux', it is important to mark the styles as players in a social drama, and I would rather think, following Bakhtin, in terms of dialogic 'voices'.[3]

If theoretical justification is required for this, we can note that Bakhtin himself often described discourse, especially literature, and most especially the novel, as 'polyphonic', a quality achieved through 'orchestration' of the 'voices', counterpointing their varied social 'overtones'. For him, even a monologic utterance is structured in dialogue (between author and addressee), while the range of literary genres vary in the extent to which dialogue and linguistic diversity – 'heterology' – is explicitly built into the form. A similar range seems to exist in music, with a repertory like the Eurythmics' being analogous, in its way, to the 'polyphonic' novel. As Adorno reminds us (1973: 18), 'polyphonic music' – always, just because it is polyphonic – 'says "we"'. Even mono-stylistic pieces can be regarded as the interactions of different 'voices'. Barbara Bradby (1990; 1992; also Bradby and Torode 1984) has done excellent work on Buddy Holly, Madonna and the sixties girl-group repertory, showing how the vocal textures and narratives – interactions of lead and backing singers, for example – can be read in terms of social dialogues, touching particularly on constructions of gender and sexuality. This perspective has not been much applied outside popular music, although there are exceptions; nor has it been much applied to instrumental voices.[4]

Of course, while instrumental parts may carry gender markings, sung voices can hardly avoid doing so. John Shepherd (1991, chapter 8) has sketched something of the range of vocal styles deployed across the bifurcated territory of 'hard' and 'soft' rock – or as I am calling them 'rock' and 'pop'.[5] The typical male voice of hard – or as it is sometimes called, 'cock' – rock is hard and raspy, produced in the throat; this is the voice of aggressive, macho sexual demand. With great effort, it can be appropriated by women singers – Janis Joplin, for example – when it seems to suggest

attempts to take over characteristically masculine constructions of possessive sexual desire. The classic male pop voice is thin and light, often a head voice; the image is of the vulnerable male adolescent, the 'feminized' male, craving (maternal) protection. The possibility of women appropriating this voice may turn on the availability of an appeal to the pre-gendered 'mirror phase' of Lacanian psychoanalysis. Kaplan (1987: 58–60, 93–101), in her discussion of pop video categories, describes this strategy, which would presumably rest on constructions of singer and imagined listener as androgynously, narcissistically reflecting each other's gaze. More often, however, women pop singers, in Shepherd's schema, use either a warm chest voice (woman as nurterer, sexual provider mediated by Ideal Mother), or a development of this which is given a greater edge, a head-tone sheen; here the singer's offer, a more calculated one, is of herself as willing sexual object.

As Shepherd notes, singers can move between categories within a song. Moreover, the gender positions which the categories construct are not fixed for all time; they can be renegotiated, in changing social and musical circumstances. There are, too, more categories than these available, especially if we widen the stylistic range. For instance, there is a particular female ballad voice – husky, 'lived-in' – which, especially if there is influence from the European cabaret or jazz night-club traditions, seems to position the singer as a 'woman of experience'. Annie Lennox uses this sometimes, as she does also a pure-toned 'virginal' timbre suggesting, perhaps, chastity, innocence, or, alternatively, a kind of rationalized or spiritualized control, a refusal to play sexual games. The precise meanings here may depend on where the voice is heard as coming from: from 'classical' singing, perhaps, or from 'folk-pop' (Joan Baez, Judy Collins, Mary Hopkin, the Carpenters); very rarely does Lennox's use of this voice seem to relate to any construction of a 'Lolita' persona, as Madonna's does (albeit teasingly, ironically). Which raises a particularly important point: that vocal styles do not work autonomously but are mediated by wider considerations of style. Both the dirty, raspy tones of 'cock rock' and the warm timbres of 'earthy' female pop singers take on different meanings when they appear in soul music; the head tones and falsettos of funk and disco-pop (James Brown, Michael Jackson) carry different implications from similar sounds in soft rock. Modes of singing help to delineate styles but they also move across them, responding to them, perhaps changing meanings as they go.

The Eurythmics' first hit, 'Sweet Dreams', is a good example of their use of stylistic multiplicity and of the way the styles can interact. The basic dialogue is between verse on the one hand, chorus and bridge on the other (see Figure 1). The verse suggests pop-ballad, with a low-pitched, narrativistic, worldly-wise vocal backed by synthesized string figures (strings being a traditional ballad accompaniment). But the vocal pitch contour is bluesy, and increasing pitch and rhythm inflections intensify this influence as the song goes on. The 'mechanical' synthesizer figures suggest 'techno-pop', while the straight-four-bass drum thud derives from disco. Against this constellation of style-influences, the chorus, which also appears as an

introduction and an instrumental interlude, poses a soaring, wordless, melismatic vocal with sung backing, and the bridge is built from responsorial cries ('hold your head up') over a held, hymn-like I-IV (tonic-subdominant) chord sequence; both of these stem stylistically from soul music. In the chorus, too, the rhythm acquires a strong backbeat accent, a technique most associated with rock or rhythm 'n' blues. The dialogue between these two multi-voiced perspectives (verse on the one hand; chorus/bridge on the other) seems to affect the course of the song. After the first bridge, the succeeding interlude keeps the chorus's backbeat and also picks up a new, bluesy string phrase. The backbeat continues through the next verse; and then in the playout on the final verse, not only backbeat and bluesy string phrase are superimposed on the original verse music but also the melismatic soul-style vocal from the chorus. The interplay of styles seems, then, to create some sort of musical narrative as well as a dialogue. But what does it mean? To tackle this question, we need an interpretative framework.

Constructing meaning, constructing gender

For Bakhtin, not only is heterology – the dialogic interplay of discourses – a structural condition of subjectivity; it is also the source of meaning.

> Every word [or musical effect] gives off the scent of a profession, a genre, a current, a party, a particular work, a particular man, a generation, an era, a day, and an hour. Every word smells of the context and contexts in which it has lived its intense social life . . . In the word . . . contextual harmonies are unavoidable.
>
> (Bakhtin quoted in Todorov, 1984: 56–7)

As voiced utterance, music constructs identities, offering subjective positions associated with particular social locations. These positions are contextualized, and when the contextualization is especially consistent, we can speak, with Bakhtin, of 'chronotopes' – 'spatial and temporal indicators . . . fused into one carefully thought-out, concrete whole' (Bakhtin, 1981: 84). Musical styles often place us in specific historical and geographical moments, and offer specific ways of experiencing imagined place and felt time.

But these experiences are always mediated by discourse. And one way, analytically, into this might be to envisage styles as speaking and interacting with each other on a variety of discursive planes: 'class', 'gender', 'ethnicity', and so on. If discourse is dialogic, styles will signify in relation to each other, in a field of meaning, which is 'structured in difference'; thus we can picture them as being positioned, for any given discursive plane, along axes of meaning: 'individual'–'collective', 'spiritual'–'sensual', 'black'–'white', for example. By drawing out these axes on the various planes, we can put together a series of discursive maps of the style-terrain.

For the Eurythmics, the gender map is particularly important. The multiple discursive constructions of gender and sexuality, together with their inevitable internal contradictions, make this a rich field for articulation

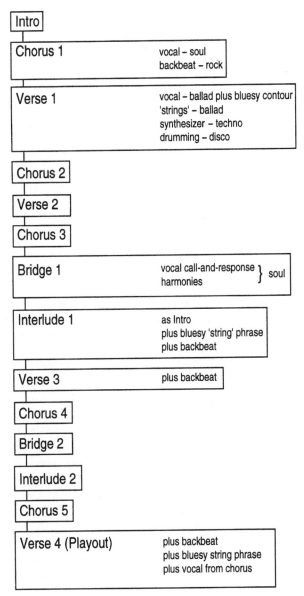

Figure 1. Sequence of verse, chorus and bridge in 'Sweet Dreams'.

by musical styles. As Birch has pointed out (1992: 50–5), the conflict within Western culture between the notion that art, and especially music, are somehow 'feminine' and the simultaneous tendency to exploit art's location in the (Lacanian) symbolic order so as to align it with structures of patriarchal authority, leads to a gendered distribution of styles and genres, some being regarded as more 'masculine', others as more 'feminine' (see

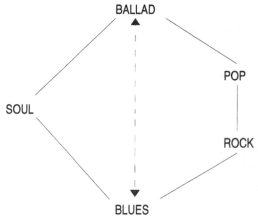

Figure 2. The gender map.

Figure 2). The ballad, drawing on the code of 'romance', is clearly located (stereotypically) in the 'feminine' sphere and can be placed at one pole of the axis. Just as in the literary romance the heroine, while acceding to the conventional passivity of her role, ensnares her man by 'feminizing' him (Radway, 1987), so female ballad singers, while offering themselves for consumption, insist on the primacy of 'emotion' over 'sex'; and male singers have to be 'feminized'. At the opposite pole stands the clearly 'masculine' sphere of blues, a music that (again stereotypically) celebrates 'sex' rather than 'romance', and usually in the form of aggressive male desire. Here, female singers (Bessie Smith, for example) have to be 'masculinized'.

In practice, styles usually interact – hardly surprising, given that 'gender' is unstable. Indeed, the basic polarity is mediated by the positioning of other styles. One line of mediation seems to run through pop and rock. In line with the established contrast between 'cock rock' and 'teenybopper pop' (Frith and McRobbie, 1978),[6] rock is positioned closer to blues, pop closer to ballad – although clearly each style has its own specific associations (relating, for instance, to aspects of adolescence, male narcissism, etc.). The other main line of mediation runs through soul music, widely perceived as representing some sort of 'spiritualized eroticism'. Drawing on gospel music as well as blues and ballad, soul has offered new positions to both male and female singers, sometimes an androgynous blurring of roles, sometimes a proto-feminist egalitarianism, almost always a politics of solidarity. Disco (and to some extent subsequent styles of 'black pop' – funk, house) extends androgyny (there are links with gay culture), relating both to soul eroticism and pop-mediated romance (see Dyer, 1990).

Exploration of new gender positions in recent popular song has often been associated with the influence of soul and post-soul styles. But, given the (chauvinistic) messages of many lyrics (from soul down to rap), and soul music's historical links with black nationalism (not always renowned for

progressive perspectives on gender), there is a need for care. Nevertheless, the link is not a false one. Just as male soul singers are often constructed as either relatively weak and needy or relatively trustworthy and responsible, so the music's rhythmic style is usually less aggressive, less thrusting, than that of blues and rock. The figure of the mature, matriarchal woman which features strongly in black American music traditions can be called up; and – a more specific chronotopic connection – the gospel lineage makes available images and associations of the leadership role of women in the black church, epitomized in the music by Rosetta Tharpe and Mahalia Jackson. Finally the general aura of *power* and *solidarity* attaching to soul through its link with black consciousness ideologies (James Brown being the best examplar) can fairly easily be rearticulated from an ethnic to a gender politics; a key chronotopic moment here is the cover of Otis Redding's celebration of black pride, 'Respect' (1965), by Aretha Franklin in 1967.

Although gender is the subject of a particularly important discursive map, certainly for the Eurythmics, it is not the only such topic. Moreover, maps interact. For example, we can envisage a 'nature'–'technology' axis, structured round a polarity of soul (where instruments are always 'vocalized', recording techniques 'humanized') and 'techno-pop', whose point is precisely to 'technologize' all sound sources. This could be seen as mediated by, for instance, disco in one way ('mechanized eroticism'), ballad in another ('glossy' orchestrations, 'mechanized' quality of old-fashioned show-biz), rock in a third (the expressive use of electric instruments signifying the masculine control of technology). There is interplay between this map and that of gender. Women, featured almost always as singers, not instrumentalists, are stereotypically associated with the body, via the 'natural' qualities of the voice; male instrumentalists, producers and sound engineers, by contrast, exemplify patriarchal mastery of the rationalized realm of technology (see Bradby, 1993; King, 1992). On the face of it, the Eurythmics seem to fit into this pattern: Lennox, the voice; Stewart, the instrumentalist/producer. Just as the division of production was not so straightforward, however (Lennox played instruments and participated in arranging and production), so Lennox's voice is sometimes used as an instrument, or is even 'technologized', while synthesized imitations of 'natural' instruments, as well as fiercely 'vocalized' electrically produced tones, also query the conventional equation.[7]

A third important discursive map is organized around a 'sacred'–'secular' axis, with soul at one pole (spiritualizing the secular), opposing the relentlessly secularizing quality of vernacular pop, especially the more 'techno' variants. Principal mediations here are provided by ballad on the one hand, blues on the other. Blues, traditionally known as 'devil's music', is religiously charged (unlike pop) but relates by negation to the gospel–soul lineage; this is a style which, via interplay with the gender plane, often constructs women, and 'sex' itself, as evil, and men's powers and follies as demonically ordered. Ballad intersects sacred and secular orbits in a different way. Its idealization of the sexual relationship resonates with old-established confusions of carnal and spiritual love, addresses to the

ethereal feminine ('my angel') summoning up images of the Virgin, which, in the context of interplay with the gender plane, stand in dialogue with complementary images (in blues and rock) of the Whore. There is plentiful historical sediment to call on, from Victorian 'sacred ballads' through protestant hymns (their passionate personalized address and typical harmonic progressions both influential on ballads), and mystical poetry, back to the confusions of sacred and secular, Madonna and Heloise figures, in mediaeval song and lyric.[8] A more speculative interplay of discourses would be to see the quasi-maternal positions available to women singers in soul as relating to matriarchal ('earth-mother') religion.

In the case of the Eurythmics, style-dialogue, and the resulting constructions of gender, were located in a very specific historical context, marked on the one hand by rising feminist consciousness and new definitions of sexuality and gender, and on the other by Thatcherite political reaction, attempting to hold back such change. Of course, the wave of 'gender-bending' in popular culture had its historical antecedents. Not only did it build on a tradition in pop music going back through Jagger and Bowie to Little Richard and Elvis, but this tradition too can be connected to earlier examples in twentieth-century entertainment (Liberace, Valentino, Josephine Baker); and to some extent the whole lineage connects to still older patterns of excess and license characteristic of theatrical performance (opera *castrati*, music hall drag artists, pantomime dames, boy actors, etc.). Nevertheless, as Garber (1992) points out, such subversive behaviour took on a new profile and new social resonances in the early 1980s. By the middle of the decade, 'cross-dressing', particularly 'male' styles for girls, was ubiquitous fashion. Ironically, Thatcherite individualism facilitated both the economics of 'second-hand dressing' and its narcissistic body politics (see McRobbie, 1989). But in a context marked by the rising influence of gay culture, changes in the structure of the family and the employment market, and post-punk experiment in pop music, 'gender-bending' possessed greater cultural power than this might suggest.

Moreover, the wave of cross-dressers which swept into pop (from Michael Jackson to Madonna, Boy George to the Pet Shop Boys) contained, for the first time, a strong representation of women performers, building on the examples of Millie Jackson, Grace Jones, Patti Smith and an array of punks. When Annie Lennox describes her 'I Need a Man' video as 'like a woman dressed as a man dressed as a woman . . . so there's a lot of sexual ambiguity in the whole thing. It's almost a homosexual statement as well' (O'Brien, 1991: 97), she acknowledges in retrospect what her notorious drag impersonation of Elvis at the 1984 Grammy Awards ceremony signalled at the time: her entry into what had become a 'continuum of strong women and feminised men who have, intentionally or not, used pop to trash gender boundaries' (Jon Savage, actually describing the 1990s band, Suede: *Guardian*, 14 July 1993).

The Eurythmics' very deliberate play with a range of visual images for Annie Lennox acquires its full meaning in this context, and these images in turn reflect back on the dialogue of musical voices. The initial, shocking

androgynous persona (1983) had Annie in a man's suit, with cropped hair, dyed orange; and several other looks played on the theme of appropriating male power. Lennox and Stewart were often photographed to look like androgynous twins. But increasingly Annie also played ironically with traditional images of femininity (flouncy dresses, lace, soft-focus blond curls, etc.), and with markers of an equally stereotypic raunchy sexuality (black leather, low-cut bra and so forth). Outfits overflowing with show-biz glitter, such as her 'Liberace' suit with keyboard-effect lapels, put the whole game in quotation marks.

Equally carefully constructed were the visual images – and indeed the visual scenes and narratives – contained in the videos accompanying the Eurythmics' records. And while it is possible to exaggerate the interpretative importance of pop videos – after all, most listening takes place without them – they do in this case often confirm or amplify the musical meanings. Besides, visual images popularized in videos tend to seep into a more general consciousness, influencing subsequent listening even in the video's absence. This was perhaps especially true in the early 1980s, when the video form was an exciting novelty. And its effects may have been particularly felt on gender readings of Eurythmics songs, given that relatively few videos featured female stars (Kaplan, 1987). I shall not be going into any great visual-analytic detail in the interpretations that follow, nor drawing with any thoroughness on film theory – though it is clear that long traditions of stereotyped images, poses and gestures lie intertextually behind pop video technique, and that Annie Lennox feeds richly on these. Nevertheless, it would be misleading to discuss her positionality solely or even mainly in terms of, say, the scopophilic male 'gaze'; and even her visual negotiations and critiques of this (for it is rare in Eurythmics videos, except for purposes of irony, for the camera to position her for the classic male 'look') form only part of the dialogic texture, alongside the interactions of vocal timbres, of polyphonic voices and of musical styles.

Video theorists who neglect the music risk missing a good deal of this textural richness – which amongst other things precludes univocal con-structions of listener/viewer response. Garber (1992) argues that cross-dressing always acts as an index of 'category crisis', gender markings mapping on to other axes of difference (ethnicity, class, cultural value, etc.), so that to upset established meanings in one sphere often puts others in jeopardy too.[9] Elvis, for example, conflating gender, ethnic and class subversions, was a 'living category crisis' (Garber, 1992: 367). Here musical ethnicity – a discursive plane not discussed in the topography sketched above – becomes vital.[10] Just as for black performers ethnic tension has often been displaced on to gender subversion (for instance, 'selling out' to white audiences being portrayed as 'emasculation'), so in the Eurythmics' music black/white and gender confusions are intermingled. The Eurythmics could 'pass for black' on US radio, just as Annie Lennox the woman could pass for . . . [what?], and when she sings 'white soul', one can think of this as a kind of 'aural cross-dressing'.

Given such rich discursive chains within the texts, it would be difficult to

argue for anything but multiple listener positions. The dialogic interplay of 'voices' offers a range of possible points of identification: not just this style but also that, not just lead vocal (itself often split in gender implications through stylistic diversity) but also other voices in the texture. Polyphonic music provides the means to subvert any monologic 'gaze' at the same time as the classic pop texture (lead vocal dominant) strives to maintain it. Moreover, listeners themselves bring to the music a range of pre-existing investments in gender and other representations, which affect the direction of their 'look'. As Frith (1992) has pointed out, the pop audience is in any case gendered in complex and, to some extent, socially unconventional ways; and in the gender-bending context of the early eighties, this may well have led to that radically heterogeneous audience response theorized, in music and more widely, by many feminist critics (see Kaplan, 1987; McClary, 1991; Gamman and Marshment, 1988; Bonner *et al.*, 1992). But if we are imagining a 'more complicated scenario, one which allows fluid relations of activity and passivity across multiple identifications . . . [involving] a whole variety of looks and glances – an interplay of possibilities' (Moore, 1988: 55, 59), this means that the interpretations that follow, while built (I hope) on evidence both in the texts and in the music-historical context, can only aspire to persuasiveness through inter-subjective scrutiny.

Some interpretations

Re-reading 'Sweet Dreams' in the light of the previous section, a quasi-narrative schema emerges, structured round the sequence of verse – the bleak, abusive setting of modern alienated society – chorus – a cry of feeling – and bridge – a soul-derived collective self-assertion ('hold your head up'). The voice moves from anonymous 'voice of experience' through the more 'expressive' pain and passion of the soul-influenced chorus, to the call-and-response of the bridge, which could be interpreted in terms of a general politics of solidarity or conceivably as the voice of a feminist sisterhood. As we saw earlier, characteristics of the chorus/bridge sections 'leak' into the verse sections, as the song is progressively 'humanized', through the 'vocalization' of the strings, the 'sexualization' of the drumming through the backbeat, and the increased role of sung voices in the texture. Parallel to this, visual images of 'nature' increasingly invade, or take over from, the representations of technology/business settings which we see at the start. Thus, the strings come to represent 'the human as natural', as we see Lennox and Stewart playing cellos in a field and in a boat. Similarly, Lennox's voice is increasingly pictured as 'natural' through 'tactile' close-ups of her face and mouth, imagery at odds with the portrayal which is dominant earlier, in which a masculinized appearance accompanies 'inhuman' gestures of mastery and domination. Surreal shots superimposing computers and cows ('nature'? or 'nature abused'?) emphasize the part played by the technology–nature axis in constructing gender in this song.

However, the implications for gender position are ambiguous. In the verse

music, the ballad/disco mix suggests 'romance gone wrong', and the pop element defines this romance as of a post-1960s (hedonistic?) type; the suggestions of 'techno' define *how* it has gone wrong: through mechanization ('some of them want to use/abuse you; some of them want to be used by you/to be abused'). But the gender roles are unclear: the hints of torch song in Lennox's vocal seem to represent the protagonist as 'the woman as victim'; but the visual images of Lennox, in conjunction with the relentlessly 'techno' backing, could be taken to be presenting *her* as the abuser. Similarly, the use of soul style-features in chorus and bridge makes available both 'strong woman' and 'responsive man' positions; and sure enough, in the later parts of the video, Dave Stewart's appearance and movements are as 'feminine' as Lennox's are 'masculine'. So both stages in the dialogic process are androgynously peopled, and this facilitates a search towards a recovery of human dignity and solidarity *without* necessarily mapping this on to a stereotyped transition from 'male' ('technics') to 'female' ('nature') – or on to an equally stereotyped progression from 'woman as victim' to the Janis Joplinesque 'woman with phallus' (a progression which a purer ballad-rock sequence might have produced). That our picture here of what 'sweet dreams' are seems less ironic at the end of the song than it did at the beginning may be tied up with a redefining of sexual desire in relation to the map of gender roles.

Many songs, especially from the earlier stages of the Eurythmics' career, offer variants of the kind of style-dialogue we find in 'Sweet Dreams'. For example, 'Love is a Stranger' plays off a disco-techno-ballad mix in the verse against a chorus and bridge which introduce more urgent, higher-pitched singing in sensuous parallel thirds, a style suggesting soul, or even nineteenth-century opera. The dialogue is between third-person description ('Love is a stranger . . .') and first-person cry ('I want you . . .'); between love as threat (its victims presented as addicts of a ubiquitous commodity) and an attempt to assert desire as control. In this song, however, the style-elements interpenetrate the various sections to a considerable extent. Thus, the 'mechanical' drum/synthesizer backing runs continuously – imprisoning the desire embodied in the chorus vocal; at the same time, the IV-I harmonic sequence (the 'Amen' gesture beloved of soul music) which is most prominent in the chorus also underlies (in reverse: I-IV) the structure of the verse, so that its 'reassuring' quality[11] 'softens' the harsh environment pictured there. The result overall is a rather inconclusive feel. In the video, Lennox appears in three radically different guises: in long, peroxide-blond curls and fur coat; in her man's suit and cropped hair look; and in punky leather, with sadistic overtones. This reinforces the inconclusiveness, but at the same time helps prevent any possibility of an orthodox positioning of the victim–desire dialectic in relation to the gender axis: Annie insists that, if this is how 'love' is in the modern world, she will be jailer as well as prisoner.

In 'Who's That Girl?' the 'story' is clearer (in the music if not in the lyrics). The verse's ballad format has Lennox singing in low-pitched, throaty, torch-song style of unrequited love, backed by synthesized strings and sustained ('cello') bass-line. This gives way in the chorus to pop-disco:

regular-beat drumming with backbeat, repeating chord-sequence, synthesizer riff; the 'timeless' setting of ballad anguish is given chronotopic specificity. And in *this* (1980s) context, the protagonist is clearly not going to submit to the passivity of private melancholy: her insistent question, 'Who's that girl?', is delivered in assertive soul style, with extravagant melismatic backing phrases and (unison) vocal group support on the repeated 'Tell me'. This chorus puts the video Dave Stewart, showing off his various new women, in his place – a move confirmed visually when Lennox switches from her 'feminine' to her 'masculine' persona, then is shown (in both simultaneously) kissing 'herself'. What happens to the listener's positioning here? A musical equivalent of the visual hermaphroditism would be if (s)he, moving through identification with Lennox's vocal, incorporated the sharp-edged instrumental riff, or the backbeat drumming, into its (her?) perspective, pulling them into its orbit (rather than adopting their ('masculine') positions as alternatives).

Sometimes the style-mix is even more clear-cut. 'Would I Lie to You' combines rock and soul. In a more explicit assertion of independence, Annie is showing the door to a lover who is no longer welcome. The verse's aggressive rock groove, use of guitar distortion, and hard-edged vocal tone suggest a female appropriation of the cock-rocker's sneer. In the chorus, the riff (over a IV-V chord-alternation), the use made of brass and vocal group, the melismatic vocal overdubs, all come from soul, providing the emotional and social foundations for her self-confidence. In the video, Lennox arrives by motorbike, clad in black leather, then performs in 'sexy' black dress, with an extravagant take-over of the male rock singer's strut. But the camera does not fetishize her body (she often turns her back, disappears from centre stage, and is shot at an angle), and her freedom of movement, together with the unfeminine hair, suggest a 'new woman' redefining male freedom in terms of her rights to her own body.

In 'I Need a Man', which is blues-rock rather than soul-rock, adoption of a 'reverse-macho' stance is pushed over an extreme into parody. The harsh, raspy timbre and exaggerated arrogance of the vocal are matched by the heavy bass riff and Keith Richard-style guitar, and by Lennox's outrageous flaunting of herself and the phallic suggestiveness of her mike-handling. This is one-way sexual demand, a reverse image of Mick Jagger – except that for a woman to assume such a position, she has to start from the basis of her received role as object rather than actor: hence the peroxide curls, heavy make-up, low-cut dress. But the performance is, musically and visually, so over the top that, as Lennox herself was aware (see above), this parody of a man-eating vamp can hardly conceal other, deeper layers of interpretation. Behind it lies the suggestion that this performer is a male, in drag; and, further back again, we know (or do we?) that this male is only being played by a woman. The complexity is in the performance here, and this twisting of the received connotations of the blues and rock traditions (a clear case of Bakhtin's 'double-voiced utterance') is why the style-mixture of the song can be so relatively simple. This sort of ambivalence is absent in the stylistically similar 'Missionary Man' (the Eurythmics' 'Jumpin' Jack Flash'); but here

the articulation of predatory sexuality with the sacred–secular axis (devil's music *versus* missionary man) results in musical modifications: the missionary man's message, in the bridge, is accompanied by a build-up of held, organ-like chords; and throughout (but especially in the play-out), occasional interjections of ecstatic, melismatic soul-style vocal fills attempt to recall a less conflictual relationship of sensuous and spiritual.

'There Must Be an Angel' treats the relationship of sexuality and religion very differently. The lyrics and the accompaniment, with its swooping strings and heavenly choir, signify 'ballad', but a ballad pushed by the vocal shapes with their literally fantastic melismata towards soul, and with a virginal purity of vocal tone which is indebted to 'sexless' ideals of classical singing. The playing off of erotic ecstasy, romantic longing and unearthly purity is focused by the video setting: Annie Lennox in virginal white gown; asexual angels flitting about; a neo-classical 'sensuality without sex'. The transmutation of ballad cliché ('there must be an angel playing with my heart') into a more socially generalized bliss ('an orchestra of angels') is readily explained once we interpret the song as appealing on the level of the pre-gendered mirror phase of Lacanian psychoanalysis.[12] The theatrical setting of the video performance, in front of androgynously clad king and courtiers at the Versailles court, provides a historical framing effect to facilitate listeners' regression to this phase.

The intersection of the gender and sacred–secular discursive axes in this song is made clear in the bridge, when heavenly chorus turns into black gospel choir, their characteristic and erotic syncopated rhythm backing a Lennox solo far more clearly derived from soul and with much richer, dirtier timbre. (Note, however, that the syncopated rhythm runs through the bass in the verse as well, tying 'heaven' and 'earth' together.) The ballad/soul mix produces an articulation of carnal and spiritual ecstasy which is somehow more 'radiant' than the pop disco/ballad fusions characteristic of Madonna's excursions in this area.

The soul connection, and its feminist potential, are explicit in 'Sisters Are Doing It for Themselves', in which Annie Lennox duets with soul singer Aretha Franklin, in a song which is virtually mono-stylistic. The political power of the style is deliberately drawn on to put a feminist message. And just as the musical texture builds up a composite female subject through call and response between the soloists and between them and the backing singers, so the video constructs a montage of historical women, intercutting this with shots of the (female) audience, and of the two stars: the one presented as androgynous 'new woman', the other as black matriarch;[13] far from being monolithic, the position offered here for women consciously embraces a range of possibilities (and apparently Aretha was not too thrilled by Annie's sexual politics: see O'Brien, 1991: 83–4), though it is noticeable that all the vocal relationships (unison doubling, echoes, decorative descants) are supportive rather than describing structural contrasts.

The music is erotic, but, through the use of long shots, angled shots and quick intercutting, the camera never fetishizes either Annie or Aretha. Similarly, the supposedly phallic power of the rock backbeat, appropriated

for soul, is captured for a less oppressive eroticism. Interestingly, the guitar solo by Stewart, in a wah-wah style derived from heavy rock, is 'framed', not only musically – coming between sections with women singing – but also visually: it is intercut with shots of the two women soloists, and in the succeeding verse he is framed literally on a giant video screen behind them. In a neat reversal of the norm, *they* control *him*. Coming immediately after a bridge asserting that, whatever some may think, 'sisters' have no wish to rule out heterosexual love, this treatment of the guitar solo – which in rock conventionally signifies sexual desire from the male point of view – suggests how such desire can be redefined in a new context.

Some implications for method

Arguably, even songs that are close to being mono-stylistic, like 'Sisters', are heard dialogically, not only in the limited sense that they offer a range of polyphonic voices for us to identify with, but also because the style's 'others' are present *in absentia*, within the surrounding musical field. The style makes sense only in the context of what it is not. 'Sisters' and 'I Need a Man' could be seen as feminist attempts to take over and redefine a traditionally male strategy of suppressing heterology *within the text* by means of an imposed monological purity – an authoritative voice. McClary (1991) has suggested that as a rule it is *refusal* of closure and a single-point-of-view that is the mark of the feminist voice in music. This would imply that the stylistic multiplicity which is characteristic of most Eurythmics songs can be placed within a longer history; but, as well as denying to feminists the possibility of tactical appropriations of monological authorship, it would also tend to cut across interpretations tying the Eurythmics' multiplicity to the specifics of its 1980s (postmodern) moment, a moment when style-pluralism was by no means confined to explicitly feminist projects. It seems better if we steer clear of a dangerous essentialism, and emphasize the need to assess strategies in relation to specific historical conditions.

In a broader methodological perspective, the implications are that the interpretative approach put forward here need be confined neither to overtly heterological pieces nor to gender analyses. It appears to offer promise in the wider task of understanding musical textures as a location for the composition of human subjectivity.

Notes

1 An earlier version of this article was presented to the annual conference of the Royal Musical Association at Southampton University, March 1993.
2 For a recent demonstration of this, see Toynbee (1993).
3 This is not meant to deny the importance of other levels of interpretation – for example, that more 'introversive' level treated by Agawu (1991) in terms of quasi-rhetorical structure – and discussed elsewhere by myself in terms of 'gestural' structure (Middleton, 1993). Nor is it to deny the importance of interplay between levels. In fact, although I leave such other levels to one side in this article, it is interesting to wonder whether – in, for example, the sphere of

'sexuality and gender', to be treated shortly – (gendered) perspectives outlined on the level of 'dialogic semiotics' may 'feed back' on the performance of gestures, gendering them; and, vice versa, whether the gesturology of a piece (gendered? pre-gendered? cross-gendered?) might affect the precise shape taken by the social dialogue.

4 McClary (1991) pays considerable attention to gender coding of vocal styles and textures, across a range of genres; see, e.g., pp. 36–7, where she discusses seventeenth-century opera. Abbate (1991) sets up a theory of multiple 'voices' in the textures of nineteenth-century opera, and these may clearly be 'unsung' (they are just defined as 'localised in . . . invisible bodies': Abbate, 1991: 13); but disappointingly, in an otherwise brilliant work, she more or less confines her analysis to the singing characters. Kramer (1990), in another highly suggestive work, does broach the possibility of textural voices in nineteenth-century instrumental music, in his final chapter ('As if a voice were in them').

5 Behind this lies a more general discursive topography related to gender codings of vocal qualities and behaviour in our culture, covering aspects of pitch, register and timbre; for example, 'feminine' voices are expected to be high pitched but not shrill. See Henley (1977: 75–6).

6 Widely criticized by theorists, but still catching assumptions commonly held by listeners and in the music industry.

7 Such voice/instrument 'crossovers' are common in African-American musics – another reason why they contain so much potential for subversion of gender images. See Middleton (1990: 264).

8 Interestingly, it is precisely by drawing on ballad on the one hand, blues (via rock) on the other, and building her disco-ized pop that way, that Madonna is able to construct her Virgin-Whore persona, one of her big themes. McClary (1991: 163–5) and Bradby (1992) have analysed the roots and mechanisms of her 'sexualised virgin-Mary persona'.

9 This seems the best route towards solving what is otherwise a problem in McClary's analyses (1991). Reading such techniques as cadential closure in terms of patriarchal authority (and hence refusal of cadential closure as a feminist move), while persuasive in many contexts, misses out the point that such techniques appear to signify also in important other ways, on other discursive planes. Thus cadential closure, and the typical tonal narratives in which it operates in European music, have been read by Shepherd (1991, chapters 6 and 7) in terms of *class* oppression. Garber's (1992) approach enables us to think of how these different discursive spheres are connected, in producing 'category crises' (or alternately, of course, in operating 'category stability').

10 Despite the difficulties in ascribing ethnicity to musical styles ('black music' being the most familiar case: see Tagg, 1989), the importance of this practice to the way people locate them within the discursive topography cannot be denied.

11 On the effect of the IV-I gesture, see Middleton (1993). The harmonic 'reversal' means that the 'open' I-IV structure of the verse is in effect answered and completed by the IV-I closure of the chorus, pointing up the 'danger' portrayed in the former and strengthening the possibility of fulfilment for the desire expressed in the latter.

12 See p. 471. Kaplan (1987) has one of her categories of pop video (her 'romantic' type) working on this level – though she does not address any musical corollaries.

13 Some of the video analysis here is indebted to Kaplan 1987.

References

Adorno, Theodor Wiesengrund (1973) *Philosophy of Modern Music*, translated by Anne G. Mitchell and Wesley V. Bloomster, London: Sheed & Ward.

Abbate, Carolyn (1991) *Unsung Voices: Opera and Musical Narrative in the Nineteenth Century*, Princeton: Princeton University Press.

Agawu, Kofi (1991) *Playing with Signs*, Princeton: Princeton University Press.

Bakhtin, Mikhail (1981) *The Dialogic Imagination*, translated by Caryl Emerson and Michael Holquist, Austin: University of Texas Press.

Birch, Dinah (1992) 'Gender and genre', in Bonner *et al.* (1992): 43–55.

Bonner, Frances, Goodman, Lizbeth, Allen, Richard, Janes, Linda and King, Catherine (1992) editors, *Imagining Women: Cultural Representations and Gender*, Cambridge: Polity Press.

Bradby, Barbara (1990) 'Do-talk and don't-talk: the division of the subject in girl-group music', in Frith and Goodwin (eds) (1990): 341–68.

—— (1992) 'Like a virgin-mother?: materialism and maternalism in the songs of Madonna', *Cultural Studies* 6: 1: 73–96.

—— (1993) 'Sampling sexuality: gender, technology and the body in dance music', *Popular Music* 12: 2: 155–76.

Bradby, Barbara and Torode, Brian (1984) 'Pity Peggy Sue', *Popular Music* 4: 183–205.

Clark, Katerina and Holquist, Michael (1984) *Mikhail Bakhtin*, Cambridge, Mass: Harvard University Press.

Cohen, Sara (1991) *Rock Culture in Liverpool: Popular Music in the Making*, Oxford: Oxford University Press.

Du Noyer, Paul (1984) 'Well suited', *New Musical Express*, 10 November: 6–7, 51.

Dyer, Richard (1990) 'In defence of disco', in Frith and Goodwin (1990): 410–18.

Finnegan, Ruth (1989) *The Hidden Musicians: Music-Making in an English Town*, Cambridge: Cambridge University Press.

Fitzgerald, Helen (1983) 'Lovers and strangers', *Melody Maker*, 9 July: 20–1, 30.

Frith, Simon (1989) 'Only dancing: David Bowie flirts with the issues', in Angela McRobbie (ed.) *Zoot Suits and Second-hand Dresses*, London: Macmillan, 132–40.

—— (1992) 'The cultural study of popular music', in Grossberg, Nelson and Treichler (eds) (1992): 174–82.

Frith, Simon and Goodwin, Andrew (1990) editors, *On Record: Rock, Pop and the Written Word*, New York: Pantheon.

Frith, Simon and McRobbie, Angela (1978) 'Rock and sexuality', *Screen Education* 29: 3–19.

Gamman, Lorraine and Marshment, Margaret (1988) (eds) *The Female Gaze: Women as Viewers of Popular Culture*, London: The Women's Press.

Garber, Marjorie (1992) *Vested Interests: Cross-Dressing and Cultural Anxiety*, London: Routledge.

Goodwin, Andrew (1990) 'Sample and hold: pop music in the digital age of reproduction', in Frith and Goodwin (1990): 258–73.

Grossberg, Lawrence, Nelson, Cary and Treichler, Paula (1992) editors, *Cultural Studies*, New York: Routledge.

Henley, Nancy (1977) *Body Politics: Power, Sex and Non-Verbal Communication*, Englewood Cliffs: Prentice-Hall.

Hill, Dave (1986) *Designer Boys and Material Girls: Manufacturing the '80s Pop Dream*, Poole: Blandford Press.

Irwin, Colin (1986) 'Thorn of crowns', *Melody Maker* 22 November: 24–5.

Jackson, Alan (1987) 'Out of her box', *New Musical Express* 7 November: 26–7.

Kaplan, E. Ann (1987) *Rocking Around the Clock: Music Television, Postmodernism and Consumer Culture*, London: Methuen.

King, Catherine (1992) 'The politics of representation: a democracy of the gaze', in Frances Bonner *et al.* (1992): 131–9.

Kramer, Lawrence (1990) *Music as Cultural Practice, 1800–1900*, Berkeley, Los Angeles and Oxford: University of California Press.

McClary, Susan (1991) *Feminine Endings: Music, Gender and Sexuality*, Minneapolis: University of Minnesota Press.

McNeill, Kirsty (1983) 'Second bite is the sweetest', *New Musical Express* 19 March: 22.

McRobbie, Angela (1989) 'Second-hand dresses and the role of the ragmarket', in McRobbie (ed.) (1989) *Zoot Suits and Second-Hand Dresses*, London: Macmillan, 23–49.

Mellers, Wilfrid (1986) *Angels of the Night: Popular Female Singers of Our Time*, Oxford: Blackwell.

Middleton, Richard (1990) *Studying Popular Music*, Buckingham: Open University Press.

—— (1993) 'Popular music analysis and musicology: bridging the gap', *Popular Music* 12: 2: 177–90.

Moore, Suzanne (1988) 'Here's looking at you, kid!', in Gamman and Marshment (1988): 44–59.

O'Brien, Lucy (1991) *Annie Lennox*, London: Sidgwick & Jackson.

Radway, Janice (1987) *Reading the Romance: Women, Patriarchy and Popular Literature*, London: Verso.

Reynolds, Simon (1989) 'Against health and efficiency: independent music in the 1980s', in McRobbie (1989): 245–55.

Shepherd, John (1991) *Music as Social Text*, Cambridge: Polity Press.

Stallybrass, Peter (1992) 'Shakespeare, the individual and the text', in Grossberg, Nelson and Treichler (1992): 593–610.

Sutcliffe, Phil (1988) 'Just think . . . ', *Q* 2(5): 44–8.

Tagg, Philip (1989) 'Open letter: black music, Afro-American music and European music', *Popular Music* 8(3): 285–98.

Todorov, Tzvetan (1984) *Mikhail Bakhtin: The Dialogical Principle*, Manchester: Manchester University Press.

Toynbee, Jason (1993) 'Policing Bohemia, pinning up the grunge: the music press and generic change in British pop and rock', *Popular Music* 12(3): 289–300.

Waller, Johnny and Rapport, Steve (1985) *Sweet Dreams: The Definitive Biography of the Eurythmics*, London: Virgin.

DISCOGRAPHY AND VIDEOGRAPHY

All records discussed are available on Eurythmics (1991) *Greatest Hits*, BMG PD 74856. The videos are compiled on Eurythmics (1991) *Greatest Hits*, BMG Video 791 012.

MARCUS BREEN

THE END OF THE WORLD AS WE KNOW IT: POPULAR MUSIC'S CULTURAL MOBILITY

Abstract

Popular music has moved to the centre of economic life, suggesting a shift in the political economy of advanced societies. The transition has been marked by a concomitant shift in the centrality of popular music in social life, assisted by new technologies. More importantly, the changes have been brought about by the reorganization of record company ownership and activity since the 1980s. This paper suggests that cultural studies could apply aspects of the research and analysis methods developed in institutional economics, to a study of the relationship between cultural and economic formations. Institutional economics, especially as proposed by Thorstein Veblen, provides a pragmatic critique for cultural industries in an era of globalization and rising corporate power. In this paper I have used institutional economics to illustrate how the shift in the organization of popular music has taken place within the corporate economy. The use of popular music as a feature of the corporate economy has involved the expansion of all forms of entertainment into the information economy. This convergence of activities and interests located in and around popular music is described by the term 'cultural mobility'.

Keywords

popular music; Thorstein Veblen; institutional economics; cultural policy; corporate economy

In an era of easy reproduction, the informational abstractions of popular experience will propagate out from their source moments to reach anyone who's interested.

(John Perry Barlow, 1994)

Jacques Attali began *Noise: The Political Economy of Music* with the pronouncement that music is *prophetic*. He went on to state, in that flamboyant manner that the French have made so endearing, that 'music is a way of perceiving the world' (1985: 4). Building on this he suggested that it is music that can provide us with the theory for explaining shifts in society.

In 'theorising through music' as Attali put it, the doors of a much broader world are opened for elaborate investigation (1985: 4). For my purposes, it is especially important to recognize the shift Attali identified, where music is defined as 'an immaterial pleasure turned commodity' (1985: 4). Cultural

© 1995 Routledge 0950-2386

studies has indicated that the encroachment of the market economy into everyday life is always the site of contestation, or more technically speaking cooptation and resistance. But even that binary option, the give and take of the market, has changed. Articulation theory now provides a means of giving broader expression to the ways in which culture and the market economy, values and commodity, are in rapid transition. More importantly, the commodification of music is a key to opening the door to an understanding of the transition. In this sense then, to return to Attali, music has prophesied new developments that are essential to the social processes of contemporary life.

While Attali is perfectly right in seeing music as the prophetic vehicle for developments in capitalism, his self-proclaimed 'theoretical indiscipline' is less helpful (1985: 5). We need 'ways of seeing', as John Berger put it. In looking to rework the biblical metaphor of the prophecy in the 1990s context, I want to ask if we can expect the imminent arrival of a messiah, which will be announced with the boom-box razzamatazz of popular music. Or does popular music itself need rethinking? Certainly it is possible to argue that popular music has not changed much in the past thirty to forty years, apart from an intensification of its penetration across social life, linked to its refinement as a commodity. There are, however, changes that reflect a new ubiquity about popular music which is an expression of its general appeal as an expression of everyday experience as well as its use as a commodity.

It is possible to give an indication of how the (music) prophecy is being worked out in the 1990s. In order to do this I want to begin with two examples from recent popular music industry history, before moving on to suggest a theoretical and methodological approach first proposed by the late nineteenth century US institutionalist economists and their contemporary counterparts. I will then conclude with examples of new music commodity forms and theorize about the messianic qualities of the object of our study.

Selling and developing: shifts and countershifts

One of the biggest events in music industry history took place on 6 March 1992, with the sale of Virgin Records to its (British) compatriot company EMI. The sale price of £510 plus £50 million assumption of Virgin's debts (= a total of US$1 billion) to Thorn-EMI, marked the end of the independents as a force in the music business, according to some. Perhaps. More correctly, it probably ended the era of the independent entrepreneur as a key in the music business. The Virgin sale indicated that popular music had shifted to the centre of the national and global economy. Since the 1950s and 1960s popular music had been contesting the centre of cultural developments in western societies. Prior to that it had loitered on the margins. Changes such as those reflected in the absorption of Virgin into EMI have seen music become a key *economic* component of modern life, thereby adding to its cultural currency. This shift has served to make demands on the music which was previously less inclined to be captured by the concerns of the commodity form (Berube 1994).

We can place the transition more clearly within the record business by briefly examining the perspective of cultural difference inherent in the independent record company. An example of the 'otherness' of independents, in separating themselves from the mainstream of major record company behaviour can be seen in the statement from Virgin employee, Al Clark, commenting on the demise of Virgin as an independent. His comment also suggests the demise of the petty entrepreneurial class:

> Its like will never be seen again. You could never set up anything like that now, not just because of a nervous economy. The spirit has changed. People now talk in a kind of ludicrous biz-speak entirely devoid of irony – that betokens a solemn world. You get twenty-year-olds talking about market penetration without having the grace to snigger.
>
> (Goodman, 1992: 122)

For his part, Virgin founder Richard Branson is said to have been motivated by the excitement of music, with money an afterthought, according to his former offsider, Nik Powell (Goodman, 1992: 139). When money spoke and the music followed, Branson believed the time had come to move on. As consumers and students of popular music we are not, of course, so free to evade the colonizing of the commodity.

Richard Branson's Virgin sell-off then, like the sale of MCA to Matsushita and Columbia/CBS to Sony, was indicative of a major shift. The music industry had moved from a peripheral position to consolidate itself at a central position in the international economy, where it became part of a global industry agenda.

Reaching this conclusion about the dramatic wind change in the music business came about after searching for a way of assessing what the Virgin sale meant. The clue came from *Vanity Fair*, where Fred Goodman recounted the details of the countdown and the context of the Virgin sale (May 1992). In the article two phrases were used to explain the Virgin sale and transactions. One described music as a 'strategic interest' (to Matsushita), the other referred to the 'record business' as a 'strategic business' (1992: 121, 122).

Looking at these terms as a political economist, I am particularly interested in how they are suggestive of the development of capitalism's permutations. In particular, I am interested in how a middle order country like Australia arranges itself via policy, within a strategic economic and cultural map, for national benefit. As Australia works to position itself in the new economic relations of the 1990s, any means of 'theory building' about the strategic map, is welcomed (Cooper *et al.*: 1993: 14). In a world where culture is part of intense trade wars (eg. GATT and NAFTA), music has a much broader strategic purpose than merely its entertainment or economic value. Interestingly, music has become part of the national policy platform and part of the trade rhetoric of the Australian government. In Australia's social democracy, popular music has been given a public profile as a concern of state and federal government policy. Consequently, the political economy of music cannot be tied off by an invisible tourniquetfrom the mainstream of

social life. The suggestion that music is strategic, as the *Vanity Fair* article claimed, is therefore like a beacon in an era when economic strategy is an implicit aspect of the national program of development, and music is part of that economic regime.

The term 'strategy' itself is fundamental to cultural policy studies and its intersection with political economy (Bennett, 1992: 35). When used in the business context it refers to the positioning of an item within the entire range of transactions available.[2] The mechanics of the implementation of the strategy involves tactics, based on plans devised as part of the strategy. Strategy and planning are often used together in the management literature. For example: 'Strategic planning is a highly creative process that involves all relevant stakeholders in the development of long-term direction'; furthermore, 'strategic planning identifies the goals of the interested operating units and technical stakeholders...providing a framework for them to share ideas using a common language' (Johnson-Turner, 1993: 22, 23).

Emphasizing the process over a lengthy period of time and the framework of commonality expressed by the shared language, helps explain the strategy reflected in the Virgin sale and the EMI purchase. By that I mean to emphasize the way in which strategic business is about economies of scale and economies of scope. The purchase of Virgin sought to extend both economies within the much larger EMI corporation. Manifestations of this are evident in Table 1 which explains a central thesis of this paper – that within the transnational conglomerates referred to as major record companies, music, or the record business, is one element of the general corporate structure and economy (Dugger, 1988: 986-7).

Further evidence of the transformation of music as a commodity within the general internal workings of conglomerates appeared in the *Vanity Fair* story mentioned on page 488. It claimed – and this has yet to be fully researched and analysed – that 'although the record operation (of Virgin) wasn't a big money-maker, the cash turnover was impressive' (Goodman, 1992: 122). The advantage for a major like EMI or BMG, according to Goodman, was that 'Virgin could deliver hits and be expected to keep BMG's distribution pipeline and billing up for years' (Goodman, 1992: 122). I think it is clear that there are processes within corporations that involve music only as a tangential element of a much larger programme. Theorists and researchers may need to isolate this shift in music's corporate development.

The strategic placement of music within the corporation cannot be underestimated. Certainly the purchase of well-placed companies with large music catalogues or copyrighted software – CBS, MCA, Virgin – indicates that the conglomerates have other plans. These include strategies such as the development of hardware-delivery system products to carry the software Philips with CD players, for example.

Branson's move is less obvious, as he saw his own potential for strategic expansion in the airline business. Citing Rupert Murdoch, Branson said that 'if you get it right (airlines or newspapers) you can get it really right' (Goodman: 1992: 139). His emphasis on getting something 'really right'

Table 1 Music sales as a percentage of parent group's total sales 1991

	Total sales	*Music sales %*
Time Warner	$8.6 bn First nine months	24.1
Thorn – EMI	$6.8 bn Year to April	27.8%
Bertelsmann	$10.2 bn Year to June	21.2%
Sony	$13.6 bn Six months to Sept	11.1%
Matsushita	$27.6 bn Six months to Sept	7.8*%
Philips	$13.3 bn First six months	10.4%

* Including film; music; retail and mail order; book publishing; broadcasting and cable and other
Source: Company reports quoted in *The Economist*, 21.12.91.

suggests that the music business had personally reached its threshold for Branson and that an airline was the means to a higher level of capitalist achievement. Perhaps airlines is an activity closer to what he perceives as the centre of capitalist activity. Or to be playful, perhaps Branson shares with Murdoch the belief that airlines move capitalist activity to a higher plane!

These developments suggest the following question. What do popular music scholars make of the shifts of ownership, if they represent a transition from the established music business structure to a situation where music is business, within the global conglomerate economy?

An Australian change

An Australian example indicates another shift in the music business. This time the move is by the state, which has endorsed popular music as an aspect of everyday cultural life worthy of government support in a pluralist society.

The 1980s saw a rapid rise in government involvement in popular music. Reports and inquiries from Government departments put the case for promoting Australian popular music initiatives. The resulting policies saw funding allocations by the Victorian State Government and the Federal Government begin in 1987–8. Several institutions were established as a result. They included the Victorian Rock Foundation, The Push (Victoria), Ausmusic (Australian Contemporary Music Development Company Ltd) with offices in every state (Breen, 1993a). These organizations were committed to developing a music infrastructure, where opportunities for performance were melded with training, development and education programmes. The assumption behind their formation was that a healthy national music industry would provide youth with relevant entertainment and education, while the strong core of the industry could be simultaneously developed and strengthened. Of course, it appears that the industry has overwhelmed the training and education programmes in some cases, although the tension between the industrial and educational–cultural sectors is a point of debate for many.

Table 2 Music industry – summary 1991/2

Total output	$1,369m
Value added/contribution to GDP	$698m
Exports of goods and services	$120m
Imports of goods and services	$265m
Balance of trade (deficit)	($144)m
Proportion of household weekly expenditure spent on music industry products	0.5%
Employment – full-time equivalent (no.)	12,500
– artists and songwriters	39,000

Source: *The Australian Music Industry: An Economic Profile*, prepared for the Music Industry Advisory Council, Price Waterhouse, Economic Studies and Strategies Unit, Canberra, April/May 1993.

The contradictory nature of the policy initiatives in Australian popular music became clear as the federal government developed a popular music export strategy, after an inquiry by Austrade (Australian Trade Commission) in 1986. The result has been an emphasis by the government, in association with the major record companies, to export Australian music. The pressure on the infrastructure from the government and the major record companies is applied from this direction, namely that the development of local music is merely an adjunct to the creation of exportable music product. This 'pressure' to export suggests that in the Australian context popular music has become part of a shift. Popular music has moved to centre of the national economy, to become part of the core of the managed or planned economy.

Evidence of this appeared in the Prices Surveillance Authority's *Inquiry Into the Prices of Sound Recordings* (1990). The assessment of music production and distribution provided by the Inquiry ultimately pitted the industry – the major record companies and those independents with benefits accruing from the Copyright Act 1968 to exclusively import licensed recordings – against those without exclusive licensing arrangements. Without going into detail, it was and still is an instructive debate about the nature of the industry in Australia. In fact, a recent follow-up report summarized the total value of the music industry by expressing it in terms of its total value which was then broken down into categories that are typically applied to conventional industries. Table 2 shows how this accounting procedure was presented.

I have identified two major shifts: (1) how music has become central to capitalism's strategic interests by moving from the periphery to the centre of corporate life; (2) how music has become central to government and national interests through infrastructure and export development. I want to indicate that it is *also* and *still* very much part of the symbolic landscape of everyday life. This shift is perhaps more difficult to trace, but the two illustrations (p. 493) from major Melbourne newspapers indicate that popular music is a source of symbolic representation. As such, popular

music represents the everyday of political and social life and maintains its popular currency at a multitude of sites, where it is variously used, interpreted, appropriated and recontextualized according to the circumstances.

Popular music is called upon to provide the images which have proliferated through the visual presentation of popular music as seen in live performance, on television and in film, as well as in images suggested by song lyrics. Popular music imagery is now unquestioningly accepted and grafted on to the public perception of key individuals as part of the process of the imaginary appropriation (Figures 1 and 2). The caricatured image of Australia's Prime Minister Paul Keating, sending up Bill Clinton, sending up Ray Charles is symptomatic of the symbolic reflex to popular music and its images. The caricature of conservative opposition leader John Hewson stage diving actually proved to be prescient, suggesting that he was self-destructing. His Liberal Party coalition was defeated at the federal election in March 1993, for which both cartoons were drawn.

Research strategies

How do we make sense of the transformations to popular music? How do we find a system of analysis, an appropriate methodology for research? How do we locate a methodology which is suitable for the examination of the music industry in the 1990s? These are questions that popular music studies has not asked often enough. Perhaps our disinterest in explicit methodology is a manifestation of the exhaustion that has beset us after the lengthy debates within the cultural–communication–critical theory academy?

Perhaps, and I think this is the more likely case, we have been too eager to be culturalists – promoters of our musical obsessions – rather than analysts and critics. Scholars are readily acceding to the cultural–industrial cooptive pressures. Our research and writing can look increasingly like promotional material for the sector in which we work. In this respect I have to express deep disappointment with Keith Negus's recent book, *Producing Pop*, which occasionally read like an industry endorsement pamphlet. We are not undertaking 'administrative communication research' (Babe, 1993: 16). That is, research which 'dispenses practical information and guidance to media practitioners (advertisers, media owners, public relations firms and their clients, and to governments) on how to wield their influence more effectively' and is inevitably used by 'the wealthy and powerful' (Babe, 1993: 16). The promotion of our cultural critique is part of a complex struggle against the promotional apparatus of industrial capital and its consumption ethic.

One way of avoiding the trap of bland administrative research is to locate and examine the economic processes that transform popular music into a commodity. This commodification requires ongoing investigation theory and analysis. Such is the effective engagement of the commodity with the lives of researchers, we have often assumed popular music's commodity

Figure 1. *The Age*, 27 February 1993.

Figure 2. *Herald-Sun*, 6 March 1993.

status, yet failed to examine the processes. Lefebvre suggested that a 'mythology of industrialisation', was part of the deterministic logic of contemporary society (1971: 48). Certainly it is increasingly difficult to know where to locate ourselves as western societies move from an industrial order into intensified corporate economies (Dugger, 1988: 984).

Institutional economics – a suitable methodology

The popular music terrain is changing, producing new demands on research methods and theories. In looking for a way of describing the developments I discovered an interdisciplinary approach buried within the US economic tradition. The preceding comments about the changes to the industry as well as those about research have been derived from some of the recent writings from this school, known as institutional economics.

Without going into a full explanation of institutional economics, I will briefly outline its appeal. Firstly, it is self-consciously critical. It aligns itself with critical social inquiry, which, put simply, works across the territory created by an idealized model of society. It has been described as a social problem approach that seeks to explain the 'what is and what ought' of society. In this respect it does not reject Marxist approaches, neither does it see the historical materialist dialectic leading to a class revolt. Rather, institutionalism emphasizes the way in which social 'habits' are organized into institutions. This position follows closely the work of Thorstein Veblen, who proposed an evolutionary economics, best expressed in *Theory of the Leisure Class*, first published in 1899.

Veblen (1857–1929) followed by John Commons, identified the evolutionary process whereby industrialization generated new social and economic relations that saw power devolve from the individual to the small business, to the firm, and on into the corporation and the Transnational Corporation. Veblen's emphasis was, as he admitted, 'unfamiliar', marrying 'economic theory' with 'ethnological generalization' (Veblen, 1948: 53). Importantly, Veblen identified the stages of economic and social development in human civilization from 'savagery, or barbarian' to 'predatory' to 'emulation' of ownership, which in turn produced a 'pecuniary' relationship to ownership (62–70). Ultimately, Veblen considered that all social life had progressed through the stage of individual ownership as a 'conventional right or equitable claim' (72), to a more organized 'human institution' (76). The ultimate result is that everyday life becomes habituated around industrial formations. Veblen's emphasis on the everyday is instructive given contemporary interest in the ethnographic and the everyday: 'Gradually, as industrial activity further displaces predatory activity in the community's everyday life and in men's habits of thought, accumulated property more and more replaces trophies of predatory exploit as the conventional exponent of prepotence and success. With the growth of settled industry, therefore, the possession of wealth gains in relative importance and effectiveness as a customary basis of repute and esteem' (1948: 77).

The appeal of this institutional approach is that the anthropological system of observation when mixed, as it were, with the unsteady chemical base of economic theory, produces a highly mobile, frequently volatile interdisciplinary methodology. This resulting solution is explosive, when put to critical use. The US institutional economists who have followed Veblen and Commons, such a Galbraith, Gruchy, Trebing, Tool and Averitt, are uncompromising in their criticisms of the institutions which US capitalism has produced.

Another 'activist' is William Dugger. He has argued vociferously in the *Journal of Economic Issues*, that institutional economics is only effective when it identifies and examines the social process. This is a direct flow-on from Veblen's evolutionary approach. He maintains that 'social provisioning' is essential to institutional concerns, where it involves 'a continually changing set of social processes rather than stable general equilibrium. The social provisioning process involves physical and financial flows, the industrial and pecuniary dimensions of a continually changing culture' (1988: 983).

An appeal of institutionalism is that it is inclusive. Everyday life meets radical theory perhaps. It is no surprise therefore, that some of the comments I made earlier about the changes in ownership at Virgin and transitions from periphery to centre within the economy, are central to institutional research (and some would say, its rhetoric). The institutional agenda, moving along the evolutionary path emphasises the transitions within the economy.

The centre and periphery issue is not restricted to institutional economics. I am aware that it is a major feature of sociology, where 'the politics of dominance and dependence', *vis-à-vis* underdevelopment, have been subjected to the centre–periphery microscope (Smith *et al.*, 1981: 13). The centre–periphery relationship is not welcomed within conventional economics, as Robert Averitt discovered in 1968, with the release of *The Dual Economy: The Dynamics of American Industry and Structure*. He discovered that neo-classical economists ran the academic establishment and the journals, with the result that his ground-breaking work was not reviewed and therefore remained unrecognized. Averitt proposed a model of economic dualism, where centre firms and periphery firms can be identified within the economy, as can a third tier which he called 'key industries'. His typology made it possible to identify 'the shifting boundary between the so-called market sector and the planned sector, the centre of our economy and its periphery' (Dugger, 1988: 985).

Centre firms then, are those which are:

> large in economic size as measured by number of employees, total assets and yearly sales. It tends towards vertical integration (through ownership or informal control), geographic dispersion (national and international), product diversification, and managerial decentralisation. Centre firms excel in managerial and technical talent; and their financial resources are abundant. Their cash flows are large; their credit ratings excellent.
>
> (Averitt, 1968: 2)

Averitt further noted that centre firms combine long- and short-run perspectives and their markets are commonly concentrated. This sounds like a major record company to me.

In contrast, the periphery firm is relatively small, Averitt said.

> It is not integrated vertically, and it may be an economic satellite of a centre firm or cluster of centre firms. Periphery firms are less geographically dispersed, both nationally and internationally. Typically they produce only a small line of related products. Their management is centralised, often revolving around a central individual.
>
> (1968: 2)

The contrasts are instructive, providing us with a useful means of detailing music industry developments. Averitt's main contribution was to add that although centre and periphery firms are fundamental to the economy, it is the key industries that are the motor for the system. Averitt suggested that American industries are 'divided into a hierarchy of economic importance by using a series of loosely related criteria' (1968: 3). Manufacturing was 'the critical component of US industry', he said. We might add that he was writing in 1968, when US industry seemed to have a future.

The importance of this industry map is that it can usefully describe the evolutionary development of the music industry. We can recognize the point where the transition of the music independents into the majors and the majors' presence as part of transnational conglomerates, suggests that music has become part of the key economy. Averitt insists that 'a key industry produces key commodities' (1968: 3). An obvious question: Is music a key commodity?

If a music company is a centre firm it does not follow, according to Averitt's 1960s schema, that it will be a key industry. In the 1990s we can be less assured of such a claim. The strategic aspect of 1990s corporate economy is such that a centre firm will structure its organisation so that it and those dealing with it assume that it is a key industry.

Dugger and others have progressed these ideas as part of a discussion which is part of a much broader one about the theory of the firm. That discussion has its own life within economic debates and institutional economics in particular. The discussions of the 1990s emphasize the development of the corporate economy and the intensive control over national economies which corporations claim. In particular, Dugger has noted the change from the key industry schema of Averitt to the conglomerate where, 'With strong and permanent attachments to no principle industry or product, the pure conglomerate is the ultimate centre firm' (1988: 987).

More recently, Bowring has proposed a definition of core firms. It is possible that the majors are in this category.

> Core firms are qualitatively different from periphery firms. While size is required for core membership, size is not a proxy for efficiency. Size creates access to a realm of large-scale investments required to compete across the range of tactics employed by core firms and thus is required for and creates an element of market power. Large size altogether with

significant market share held jointly with other large firms in an industry or industries requiring such investment, is required for the market power associated with core firm status.

<div style="text-align: right">(Bowring, 1986: 185)</div>

My argument is that the music industry is now part of the core firm culture, or the conglomerate corporate economy. Following Attali (1985), it is reasonable to assume that music may act as the prophetic arm of the conglomerate, setting off the fashion signals the corporations need to plan their strategic programmes in other sectors of the corporation. Such a theory needs to be examined.

Finally, in relation to institutionalism. It should be no surprise that strong reservations are expressed about the conglomeration of industries and the threat they pose. Dugger's emphasis on 'democratic economic planning' is especially relevant, emphasizing that regulation is fundamental to the current evolutionary stage of the firm (1988: 989). Although democratic planning is a term that needs to be carefully endorsed, lest it merely perform a form of political window dressing, it offers a constructive conceptual starting point for understanding the popular music programmes being funded by state and federal governments in Australia. It is at this point that some of the tangents of my approach begin to be drawn together.

Cultural mobility

Music is moving rapidly into fresh areas. Likewise, the corporations that own and control the music business are strategically using music to develop new markets for consumer products, while developing new products. I call this *cultural mobility*. In this sense, popular music is culturally prophetic. We can already observe the redemption of its own prophecy. In keeping with neo-classical economic theory, the prophecy that is wrought by music is coming from new technologies which have an important function in disseminating information and creating access in the market economy's quest for growth. This is sometimes referred to as 'diffusion'.

Economists use 'technological diffusion' to explain the process whereby national and global growth has been created since the industrial revolution (Hodgson, 1991: 223–4). The diffusion hypothesis is worthy of discussion and consideration in the context of popular music, as Simon Frith has indicated (1987). Rather than investigating technological diffusion, I want to assume that it has some merits as a hypothesis and serves to explain music's role in the corporate economy. I am more interested in explaining how the prophetic nature of popular music has been taken up by the conglomerate record companies to be used in the process of cultural mobility. I am also interested in how new cultural forms, such a video games, confirm, challenge or extend cultural mobility.

The corporate economy is vast and growing. But research would indicate that without the introduction of CDs, without classic hits radio, and without new markets in Asia and Latin America, popular music as we know it would

no longer exist. The evidence is clear that popular music as a commodity is passing through a rapid transformation, assisted by the introduction of video games from Sega and Nintendo and related new technologies, which has heightened the anxiety circulating among some in the music promotion business:

> Our aim is to encourage our kids off the computer games and back into music through this relatively easy to play instrument.
>
> (*Hands On*, 1993)

In 1992 Sega's *Sonic the Hedgehog 2* made more money on its release day than the hit CD *Stars* by Simply Red for the whole of 1992. *Stars* was the biggest selling rock CD of 1992! In their quieter moments, record company executives will admit to the possibility of 'the end of music', or at least, the intensification of the transition into a different set of relations between popular music and consumers. This is a very small percentage of executives, suggesting that the music business has not yet reached the stage of organizational panic that sometimes besets well-entrenched industries when new or better technologies overtake them (e.g., IBM and Apple, US and Japanese car manufacturers). Cultural mobility may usefully describe this survival and lack of panic in the face of change, as corporations have learned to manage the convergence of popular entertainments built around the established music–film–entertainment–marketing nexus that has been commonplace since the 1950s. This convergence has taken the historical relationship between music and other media into an altogether different realm by marrying the intensified entertainment economy to the global telecommunications-computer infrastructure. Music is a key component, offering new potential, and prompting Peter Gabriel to suggest that 'explorers and artists' are increasingly 'fairly free to follow their instincts and their hearts' across the terrain opened up by the convergence (Davis, 1993: 91). This has implications for the theory of popular music that will include elements of this dynamic relationship across many sectors of society, where core conglomerate firms purchase almost any medium available in the periphery, in an effort to maintain and predict the processes developed by the commercial success of popular music and film.

Contrast this with Jody Berland's suggestion that the last sixty to eighty years 'had been propelled by two changing but inseparable processes of technical production: one which increasingly fractures the practices of making/recording/hearing/watching/visualizing music, and a second which reconstructs their relationship by artificial means' (1993: 27). She went on to emphasise that the 'audio-visual reconstruction' is the prevailing method of production and consumption of popular music (1993: 27). Cultural mobility makes such a worthy analysis seem less likely, as music is actually deconstructed into a permanent state of transformation across many, if not all, available media. This deconstructed-techno-present means that the concept of reconstruction is no longer the only appropriate way of analysing musical production.

Similarly, the sense in which the 'sampler' made it possible for music to engage in 'auto-cannibalism' has arrived to contribute to the newer cumulative whole (Beadle, 1993: 7). While the sampler offered a musical take on all recordable sound (in fact all data, as sound and music underwent a transmogrification into a new physical form as bytes), it did not mark the end of the rapid migration of music across media. The result is that all music is part of a constant mosaic that changes and reinvents itself according to the availability of technology and the capacity of technology to deliver whatever sounds are transmitted. The notion of a conscious vantage point from which to observe the reconstruction, as Berland suggested, is now an indulgence few can afford. Such an intensified environment, enhanced by technology, allows music to be effectively interposed in spaces that were otherwise remote or isolated from music (Berland, 1992). As such, the sound itself may not even be recognized as music, although it bears some of the hallmarks of music – beat, rhythm, melody. This is the most remarkable aspect of cultural mobility, which challenges the existing postmodern categories and descriptions detailed by Andrew Goodwin, moving beyond the 'epistemological feedback loop' into new aural and textual contexts (1991: 188).

The corporate building blocks that incorporate and encourage this change can be observed already. For example, Michael Schulhof is chairman of Sony Music Entertainment and president of Sony Software Corporation. Note the convergence of positions for the one person within the corporation – music and software. Schulhof's task is to link Sony corporation's music, film and electronic publishing arms as '*total entertainment*' (Shoebridge, 1993: 66).

Multimedia by any other name is making it increasingly difficult to distinguish popular music within the social and economic relations of the major record company. That small independent companies like Apple, Sega and Nintendo are constantly reorganizing and realigning themselves with the major companies, such as Philips, Sony, BMG and Time-Warner, makes it more necessary to appreciate the nature of the industrial and corporate organization of the music business. Indeed, we may soon be faced with a situation where popular music is merely the adjunct to a total entertainment package within the leisure economy. Massive deals between Time-Warner and US West, Bell Atlantic and Tele-Communications Inc. indicate that the arrangements are being put in place to facilitate the multimedia future. They are fully endorsed by Vice President Al Gore, who believes 'information superhighways' hold the key to the future of the US (Landler, 1993: 48). Two questions follow: which corporations will benefit most from the massive information-economy investment; what further implications will there be for popular music?

New technology, combined with the conglomerate nature of the majors, is helping facilitate the introduction of the leisure economy. Forecasts predict that multimedia will be an effective way of converging entertainments and information within the information/entertainment economy. They also suggest that by 1995 the multimedia economy will have

grown from its 1992 value of US$4.2 billion to US$25 billion. And it is predicted that the greatest growth and the commensurate largest share of the market will be in the entertainment sector of the economy (Liebowitz, 1993: 149). It is possible to see music as the glue that links the converging levels of activity together in the corporate economy.

And yet the guerilla-style development of new technologies, such as multimedia, provides richer avenues for experimentation at the micro level. The magazine *Wired* provides a monthly indication of this remarkable assimilation of technology for individual and community needs, while maintaining its corporate identity! Peter Gabriel is effusive on this subject, noting that multimedia, provided through CD-ROM and interactive media 'demand a re-thinking, in essence allowing the audience to become the artist' (Harrington, 1993: 14–15). U2's ZOO-TV, with music-video interaction, already makes it clear that audiences are anticipating more than a display of light, sound and movement at a rock concert. How do we interpret the cultural mobility of music in this context?

I will conclude with two examples that indicate just how much popular music has changed under the influence of the conglomerate corporation's cultural mobility.

The first comes from Sony and is drawn from the corporation's plans to use Arnold Schwarzenegger in a combination of 'star power and sales-manship' (Grover and Landler, 1993: 38). 'Arnie' combined these two roles in Sony Corporation's *Last Action Hero*, a US$60 million film. Coming from the Columbia Studios, owned by Sony, the Corporation anticipated that the 'tie-ins' provided across the media would promote Sony products. The film promoted the use of Sony hardware – by what is known as product placement – so a Sony Walkman mini CD player is used by the film's star. 'Arnie' places a call on a Sony cellular phone. The bands Alice in Chains, AC/DC and rappers Cypress Hill, all signed on Columbia records and Epic, appear in the film. It is difficult to separate music from the film and technology marketing fetish of the corporation. Music becomes an avenue down which the marketing logic of the corporation moves, constructing contemporary life around the processes of entertainment promotion: cultural mobility in the guise of the corporate fascist. Instructively, the article which reported this development – which is one of dozens in the past two years – was titled '*Last Action Hero* – Or first $60 million commercial?' (Grover and Landler, 1993).

Institutional economics insists that Sony's monopoly activity is unhealthy and undemocratic. Certainly this is a theme of Chappel and Garofalo's 1977 study of US music, *Rock 'n' Roll is Here to Pay*. The issue no longer involves music alone, but the convergence of business interests with ever larger numbers of products, circulating across the more intensively served social domain.

My second example suggests another level of technological and corporate transformation occurring around us that serves to bolster the explicit shifts in cultural mobility occurring in the technology area. The example is drawn from an Australian company. It illustrates that popular music is both a part

of the multi-media environment, as well as part of the generally orchestrated environment of everyday life. As I have noted, multimedia uses music as part of its package. But popular music's ubiquity is already well established with Muzak. This 'piped music' or 'elevator music' as it was previously known, has become part of the retail environment. Now referred to as Environmental Instrumental Music, Muzak allows musical data to be seamlessly sewn into our lives in ways that make it impossible to distinguish the real from the virtually real.

In Australia, local songs and overseas songs – mostly US – from a variety of programming genres are used. They are narrowcast to shopping centres and malls under licence from the US company which owns Muzak. According to Soundcom, the Australian company which owns the rights to Muzak, the music has several uses: 'It is a business tool, to be used as background; it is used to mask unwanted sounds; it is a pacifier; it tends to make people feel comfortable, want to stay longer in the store and (I suppose) buy more'. More significant for my purposes, it is produced and circulated together with what was described as 'an incredible amount of research' (Soundcom interview, 3 May 1993). The resulting controlled environment should be of considerable interest to researchers in the popular music field and in cultural studies. An understanding of the use of technology in this narrowcasting context may provide us with the means of theorizing what is becoming of popular music as an everyday phenomenon.

In particular, we may usefully be able to examine the linkages between music as a commodity and the construction of everyday life as a commodity and the points at which the commodity process changes and moves to other levels of social engagement. An example of this sort of research and the approach that institutional economics encourages can be observed in the allegiance between major record companies and Soundcom, Muzak and equivalent Environmental Instrumental Music companies. This alliance sees record companies make available to Environmental Instrumental Music companies such as Soundcom singles the record company believes will be popular. By the time the single is ready to spontaneously climb the charts, a version is ready to circulate in shopping centres, lifts and other public places. The final and strange irony is that when the Lemonheads had Paul Simon's *Mrs Robinson* due for release and when Ugly Kid Joe had their version of Harry Chapin's *Cat's Cradle* ready for release, so did Soundcom Australia. Both the songs were released in the same week: one for radio/CD purchase and the other by Soundcom. These tunes are being built into our everyday lives in new, unexpected ways. Incredibly, these songs were released as cover versions of 'classic hits' by bands with 'alternative' credentials, presumably at strategic points in the bands' careers, as dictated by the band members/ record labels/managers, who have an eye to broadening their appeal to pop audiences. It all makes for challenging, even contradictory, interpretations of popular music.

These developments, which I have collected and described as cultural mobility, suggest that popular music may no longer be classifiable as

popular, according to previously existing definitions. Then again, it may be more popular, if that means increasing ubiquity. It may well be that the commodification of music at these levels is yet another phase in the transformation of everyday life, admirably assisted by corporations taking music into the centre of social and economic life.

As such, music's cultural mobility should come as no surprise. Institutional economics is a valuable tool in describing the historical development of popular music within corporate society. Inevitably, our theories and concepts of popular music need constant, creative reworking as music moves to the centre of our economies. At least part of our task as researchers is to explain the prophetic nature of popular music and its changing place in contemporary society.

Notes

1 An earlier version of this piece was presented at the July 1993 conference of the International Association for the Study of Popular Music (IASPM) at Stockton, California. For comments thanks to two anoymous Cultural Studies referees and Terry Flew.
2 This is not altogether different to Michael de Certeau's use of strategy invoked by Meaghan Morris, where strategy is a 'mode of action specific to regimes of *place*'. To de Certeau, strategy is 'the calculus of force-relationships which become possible when a subject of will and power (a proprietor, an enterprise, a city, a scientific institution) can be isolated from an environment'. [It] assumes place that can be circumscribed as *proper* and thus serve as the basis for generating relations with an exterior distinct from it. . . . Political, economic and scientific rationality has been constructed on this model' (cited in Morris, 1992: 27).

References

Attali, Jacques (1985) *Noise: The Political Economy of Music*, Manchester, Manchester University Press.
Averitt, Robert T. (1968) *The Dual Economy: The Dynamics of American Industry Structure*, New York: Norton & Co.
Babe, Robert (1993) 'Communication: blindspot of Western economics', *Illuminating the Blindspot: Essays Honoring Dallas W. Smythe*, (edited by Janet Wasko, Vincent Mosco, Manjunath Pendakur), New Jersey: Ablex: 15–39.
Barlow, John Perry (1994) 'The economy of ideas: a framework for rethinking patents and copyrights in the digital age', *Wired*, March: 85–90, 126–9.
Beadle, Jeremy, J. (1993) *Will Pop Eat Itself: Pop Music in the Soundbite Era*, London: Faber.
Berland, Jody (1992) 'Sound, image and social space: music video and media reconstructions', in Simon Frith, Andrew Goodwin, Lawrence Grossberg (eds), *Sound and Vision: The Music Video Reader*, London: Routledge (1993) 25–44.
Berube, Michael, (1994) 'Bum Rap: The Organic Intellectual and the Original Gangsta', *Transition*, No 64: 30–40.

Bowring, Joseph (1986) *Competition in a Dual Economy*, Princeton: Princeton University Press.

Breen, Marcus (1993a) 'Making music local', in Tony Bennett, Simon Frith, Lawrence Grossberg, John Shepherd, Graeme Turner (eds), *Rock and Popular Music: Politics, Policies and Institutions*, London and New York: Routledge (1993): 66–82.

—— (1993b) 'World music: an obvious logic in popular music', in David Bennett (ed.), *Cultural Studies: Pluralism and Theory*, Melbourne: Department of English, Melbourne University (1993): 171–180.

Chappel, Steve and Garofalo, Reebee (1977) *Rock'n'Roll is Here to Pay: the History and Politics of the Music Industry*, Chicago: Nelson-Hall.

Cooper, Andrew, Higgott, Richard and Nossal, Kim (1993) *Relocating Middle Powers: Australia and Canada in a Changing World Order*, Vancouver: UBC Press.

Davis, Fred (1993) 'I want my (desktop) MTV!', *WIRED* July/August: 84–91.

Dugger, William (1988) 'A research agenda for institutional economics', *Journal of Economic Issues* xxii(4): 983–1002.

The Economist (1993) 'Cui bono?', 21 August: 74.

Frith, Simon (1987) 'The industrialisation of popular music', in J. Lull (ed.) *Popular Music and Communication*, London: Sage (1987): 53–77.

Goodman, Fred (1992) 'The virgin', *Vanity Fair* May: 119–22, 137–40.

Goodwin, Andrew (1991) 'Popular music and postmodern theory', *Cultural Studies* 5(2): 174–90.

Grover, R and Landler, Mark (1993) '*Last Action Hero* – or First $60 million commercial', Business Week, April 12: 38–9.

Hands On, Head Down, Heart Beat: Introductory Workshops for Electric Bass Guitar (1993) video brochure, 1 June.

Harrington, Richard (1993) 'Genesis of a storm', *Entertainment Guide, The Age* 23 July: 14–15; first published in *Washington Post*.

Hodgson, Geoffrey, M. (1991) 'Institutional rigidities and economic growth' in *After Marx and Sraffa: Essays in Political Economy*, London: Macmillan: 214–43.

Johnson-Turner, Mary (1993) 'Thinking strategically', *Network World* June: 22–8.

Landler, Mark (1993) 'Time Warner's technie at the top', *Business Week* 10 May.

Lefebvre, Henri (1971) *Everyday Life in the Modern World*, translated by Sacha Rabinovitch, New York: Harper & Row.

Liebowitz, Jay (1993) 'Promising applications of multimedia', *Telematics and Informatics* 10(2): 149–56.

Morris, Meaghan (1992) *Great Moments in Social Climbing: King Kong and the Human Fly*, Sydney: Local Consumption Publications.

Negus, Keith (1992) *Producing Pop: Culture and Conflict in the Popular Music Industry*, London: Edward Arnold.

Shoebridge, Neil (1993) 'Sony lays foundations for a brave new world', *Business Review Weekly* 16 April: 66–9.

Smith, Michael, Little, Richard, and Michael Shackleton (1981) 'Introduction', *Perspectives on World Politics*, London and New York: Routledge, in association with Open University Press: 11–24.

Veblen, Thorstein (1948) *The Portable Veblen*, includes excerpts from *Theory of the Leisure Class*, New York: Viking Press.

—— (1964) *Absentee Ownership and Business Enterprise in Recent Times*, New York: A. M. Kelley (first published 1923).

Wark, McKenzie (1993) 'Suck on this, planet of noise', *Media Information Australia* No. 69, August: 62–9.

—— (1994) 'The video as an emergent form', *Media Information Australia*, No. 71, February: 21–30.

JOHN FISKE AND
KEVIN GLYNN
TRIALS OF THE POSTMODERN

Abstract

The criminal courtroom is an important institutional site where a modernist epistemology works hard to keep the postmodern disturbance of such concepts as 'truth' and 'reality' at bay. Nevertheless, some popular television programs exploit the imagistic conditions of postmodernity in order to volatilize the truths certified as final ones by criminal courts. Similarly, in the first trial of the LAPD officers who beat Rodney King, the prosecution team exploited the instability of truth in a mediatized society in order to resignify events whose meanings had previously been configured quite differently. This essay examines these events as manifestations of cultural and political contestation in an image-saturated society where the modernist 'reality principle' has dissolved and been replaced by a mediatizing process of resimulation and resignification.

Keywords
postmodern; image saturation; reality; courtroom; video

While what postmodernism *is* continues to elude anchorage, there is an emerging set of issues which most users of the word would agree are ones with which it centrally engages. One of these is the image saturation of late capitalist society that has volatilized any notion of a stable and singular reality principle. In these conditions, truth loses its finality and objectivity, multiplies and becomes a process of constant resimulation and contestation.

Television has no problems in coping with these symptoms of postmodernity; for, in deluging us with images more comprehensively than any other medium it is responsible for producing those symptoms rather than responding to them. The courtroom, however, is entirely different. Legal truth is a final singular product that results from the contest between prosecution and defense truths, which, although presented as objective, are performed as partial. The different realities presented to the jury prefigure elements of postmodernity only to deny them. The courtroom is a vivid site whereon to trace the struggles of the modern to keep the postmodern at bay.

Television is, too. Its official news still propounds truth claims and reality claims that are inescapably modern, and singular as that of the courtroom but its tabloid news volatilizes these claims and denies their finality. The swirl of images around courtrooms, official TV news and tabloid TV becomes a site where modernist notions of reality and transcendent principles meet postmodern forces of destabilization, localization and

volatility. The problem postmodern conditions pose in the courtroom is that of representation: in an age of multiple and shifting realities, how can lawyers represent *the* reality of an event to a jury? Similarly, in a society of shifting and multiple social formations, how can one jury represent the defendant's equals or society in general (which, in the legal system, are identical concepts)?

It is with these issues in mind that we turn to consider some of the relations between some trials of tabloid TV and the trial of the Rodney King video.

Trials, errors and final appeals

An immense uncertainty is all that remains. The uncertainty at the very root of operational euphoria, resulting from the sophistication of networks of information and communication . . . No one understands the stake of these techniques any longer . . . The crucial stake, and the actual one, is the game of uncertainty. Nowhere can we escape it.

(Baudrillard, 1987: 1988)

Tabloid TV has become known in the industry as 'reality based', whereas perhaps 'reality disturbing' would be a better description. Official TV news struggles hard to maintain its footing in Baudrillard's second order, that where reality can be reproduced. Tabloid TV, however, dances playfully and sometimes seriously in his third order, that of simulation. Such programs as *Final Appeal* and *Trial and Error* exemplify the culture of the third order, as they volatilize the discourses that American courts certify as final truths. *Final Appeal* and *Trial and Error* mobilize simulatory video technologies to disrupt those truths, leaving only an 'immense uncertainty' in their wake. Since the truths put in question are those produced by the policing, prosecuting, and judicial apparatuses, there is institutional power at stake. *Final Appeal* and *Trial and Error* combine techniques of simulation with popular skepticism toward the power-bloc to cast a large shadow of doubt over its second order truths. In doing this, they exemplify Baudrillard's 'hyperrealism' of communication, wherein screen events displace the primacy of materially lived ones. In these shows, cases upon which official judgement has been passed and certified, are re-opened, re-examined and re-problematized. The re-simulation of these cases on our television screens unfreezes the truths that have been made of them. If legal discourse converts complex realities into *a* truth (*the* truth), the broadcast resimulation of courtroom trials in tabloid television reconverts certified truths into a discourse of the hyperreal which is 'beyond true and false' (Baudrillard, 1983: 40). The hyperreal operates beyond the distinction between reality and unreality upon which courtroom truths rest. Hyperreal culture 'cancels out' or 'implodes' this distinction so that, as Baudrillard argues, '*it is now impossible to isolate the process of the real*, or to prove the real'. The imagistic order of hyperreality, wherein the truth of an event becomes unstable and manipulable, forms a point of conjuncture for *Final Appeal*, *Trial and Error*, and the trial of Rodney King (which made the uncertainty of

the links between image, meaning and reality explosively apparent). According to Baudrillard, on the terrain of the postmodern mediascape, images no longer accurately reflect or treacherously betray the reality of events whose meanings ostensibly lie within the events themselves. On the contrary, images produce a more urgent (though necessarily more unstable) reality than events themselves. Images which once stood in for a reality outside themselves, now increasingly displace that reality altogether. Images become our primary reality. Their exponential multiplication gives rise to the 'defection' of reality and referentiality everywhere. Screens and images invade more and more of the territories within which we conduct our lives. Even in hospitals, for example, an expanding array of technologies substitutes the screen-reality of images for the materiality of bodies. Arthur Frank writes that 'the body is real for medicine' only in the sense that 'it is the locus of the reproduction of images which become its reality'. Thus, although 'a traditional intuition suggests that at the center of medical practice we ought to find the body of the patient', instead, in the postmodern hospital, we find 'multiple images and codings in which the body is doubled and redoubled'. We find that 'bedside is secondary to screenside', and that 'our initial certainty of the real (the body) becomes lost in hyperreal images that are better than the real body' (Frank, 1992: 83, 87).

But the hyperreal liquidation of such categories as real and unreal, true and untrue is not yet the accomplished fact Baudrillard's analysis sometimes suggests it is. Baudrillard himself discusses a number of 'deterrent' powers that fight off the postmodern evacuation of modern categories. Disneyland, for example, can be understood as a 'scenario of deterrence' that recuperates a decrepit reality principle. Although it is a 'complex play of illusions and phantasms' that simulates its own reality, Disneyland works hard to convince us that the *rest* of America is real (and not hyperreal). Indeed, Los Angeles is encircled by 'imaginary stations' like Enchanted Village, Magic Mountain and Marine World that 'feed reality, reality-energy, to a town whose mystery is precisely that it is nothing more than a network of endless, unreal circulation'. Similarly, Watergate, 'a simulation of scandal to regenerative ends', reinvigorated a dead political morality that is irrelevant to the operations of late capitalism (which is, quite simply, an 'unprincipled undertaking'). Thus, although our cultural condition may be one in which modern notions of truth, reason, morality and reality no longer apply, these concepts themselves have not yet been jettisoned from the discourses through which we articulate a sense of that condition. Scenarios of deterrence enable the perpetuation of such concepts by maintaining or 'proving' them 'in reverse' (Baudrillard, 1983: 25–36).

At one level, *Final Appeal* and *Trial and Error* may be read as scenarios of deterrence that rescue the truth principle upon which the courts rely. Consider, for example, the 'deterrent' power of the words and images that open each edition of *Final Appeal*. As video cameras lead us through a crowded prisonhouse reverberating with the angry taunts of inmates, a voice-over proclaims:

700,000 men and women in our nation's prisons. Walk through any cell block and many will tell you that they are innocent, wrongfully convicted. They are, of course, guilty, and are exactly where they should be. But no system is perfect. Mistakes can happen. Not often – perhaps one in 10,000. But if you are that one, the cost is horrific.

This deterrent strategy works to contain the extent to which *Final Appeal* undermines the modernist notion of truth upon which courts depend for their social power. A statistical insignificance (one in 10,000) absorbs the power of a radical epistemological challenge. Ultimately, then, *Final Appeal* reinforces the modernist reality principle by claiming the courts' use of it, not the principle itself, was false. But the *mode* of its challenge destabilizes the principle to which, rationally, it appeals. This game of destabilization surfaces more forcefully in *Trial and Error*'s opening segment, where a jarring montage of 'real' and 'simulated' images, juxtaposed, is accompanied by the following monologue:

'Beyond a reasonable doubt.' This is the guardian phrase that empowers juries to protect the innocent in America ... The most conservative estimates say that we wrongfully convict and imprison between six and seven thousand people every year. Two half-brothers were within sixteen hours of being executed when it was discovered that the prosecution's star witness was actually nowhere near the crime scene, and she'd only seen it in a dream. A couple in Southern California was convicted of a murder that never even occurred. The alleged victim was found alive and well, and living in San Francisco, years later.

In what 'reality' did these crimes occur?, *Trial and Error* asks. In what 'reality' were these convictions grounded? *Final Appeal* and *Trial and Error* ultimately question whether or not any of the institutions of judgement *ever* operate 'beyond a reasonable doubt', and thus whether any of our institutions of criminality – built, as they are, entirely upon the alleged sturdy bedrock of objective facts whose existence is certain – ever have any foundation in any reality outside of their own evidentiary models and procedural codes. Put differently, courts have developed elaborate systems of rules for the production and certification of truth, but we must question the relationship between courtroom truths and purportedly objective realities. Postmodern and poststructuralist epistemologies would insist upon the discursivity of such truths, upon their status as institutional artifacts that make *a* sense – though not the only possible one – of certain events. Tabloid television shows like *Final Appeal* and *Trial and Error* imagistically exploit this discursivity in order to question institutionally certified truths and to produce alternative meanings of certain criminal events and courtroom convictions.

While these programs claim, at one level, to offer a 'better truth' than the official one, their images operate at a level where the distinction between the real and the unreal has imploded. In an imagistic social milieu, images take

on a life of their own, as their relationship to a reality beyond themselves becomes attenuated. Baudrillard makes the claim that

> events, politics, history, from the moment where they only exist as broadcasts by the media and proliferate, nearly globally, their own reality disappears. In the extreme case the event could just as well not have taken place . . . They are screen events and no longer authentic events
>
> (1993: 146).

When events are 'mediatized', their independent reality dissolves in a rush of imagistic hyperreality. 'As Benjamin said of the [mechanically reproduced] work of art, you can never really go back to the source, you can never interrogate an event, a character, a discourse about its degree of original reality.' It isn't that its originality never existed, but rather that the power of the original is absorbed by the power of simulation in a mediated world (much as the power of mechanical reproduction absorbed the power and 'aura' of the original work of art). In the hyperrealized universe of third order signs, 'you can no longer interrogate the reality or unreality, the truth or falsity of something', since the 'mediating principle' becomes more powerful than the 'reality principle'. The imagistic mediating principle absorbs its energy, renders it irrelevant. In an image-saturated society, where media images come increasingly from a diverse array of sources – file footage, computer generation, Hollywood films, 'photo ops' (where the 'real' event exists solely for the purpose of media image generation), reenactment, and so on – the distinction between 'true' and 'false' or 'real' and 'unreal' images becomes difficult to sustain, if not entirely meaningless.

The courts maintain their social power by repressing the fictionality of the truths they produce. For their part, the court programs counter judicial fictions with a sort of mediated hyperfictionality. Their resimulation of competing and compelling scenarios questions judicial truths by situating them within a postmodern epistemological frame where meaning is detached from the original contexts of its production. At the same time, their suspicion towards police, courts, prosecutors, and official investigators, which assumes varying degrees of intensity, implicates the powerful manipulations that produce official pronouncements of guilt. The conversion of criminal cases into television images rips the contestation between prosecution and defense truths out of its courtroom context and resituates it in a multitude of television viewing ones. Audiences become juries as images are placed on trial.

Consider the case of Jeffrey MacDonald, a.k.a. 'the Green Beret Killer', who was sentenced to three consecutive life terms in prison for the murder of his wife and two children. The case was taken up by *Final Appeal* in its premiere episode on 18 September 1992, not long after the US Supreme Court rejected an appeal from MacDonald for the sixth time. Since 1970, when MacDonald's family was brutally murdered, he has maintained that he, his wife, and his children were the victims of an attack by mysterious

intruders into his home. The prosecution, by contrast, has produced an intricate scenario in which MacDonald, during a banal domestic quarrel, loses control, stabs and bludgeons his wife and children, and then stabs and bludgeons himself to cover his tracks. *Final Appeal* simulates both versions, using an intricate mix of acted re-creations, retrospective talking-head commentary, presumably original photographic evidence, and other miscellaneous images. These simulations convey a strong sense of both the plausibility and the partiality of both accounts, the sense in which both truths are simultaneously compelling and fictitious, somehow unable to deliver the goods, to recapture the lost wholeness of events. In a third segment of the program, after we have been given imagistic re-creations of the cases for and against Dr MacDonald, we are presented with evidence that has surfaced after the trial – evidence that seriously undermines the prosecution's case. We learn of deceit and manipulation by prosecutors driven by a vendetta against MacDonald. We learn of exculpatory evidence hidden in government documents that were unavailable to the defense at the time of the trial. (It is worth noting that the theme of a government cover-up of 'the truth' is a common one in tabloid storytelling.) We learn, most importantly, of an eyewitness account that supports MacDonald's story of an attack by intruders. Although the provider of this account has been dead since 1983, she appears, ironically and appropriately, on a videotape recorded one year before her death. Such testimony would surely be ruled inadmissible in a court of law, though in a mediatized venue like tabloid television, a videotaped witness speaking from beyond the grave is no less real nor less compelling than any other image. In a tabloid inversion of law-and-order populism, it turns out that an arcane rule of evidence – a 'technicality' – keeps an innocent man imprisoned. Thus, while *Final Appeal* never repudiates the modernist discourse of 'truth', it produces a screen reality that simultaneously counters the official version of things, undermines the mechanisms of official truth production, and shifts the terrain of judgement from an institutional locus to a popular one (an action we shall see reversed in our examination of the Rodney King affair). Not only are the images swirling around real criminal events placed on trial in tabloid television programs like *Final Appeal* and *Trial and Error*, then, but so is the capacity of courts to produce adequate truths.

Final Appeal's account of the case of Paul Ferrell, broadcast 25 September 1992, provides another example of this game of destabilization at work. Ferrell was convicted of murder in 1989, though the body of the apparent victim has never been found. We learn that he had been having a clandestine love affair with Cathy Ford early in 1988, when Ford disappeared under mysterious circumstances. Ferrell (now serving a life sentence in prison) and others involved in the events surrounding Ford's disappearance and his conviction provide the commentary that forms the narrative framework for the presentation of screen events. These screen events eclipse the original ones they supposedly reproduce by perfecting and magnifying irretrievable details whose truth or falsity would be impossible to determine.

Final Appeal mounts a damaging attack on the prosecution's production

of the truth of Paul Ferrell's guilt. Some time after Ford's disappearance, her boyfriend, Darvin Moon, discovered her badly burned truck in the vicinity of Ferrell's trailer home. The proximity of the truck to the trailer immediately cast Ferrell into the spotlight as the prime suspect in a crime scenario. Some observers, however, believe the truck was burned elsewhere and planted near Ferrell's trailer home because of the absence of scorching in the flora surrounding the vehicle. A video-verité simulation of the discovery of the truck confirms the alternative theory and simultaneously hyperrealizes the entire spectacle.

FBI agents investigating Ferrell's trailer find traces of blood under a newly laid carpet, and on a wall and ceiling. Laboratory tests show the blood to be that of a woman. DNA tests, however, provide no positive match between the blood found in the trailer and the blood of Cathy Ford. Ferrell tells the camera that the trailer is eight years old, has been previously occupied by others, and may well be stained with blood from a variety of alternative sources. Dan James, Ferrell's appellate attorney, announces that 'the blood analysis proved nothing, but the engaging mathematical wizardry that was . . . presented to the jury made that blood look like it was Cathy Ford's blood, when in fact, we have no idea who's blood it was.'

During Ferrell's trial, Tamela Kitzmiller testified for the prosecution, claiming to have received an obscene phone call from a man she took to be the accused. On camera for *Final Appeal*, however, Kitzmiller recants, claiming that the prosecution convinced her to testify against Ferrell by telling her that he had been involved in a series of murders in Yellowstone Park. 'They told me that he was a sicko, and that he needed to be put away' says Kitzmiller. 'You know, you have people in an official capacity who are telling you these things as if they're fact.' After giving her testimony, Kitzmiller says she waited for prosecutors to produce proof of Ferrell's involvement in the Yellowstone murders, as they had promised her they would do. This proof never arrived.

Another prosecution witness, an FBI agent, testified that while giving Ferrell a 'hypothetical scenario about Cathy Ford's murder', he had 'observed signs of guilt' in Ferrell's 'body language'. James claims on camera that 'this is the first time, *ever*, in the history of American criminal jurisprudence, that this kind of evidence has . . . been allowed to go to a jury'. Says Ferrell, 'there's no evidence' to show 'that I killed or kidnapped Cathy Ford . . . and they know it. And that's why they had to use the body language. That's why he had to make up a complete fabrication of that blood evidence. You know, 'cause he had no evidence against me.'

The most damaging testimony against Ferrell came from Kim Nelson, a neighbor. Nelson testified in court that on 17 February 1988, the day of Ford's disappearance, she heard 'banging, a gunshot, and a woman's scream' coming from Ferrell's trailer. Nelson tells *Final Appeal*, however, that she really 'didn't know nothin' about Paul Ferrell killin' anybody', and that she hadn't seen nor heard anything out of the ordinary on the date in question. In voice-over narration accompanying a video-simulation of the scene being described, Robert Stack explains that 'before the trial', Nelson

had 'signed a statement typed up by the . . . prosecution team without reading it'. Later, prosecutors threatened Nelson with jail time if she didn't follow the signed statement in her courtroom testimony. They also warned that if Nelson didn't help put Ferrell away, she and her children might be his next victims. 'So', says Nelson, 'I said what was on that paper.'

There's a common strategy at work in *Final Appeal*'s re-examination of the damaging testimony given at Ferrell's trial by each of these three witnesses. It is a strategy made possible by the displacement of original events by screen events. In each case, the re-enactment of courtroom proceedings, followed by the insertion of new video-evidence, demonstrates the untrustworthiness of accounts that were originally persuasive. The retrospective, mediated version of events displaces the primacy of the original trial, which is shown to have been flawed. Moreover, it places the events of the original trial on an equal footing with the new mediatized evidence destroying the sense of authenticity and authority they gained merely by virtue of their enactment within a real courtroom. As the witnesses' testimony is shifted out of its original courtroom context and into that of tabloid television, that testimony is turned to testify, not against the defendant but against the legal production of truth: it is made to reveal not what went on in 'reality' but what went on in the courtroom. It thus questions the supposedly stable relationship between them that enabled the court to claim that it did not produce the events in 'reality' but merely reproduced them. The only reality of tabloid television is that of its images so when courtroom images are 'tabloidized' the reality principle inevitably dissolves.

Krista Bradford, a former tabloid TV journalist, writes, 'I have watched reality become fiction in the edit bays as news footage was intercut with movie scenes and music videos and tarted up with sound effects and music' (1993: 40). In her statement, Bradford underscores an important aspect of the postmodern condition: that its 'reality' is always amenable to recon-figuration through the process of simulation. That its truths are never final, stable, or fixed for all times and places. By contrast, they are quite ephemeral, perhaps only authoritative within the local contexts of their production. Most importantly, Bradford indicates the crucial role television plays in the volatilization of the boundary between the authentic and the inauthentic. Its mediatizing power means the truth or reality of anything or any event can, perhaps, never be finalized. Rather, it can always be reprocessed. We can give this situation both a pessimistic and an optimistic interpretation. On the one hand, it means that truths produced against the power-bloc are never entirely safe from the mediatizing apparatus that, finally, it controls. On the other hand, it means that the power-bloc must find it harder and harder to ground its truths in some fixed notion of *the* real, and that political contestation over truth cannot, therefore, be brought to an end (as the power-bloc would wish it to be). In the words of Graham Knight, 'the real still exists, but it no longer seems to be in place; it is displaced – and replaced – by the expansion of competing sign systems that seek to pin it down from the outside' (1989: 97). For Baudrillard, this means that we

increasingly inhabit 'a domain where you can no longer interrogate the reality or unreality, the truth or falsity of something'. Thus, 'we walk around in a sphere, a megasphere where things no longer have a reality principle. Rather a communication principle, a mediatising principle' (1993: 146).

Rodney King[1]

The trial that became the media event of the decade was the state trial of the LAPD officers accused of using excessive force in the beating of Rodney King. The home video shot by George Holliday became a fluid set of images moving around in a 'megasphere' where things are understood through communication and mediatizing principles rather than by any reality principle. In this section we explore the potential and limits of Baudrillard's postmodern account of meaning and images through these 81 seconds of video tape.

The quotation with which we ended the last section can provide us with a point of departure for this one, especially its claim that the loss of the reality principle carries with it the loss of the ability to interrogate reality or unreality, truth or falsity. The Rodney King video suggests the opposite, for though it demonstrably lacked any reality principle, the lack provoked massive interrogations, none of which produced a final truth or falsity, but all of which were conducted in the terms that they could not satisfy.

The courtroom, of course, is the place of interrogation *par excellence*. The video was a major player in a white court room, in front of a white judge and jury. It was not just a video-witness, a technological extension of the eyewitness, but became the video accuser, the video defendant, and, finally, the video verdict. The video was multiplied, turned into many different videos by the prosecution, the defense, the jury, the TV audiences. The trial was a trial by and of video, conducted through the mediatizing principle in terms of multiplied reality principles, in which reality was cast in the simultaneous roles of the grounding authenticator of truth and the destination at which the production of truth was aimed.

The trial replayed the multiple social relations of the original video in a different setting – discursive, physical and social: socially the legal system replaced the neighborhood, physically the courtroom replaced the street or the store, and discursively the visual obviousness of each video was overwhelmed with calculating words. As context is crucial to meaning, each contextual shift made the video into something different. But its status as a media event also took it out of any originary context and made it available for uncountable recontextualizations. A media event is hypervisual, for it is technologically broadcast and thus made available in an unpredictable multiplicity of contexts. Its mediatization gives it a different social reality from an event that is confined to the immediate conditions of its occurrence.

Let's reduce, for convenience's sake, the multiplicity of the Rodney King videos to two, and then multiply each into two more as instances of their uncertain multiplicities. First there was the low-tech video shot by George Holliday which we might call the 'videolow'. Then there was the technologized version of this used by the defense in the trial: computers enhanced it, technology froze its individual frames, slowed or reversed its motion and inscribed explanatory arrows and circles upon it. This we call the 'videohigh'. Extracts of both these videos were also shown, not in the court room, but on broadcast television, and thus transformed by both their extraction and their new mediatization into new videos.

The videolow was characterized by its poor and unsteady focus, its unplanned camera position and angle, and its subservience to 'real time' (no editing). This low-technicity meant that it was low in clarity but high in authenticity; it appealed vociferously and explicitly to a reality principle. The 'lowness' of its technology indexed the 'lowness' of the social position from and for which it spoke, and carried a sense of authenticity which depended upon the videolow's apparently continuous or metonymic relationship with the experiential truths (or 'true' experiences) of the socially disempowered. It is not unusual in our hierarchical society to look for the authentic in the low, to see the blue collar in closer proximity to a 'real' reality than the white. There is a sense that, because the low or the weak have only limited power (economic, social, discursive) to manipulate or control their conditions of existence, they are trapped in an authenticity that the powerful have the fortune to escape and the misfortune to lose. The experience of low power produces a reservoir of authenticity upon which the strong can draw when it suits them.

The popularity of the home video camera (as of the still and moving film camera) lies less in its products (most of which are once viewed and soon forgotten) than in its access to the power of the visible with its ability to overcome the passage of time and the non-existence of the not-here, the power to give presence to the temporally and spatially absent. TV shows like *I Witness Video* and *America's Funniest Home Videos* extend this power of the visible from the private to the public domain.

On network news, Rodney King's beating became America's unfunniest home video. Its authenticity was underlined by the contrast between the low-technicity of its images and the high tech gloss of the rest of the news. Its authenticity appeared uncontestable because the initial conditions of its screening and reception contained no motivations to contest its raw truthfulness. The USA is fiercely attached to the common sense that it is a non-racist society and that the civil rights movement has dismantled the racism of previous generations. This video brought the properly invisible into hypervisibility, and thus lined up most white Americans to accept its authentic 'truth', to deplore what it showed, and to drive its racism back under the surface where it belongs.

Its hypervisibility was a consequence of high and low discursive technologies (the home video image uplinked to geostationary satellites and

globally distributed), the variety of its discursive conjunctures (we have to imagine the stories it may have been linked with on the TV news in South Africa, in Cuba, in Nicaragua, in Somalia), in the variety of social conjunctures (in the living rooms of whites and Blacks and Latinos, in Native American reservations, in shelters for the homeless, in South Central LA or Harlem, in Orange County, Manhattan or Simi Valley, in precincts and cop houses, in . . .): hypervisibility entails an inexhaustible visibility.

This visibility was most highly charged in the Simi Valley courtroom, where the police officers were put on trial for using excessive force on Rodney King. In effect, it was the video that stood trial. Of course there were witnesses and statements by the accused, but the video was the verdict – for the jury, for the media and the nation, and for Rodney King's fellow inhabitants of South Central LA. Indeed, Rodney King never appeared; his presence, which pervaded the trial in the courtroom and around the nation, was a video presence, a body of electronic dots.

And the defense lawyers set to work on this body just as efficiently as the defendants had worked on its incarnation in muscle and bone. First, they had to detach its low technicity from its sense of authenticity and the accents of the 'low'. By retechnologizing it they relocated it socially and de-authenticated it so it could be made into another truth. The transformation from videolow to videohigh was not just technological, but also social and semiotic.

Computer enhancement made the images tell the high truth of high-tech in a panoptic version of what Barthes called 'bourgeois clarity'. The high-tech vision of the infra-red bomb aimer and of the surveillance satellite gives truths that the powerful use for their own power, and the videohigh joined their operations. The low-tech vision of the weak reproduces in its disadvantaged viewpoints and its insecure images their own social experience, which is why, to them, the blurred images of the videolow were perfectly clear.

High-tech restructures the field of the visible, redraws the interrelationships of what it sees. Controlling the time through which bodies move is one way of controlling those video bodies. So the videohigh slowed the motion, froze instances of it to give it a bourgeois clarity and to dislodge its low authenticity. Slowing the time of the body changed its visibility: freezing its movement turned it into a presence without its own direction so that it could be redirected. One key moment occurred early in the beating when King was still capable of movement. Surrounded by police officers and still in the agony of the 50,000 volts the taser gun had shot through his body, he rose and lurched forward, in an attempt either to escape or to charge one of the officers. The verdict of most of the nation, watching only the videolow, was the former; the jury, however, saw the videohigh. Its slowed motion stretched the links between action and reaction until they could be broken. Frozen at its maximum velocity, his body became an ever-present threat. In real time, with its low authenticity, King's movements as he rose from the ground were closely linked to the blows of the batons and the jolts of the taser. In his sworn disposition after the trial, Rodney King put into words

what the videolow had already shown – that his body movements were reactions to the agony of 50,000 volts; their direction was away from not towards, their intention was avoidance not confrontation. But in slow motion the links between his body and the taser were broken: its movements were transformed from reactions into actions, their direction was reversed, their intentions redirected towards the police instead of away from them.

The defense lawyers regularly froze the videohigh and wrote upon it. Another key moment occurred some two-thirds of the way through the beating, when there was a lull in the action that was suddenly broken by Officer Briseno stamping on the back of King's neck and driving his face into the pavement. Whereupon the beating started again. Rodney King had been lying face down and slowly moved his hands behind his back as though preparing to be handcuffed. As he did so, his left foot moved, in our judgement, two inches upwards, and three or four inches to one side. It could well have been an involuntary movement balancing that of his hands. The defense froze the leg at its maximum elevation, drew a circle round it to isolate it from his hands, and argued that it showed King was about to rise and attack the officers once again: His leg was 'cocked'. Retechnologizing the videolow enabled King's body to be held indefinitely at the moment of maximum threat, to be remade into a primed bomb, an ignited fuse, a cocked gun. Rush Limbaugh seized this moment to resimulate the event. He produced a populist videolow designed to work upon his audience as the videohigh did upon the jury. This resimulation consisted of a continuous loop of those three seconds when Rodney King, in Rush Limbaugh's words, 'gets up off the ground and lunges at a cop'. The loop did not show, before this moment, Stacey Koon and his taser, nor, after it, Laurence Powell knocking King to the ground with his baton. Rush Limbaugh was in no doubt about either what was happening on the street, nor about the need to manipulate the video and saturate it with words to ensure that it *really* showed what *really* happened:

> The Rodney King trial – first one; the – the – trial of four cops, in most people's minds – and by the way, since this is being tried on TV, it's about time there was a little balance. So we're going to enter the case here on this show tonight. And that's what I want to get to next, and that's the ver – the Rodney King video. You saw over and over again, 15 seconds of this video, where he was being clubbed and beaten relentlessly. And you were led to believe – I mean, for a year and a half, we all saw this. We were repulsed by it. We were sickened by it. We couldn't believe that this could happen in America. And we demanded a verdict of guilty. There was only 15 seconds of it.
>
> Well, I've seen the whole video. And I want to show you parts of it – a part of it that you haven't seen – maybe. You may – it's been shown, but not very much. And to replicate the way this video has been shown to the country – the 15 seconds of horror; we've taken the beginning of this; we've done what's called looping it. We've taken the first – What is it? – two or three seconds of this, and are just going to show it to you over, and over, and over again.

And I want to tell you what you're going to see here. This is the beginning of the whole incident. This is when Rodney King has been got – has been asked to get out of the car. He's on the ground and the cops are surrounding him. I want you to watch this and watch it. Surprised? You seen that before? Maybe a little, but you haven't seen it very much. Watch it again. Watch it some more times. We've got a lot of ground to make up here on this video. Watch this again, folks.

(Rush Limbaugh's TV show, March 10, 1993)

All media commentators present their view of events as the truth, but unlike most, Limbaugh explicitly argues that his truth must be fought for in opposition to other truths (which, of course, he calls 'lies' or 'distortions'). He knows that truth and video tape are equally manipulable, and with cynical postmodernity, uses the truth of the manipulability to underscore the truth that it produces, thus foregrounding both the process and the politics of producing the truth-telling simulacrum in a way that Baudrillard does not.

In the court room as well as the living room, a remediatized simulation was materially real in its effects. In the first trial, Officer Briseno testified that he tried to restrain his fellow cops because he considered their beating was excessive: in the second trial he refused to give this testimony, and agreed with his colleagues that the force was reasonable. The reason for his change? His first testimony was based only on his experience of the event: by the time of the second, however, he had experienced the computer-enhanced video, and its higher truth. In the second trial, the defense included a *video* tape of Briseno's original testimony as evidence of what he *really* saw.

The hypervisuality of a media event makes it more explicitly contentious than an event that appears to have an objective existence of its own, but the contention is typically conducted in a discourse that uses the terms of an objective, pre-discursive 'truth'. Postmodernity's destabilization opens the simulacrum up to contestation, but it is modernity that provides the discourses by which people enter the contest.

Our age may be that of the visual simulacrum, where what is seen is what matters, and any distinction between an unseen ('true') event and its (false) representations no longer seems achievable. Much of the thrust of our cultural technology is to extend what can be made visible and to technologize a panoptic power that lies in the means of seeing as much as in what it sees. The eye of the 'smart bomb' makes visible the experience of power: we can see why the US 'won' the Gulf War, and in the seeing experience a videohigh that is the pleasure of power. This hypervisuality has not swept logorationality out of the picture – history is never dislodged as simply as that. Rather the visual and the verbal enter complex relations with each other as they move up and down the social and discursive hierarchies, as they oppose or endorse each other's ways of knowing.

Words work through categories, so putting an event into words involves categorizing it, and momentarily resolving its uncertainties. The LAPD had produced a precise and very modern system of categories which its officers imposed upon any event they encountered on the streets to fix it in a grid of

intelligibility. They could thus select the behavior appropriate to it. Meanings and behaviors are continuous with each other within the same spots in this grid. In his opening statement the lawyer defending Stacey Koon showed the jury a huge chart on which were drawn boxes representing the grid of categories into which events were to be put:

> You will hear testimony that it is the suspect who controls what happens on the streets; that the officer is standing there in his uniform, with his badge, and he tells people what to do by verbalizing, 'Get down, get on your face!' When that does not work there is an array of tools that the sergeant has. You will hear basically what the Los Angeles Police Department gives him. You will hear about the escalation of force and the de-escalation of force. This chart will show you the tools that Sergeant Koon had available to him. He started off with verbalization, and then he goes to the next one, which is called 'firm grip'; in essence what it means is that you grab hold of somebody, whether it's by the arm, or you twist a wrist, a wristlock. Then you go to a chemical agent, which might be tear gas or mace, which officers carry on their belt, but that's only used in certain situations, not here where the suspect might have been on drugs. The next level up is the Taser, which is meant to incapacitate, it shoots 50,000 volts and causes most people's motor nerves, causes them to collapse. The next tool up is the handheld baton; a metal baton is a tool to protect yourself against an attacker; in addition to that, on the same level, the experts will tell you, there are kicks, and officers know how to use those kicks. But when these tools are ineffective, ladies and gentlemen, then you rise to the level of deadly force – restraints that can kill, like the carotid chokehold, or you have firearms – you have instruments of death.

This grid of 'escalating force' functions as an instruction manual for the technological application of power to the body. The arguments were logorational in their presentation of the grid as an extracted essence of reality, so that Rodney King, as part of that reality, moved his behavior up the grid from one category to the next: In that reality he was, therefore, in control of his own beating and it was really him, and not Sergeant Stacey Koon, who directed the blows of the batons and boots. Fortunately for King, the defense argued, successfully, the police were able to prevent him reaching the final category, that of 'deadly force', in which, presumably, he would have committed suicide.

The argument was successful. The anonymous jury member who explained on television that King *was* in control assumed that King's behavior and the grid of intelligibility were both part of an objective reality that the video truly represented and in which the police behavior was the natural effect of King's actions, just as pain is the natural effect of putting one's hand into the fire.

The principle of a singular reality resolves the awkward contradiction between the Blackness of King's behavior and the whiteness of the grid: the knowledge that the grid does not and cannot exist in a Black reality can be discounted, because, if reality is singular African Americans cannot have a

different one from whites. A simulation may be a concept within which realities, discourses and truths implode into each other, but more is involved here than mere implosion. Simulation does not have necessary effects, but in particular conditions it can have very material ones. On the pavement, the baton blows were material effects of the implosion of the grid, the event and the 'reality' inside the officers' heads. In the courtroom the verdict was a similarly material effect of a powerful simulation. Baudrillard's free floating simulations can become materially effective ones in particular conditions, which in our society, are inevitably ones of structured and probably institutionalized inequality. Certainly in this case they were. The police force and the courts institutionalize power. Rodney King had no access to those institutions, nor to their power to give simulations specific material effects, and it is in its effects that any reality principle is materialized and therefore made true. As Rodney King was denied the means to produce truth-in-effect, his own experience of the event could not be, therefore, the 'true' one.

The new never replaces the old, it invades its territory, intermingles with it, pushes it from the center to the margins where it can and conjoins with it where it cannot. In the courtroom more than anywhere else the logorational holds its terrain against the hypervisual: The legal system exemplifies it in its purest, most uncontradictory form. Legal truth is a product of the way that people and events are put into words and subjected to reason: legal truth is that of the 'reasonable man' [sic]. In the institution of the law the videohigh conjoined with the high verbal to produce a truth that won. But this truth never trickled down to the videolow, whose blurred, unenhanced authenticity outside the courtroom stood firm in all its insecurity against the attempts to revisualize it and make it tell another truth.

The defense lawyers took their videohigh to a new institution – network television – and attempted to make it work there as it did in the courtroom. But television is not an Enlightenment institution, and logorationalism has never been as central or powerful in it. Television had already promoted the videolow into the hypervisual, and the new videohigh, retechnologized and saturated with logorationality, could not use TV to transfer its power from the courtroom to the living room, from Simi Valley to the streets of South Central. The reasoning of the lawyers that worked so well in the courtroom failed in the living room: on television logorationality was itself made visible: the reality of what was seen was not that of the event but of the power to make the event into what it hypervisually was not. The juror explaining that *in reality* Rodney King was in control could have the power to produce that reality only in a logorational institution. Television was not that institution. Its mediatizing of the videohigh served to point out the difference between the courtroom and living room, not to extend one into the other, it set the hypervisual against the logorational, and in their contradiction, the hypervisual gained the center and marginalized the logorational.

This destabilization of any reality principle upon which truth might be secured paradoxically reinscribes the desire for and the strategic uses of the

principle that has been undercut. Truth may have become a contestable point on a greasy continuum of credibility, but it is a point to which people still aspire. We may no longer be able to rely on the once-upon-a-time categories of fact and fiction, of an event, its representation, and a reality-based hierarchy of credibility that is inherent in them, but powerful traces of that categorization still remain in the way that people cope with the uncertainties and struggles of a world, call it postmodern or not, that has lost the stability that paradigmatically related categories once offered.

Never slow to exploit opportunities to secure its interests, the power-bloc has rapidly learnt to deploy its forces effectively in such unstable conditions. It marshals all the discursive and institutional power at its command, which is considerable, to produce *a* truth that advances its interests, and to make this truth simulate *the* truth. If the videolow could be re-made to show that Rodney King was in control, and in one context at least it could, then any reality principle has dissolved and been replaced by a mediatizing one which then turns from a principle into a process in which remediatizing continues until a point is reached at which specific socio-political interests appear to be achievable. At this point, the process is halted, and a (*the*) truth is proclaimed. Lawyers, spin doctors and public relations experts have become professional postmodernists whose only function is to reach this point.

Their postmodernism is professionalized because it mobilizes institutional and technological power to produce its truths and, equally importantly, to exclude the socially weak from access to those means of powerful truth production. The strategy is to limit the truths of the people to 'weak' truths, and thus to confine them to the weaker end of the greasy continuum of credibility. But the forces that destabilized reality and its truth also destabilize the hierarchy of legitimacy by which some truths can be said, by their very nature or by their anchorage in a common reality, to be more or less believable than others. When the possibility of principles that transcend their conditions of application has dissolved, then the credibility of any truth depends upon the balance of power within the immediate conditions where it has to be put to work. In the Simi Valley courtroom, the scales of power were weighted quite differently than in the living rooms of South Central, or even of the white suburbs of the liberal Midwest. Similarly, there are no general principles by which we can prescribe and predict the relations between, say, technological and institutional power, for they will vary from one set of conditions to another. In the Rodney King case, technology produced the videohigh with its institutionally backed and effective power-bloc truth, and repressed the videolow; but technology also deinstitutionalized that truth and took both the videohigh and the videolow into unpredictably other conditions, where they might, and frequently did, exchange positions on the continuum of credibility.

Watching *Final Appeal* and *Trial and Error* may in a significant way serve as a training course for disbelieving the Rodney King verdict: it may legitimate the consequences of that disbelief, which encompass tut-tutting in the suburbs, uprisings on the streets, and Bush's ordering of a federal investigation of the case. When Kim Nelson televisually disbelieves her own

courtroom testimony, which has been prewritten for her by the police into a 'scriptohigh' (the verbal equivalent of the videohigh), she prefigures the conditions when television will rescreen Rodney King's videolow and discredit the courtroom rewriting of the videohigh. The skeptical fluidity by which disbelief is mobilized in the political relations between the power-bloc and the people is energized and maintained by the tabloidism of programs such as *Final Appeal* and *Trial and Error*.

Perhaps more than any other institution, the courtroom has been put into crisis by postmodern conditions. Politicians and preachers have always known that the truths that matter are those which can be made to work in specific conditions, educators have always known that their curriculum includes and excludes according to the balance of power that can be achieved in the conditions of its writing, but courts, whose immediate effects are emphatically real (imprisonment or freedom, uprisings or stability) are premised upon the achievability of an objective truth and the effectiveness of rationality, as a human universal, as a means of achieving it. When both truth and reasoning are contingent rather than objective, the legal system experiences crisis. Tabloid television and the Rodney King video was surely the nadir of tabloidism, is part of that crisis, part symptom, part cause, partly a move toward coping with it, partly a move toward continuing it, but inescapably part of it.

Note

1 Much of the material on Rodney King is covered in John Fiske (1994) *Media Matters*, Minneapolis: University of Minnesota Press.

References

Bradford, Krista (1993) 'The big sleaze', *Rolling Stone* 650, February 18: 39–43, 69.
Baudrillard, Jean (1983) *Simulations*, translated by Paul Foss, Paul Patton and Philip Beitchman, New York: Semiotext(e).
—— (1988) *Xerox and Infinity*, London: Agitac.
—— (1993) 'The work of art in the electronic age', translated by Lucy Forsyth, in Mike Gane (ed.) *Baudrillard Live: Selected Interviews*, London: Routledge.
Frank, Arthur W. (1992) 'Twin nightmares of the medical simulacrum: Jean Baudrillard and David Cronenberg', in William Stearns and William Chaloupkas (eds) *Jean Baudrillard: The Disappearance of Art and politics*, London: Macmillan.
Knight, Graham (1989) 'Reality effects: tabloid television news', *Queen's Quarterly* 96 (1) Spring: 94–108.

Notes on the contributors

MARCUS BREEN is teaching popular music in the English and Cultural Studies Department at the University of Melbourne. He is also working as a consultant on Multimedia and Broadband Services for the Victorian Department of Business and Employment in the Victorian Government . . . JOHN DOCKER is a research fellow at the University of Technology in Sydney. He is best known for his books *Critical Condition, The Nervous Nineties* and *Postmodernism and Popular Culture* . . . JOHN FISKE is Professor of Communication Arts at the University of Wisconsin in Madison. He is the author of numerous books on media theory and popular culture. His most recent book, *Media Matters*, was published in 1994 by the University of Minnesota . . . DIANA GEORGE is an associate professor in the Humanities Department at Michigan Technological University. Her work on visual representation has appeared in such journals as *PostScript, Reader* and *The Journal of Film and Video* . . . KEVIN GLYNN recently completed his Ph.D. in Communication Arts at the University of Wisconsin in Madison. His work has appeared in *Wide Angle* and *Communication Studies*. He is currently writing a book on the subject of 'tabloid television' . . . RICHARD MIDDLETON is Senior Lecturer in Music at the Open University in Great Britain. He is the author of *Pop Music and the Blues* (1972) and *Studying Popular Music* (1990), and has been a co-editor of the journal *Popular Music* since its founding in 1981 . . . SUSAN SANDERS is a Ph.D. candidate in Michigan Technological University's Humanities Department. She has written on issues of power and subjectivity in composition studies . . . STUART TANNOCK is a graduate student in the Department of Modern Thought and Literature at Stanford University.

Books Received from Publishers
Winter 1995 (through 31 March 1995)

Abu-Lughod, Janet L. (1994) *From Urban Village to East Village: The Battle for New York's Lower East Side*, Cambridge and Oxford: Blackwell.

Acland, Charles R. (1995) *Youth, Murder, Spectacle: The Cultural Politics of 'Youth in Crisis'*, Boulder, CO: Westview Press, $19.95 Pbk, $52.95 Hbk.

Adjaye, Joseph K. (1994) editor, *Time in the Black Experience*, Westport, CT: Praeger, $55.00 Hbk.

Altman, Dennis (1994) *Power and Community: Organizational and Cultural Responses to AIDS*, London: Taylor & Francis.

Anderson, Rob, Robert Dardenne and George M. Killenberg (1994) *The Conversation of Journalism: Communication, Community, and News*, Westport, CT and London: Praeger, $49.95 Hbk.

Aronson, Ronald (1995) *After Marxism*, New York and London: Guilford Press. $18.95 Pbk.

Aune, James Arnt (1994) *Rhetoric and Marxism*, Boulder, CO: Westview Press, $18.95 Pbk, $59.95 Hbk.

Behdad, Ali (1994) *Belated Travelers: Orientalism in the Age of Colonial Dissolution*, Durham, NC: Duke University Press, $15.95 Pbk, $44.95 Hbk.

Berman, Art (1994) *Preface to Modernism*, Champaign, IL: University of Illinois Press, $15.95 Pbk, $39.95 Hbk.

Bersani, Leo and Ulysse Dutoit (1994) *Arts of Impoverishment: Beckett, Rothko, Resnais*, Cambridge, MA: Harvard University Press, $18.95 Pbk, $37.50 Hbk.

Bingham, Shereen G. (1994) editor, *Conceptualizing Sexual Harassment as Discursive Practice*, Westport, CT and London: Praeger, $55.00 Hbk.

Blier, Suzanne Preston (1995) *The Anatomy of Architecture: Ontology and Metaphor in Batammaliba Architectural Expression*, Chicago: University of Chicago Press, $17.95 Pbk.

Brooks, Peter (1993) *Body Work: Objects of Desire in Modern Narrative*, Cambridge, MA: Harvard University Press, $19.95 Pbk, $49.95 Hbk.

Brown, Phillip and Richard Scase (1994) *Higher Education and Corporate Realities: Class, Culture and the Decline of Graduate Careers*, London: UCL Press Limited.

Brownstein, Rachel M. (1995) *Tragic Muse: Rachel of the Comedie-Francaise*, London and Durham, NC: Duke University Press, $16.95 Pbk.

Bynum, Caroline Walker (1995) *The Resurrection of the Body: In Western Christianity, 200–1336*, New York: Columbia University Press, $29.95 Hbk.

Camille, Michael (1992) *Image on the Edge: The Margins of Medieval Art*, Cambridge, MA: Harvard University Press, $35.00 Hbk.

Cavell, Stanley (1994) *In Quest of the Ordinary: Lines of Skepticism and Romanticism*, Chicago and London: University of Chicago Press, $12.95 Pbk.

Coyle, Dennis J. and Richard J. Ellis (1994) editors, *Politics, Policy and Culture*, Boulder, CO: Westview Press, $22.95 Pbk, $65.00 Hbk.

Denton, Robert E. Jr. (1994) *The 1992 Presidential Campaign: A Communication Perspective*, Westport, CT: Praeger, $18.95 Pbk, $65.00 Hbk.

Doherty, Thomas (1994) *Projections of War: Hollywood, American Culture, and World War II*, New York: Columbia University Press, $16.00 Pbk.

Dumont, Louis (1995) *German Ideology: From France to Germany and Back*, Chicago: University of Chicago Press, $32.50 Hbk.

Edelman, Murray (1995) *From Art to Politics: How Artistic Creations Shape Political Conceptions*, Chicago and London: University of Chicago Press, $18.95 Pbk.

Gaber, Ivor and Jane Aldridge (1995) editors, *In the Best Interests of the Child: Culture, Identity and Transracial Adoption*, New York: Columbia University Press, $25.00 Pbk.

Grimes, Ronald L. (1995) *Marrying and Burying: Rites of Passage in a Man's Life*, Boulder, CO: Westview Press, $18.95 Pbk, $59.50 Hbk.

Hall, C. Margaret (1992) *Women and Empowerment: Strategies for Increasing Autonomy*, Washington, Philadelphia, London: Hemisphere Publishing.

Halton, Eugene (1995) *Bereft of Reason: On the Decline of Social Thought and Prospects for its Renewal*, Chicago, IL: University of Chicago Press, $31.50 Pbk.

Hamelink, Cees J. (1995) *The Politics of World Communication*, London, Thousand Oaks, New Delhi: Sage, $24.00 Pbk, $49.95 Hbk.

Harloe, Michael (1995) *The People's Home? Social Rented Housing in Europe and America*, Oxford and Cambridge, MA: Blackwell, $26.95 (£16.99 UK) Pbk, $69.95 (£50.00 UK) Hbk.

Herdt Gilbert (1994) *Guardians of the Flutes, Volume I, Idioms of Masculinity*, Chicago and London: University of Chicago Press, $15.95 Pbk.

Himmelstein, Hal (1994) *Television Myth and the American Mind*, 2nd ed, Westport, CT: Praeger, $24.95 Pbk, $65.00 Hbk.

Howells, Coral A. and Lynette Hunter (1991) editors, *Narrative Strategies in Canadian Literature: Feminism and Postcolonialism*, Milton Keynes, Philadelphia: Open University Press.

Hussein, Taha (1995), translated by Mona El-Zayyat, *A Man of Letters*, New York: Columbia University Press, $25.00 (£19.00 UK) Pbk, $27.50 Hbk.

Jackson, Michael (1995) *At Home in the World*, Durham, NC: Duke University Press, $21.95 Hbk.

Jameson, Fredric (1994) *The Seeds of Time*, New York: Columbia University Press, $22.95 Hbk.

Jordan, Bill, Marcus Redley and Simon James (1994) *Putting the Family First: Identities, Decisions, Citizenship*, London: UCL Press.

Jordan, Glenn and Chris Weedon (1995) *Cultural Politics: Class, Gender,*

Race and the Postmodern World, Oxford and Cambridge: Blackwell, $54.95 Hbk.

Klein, Anne Carolyn (1995) *Meeting the Great Bliss Queen: Buddhists, Feminists, and the Art of Self*, Boston: Beacon Press, $25.00 Pbk.

Klein, Michael (1994) editor, *An American Half Century: Postwar Culture and Politics in the USA*, Boulder, CO: Westview Press, $19.95 Pbk, $59.95 Hbk.

Kramer, Jane (1994) *Whose Art Is It?*, Durham, NC: Duke University Press, $10.95 Pbk, $24.95 Hbk.

Liebovich, Louis W. (1994) *Bylines in Despair: Herbert Hoover, the Great Depression, and the U.S. News Media*, Westport, CT: Praeger, $52.95 Pbk.

Limon, Jose E. (1994) *Dancing with the Devil: Society and Cultural Poetics in Mexican-American South Texas*, Madison, WI: University of Wisconsin Press, $15.95 Pbk, $42.00 Hbk.

Lindlof, Thomas R. (1994) *Qualitative Communication Research Methods*, Current Communication: An Advanced Text Series: Volume 3, Newbury Park, CA: Sage, $24.95 pbk.

Loshitzky, Yosefa (1995) *The Radical Faces of Godard and Bertolucci*, Detroit: Wayne State University Press, $18.95 (£16.96 UK) Pbk, $44.95 (£40.50 UK) Hbk.

Lull, James (1995) *Media, Communication, Culture: A Global Approach*, New York: Columbia University Press, $15.00 Pbk.

Macedo, Donaldo (1995) *Literacies of Power: What Americans are Not Allowed to Know*, Boulder, CO: Westview Press, $15.95 Pbk, $49.95 Hbk.

Martin, Carol (1994) *Dance Marathons: Performing American Culture in the 1920s and 1930s*, Jackson, MS: University Press of Mississippi, $16.95 Pbk, $37.50 Hbk.

Morris, Brian (1994) *Anthropology of the Self: The Individual in Cultural Perspective*, Boulder, CO: Westview Press, $19.95 Pbk, $69.95 Hbk.

Murray, Michael D. (1994) *The Political Performers: CBS Broadcasts in the Public Interest*, Westport, CT: Praeger.

Nelson, Jack A. (1994) editor, *The Disabled, the Media, and the Information Age*, Westport, CT: Praeger, $55.00 Hbk.

Pacteau, Francette (1994) *The Symptom of Beauty*, Cambridge, MA: Harvard University Press, $35.00 Hbk.

Pemberton, John (1994) On the subject of 'Java', Ithaca, NY and London: Cornell University Press, $17.95 Pbk, $42.95 Hbk.

Ratcliffe, Peter (1994) editor, *'Race', Ethnicity and Nation: International Perspectives on Social Conflict*, London: UCL Press.

Redner, Harry (1994) *A New Science of Representation: Towards an Integrated Theory of Representation in Science, Politics and Art*, Boulder, CO: Westview Press, $59.50 Hbk.

Regan, Stephen (1994) editor, *The Year's Work in Critical and Cultural Theory, Volume 1, 1991*, Oxford: Blackwell; Atlantic Highlands, NJ: Humanities Press, $40.00 Hbk.

Richards, Barry (1995) *Disciplines of Delight: The Psychoanalysis of Popular Culture*, New York: Columbia University Press, $25.00 Pbk.

Rodriguez, Ileana (1994) *House/Garden/Nation: Space, Gender, Ethnicity in Post-Colonial Latin American Literature by Women*, Durham, NC: Duke University Press, $16.95 Pbk, $49.95 Hbk.

Rubinsten, Ruth P. (1995) *Dress Codes: Meanings and Messages in American Culture*, Boulder, CO: Westview Press, $21.95 Pbk, $69.00 Hbk.

Savigliano, Marta E. (1995) *Tango and the Political Economy of Passion*, Boulder, CO: Westview Press, $21.95 Pbk, $65.00 Hbk.

Schervish, Paul G. (1994) (editor), *Wealth in Western Thought: The Case For and Against Riches*, Westport, CT: Praeger, $55.00 Hbk.

Scholle, David and Stan Denski (1994) *Media Education and the (Re)Production of Culture*, Westport, CT: Praeger, $16.95 Pbk.

Seremetakis, C. Nadia (1994) editor, *The Senses Still: Perception and Memory as Material Culture in Modernity*, Boulder, CO: Westview Press, $50.50 Hbk.

Sharer, Robert J. (1994) *The Ancient Maya*, 5th ed. Stanford, CA: Stanford University Press, $24.95 Pbk, $75.00 Hbk.

Simons, Herbert W. and Michael Billig (1994) editors, *After Postmodernism: Reconstructing Ideology Critique*, London, Thousand Oaks, New Delhi: Sage, $22.95 Pbk.

Sloan, Wm. David and Julie Hedgepeth Williams (1994) *The Early American Press, 1690–1783*, Westport, CT: Praeger, $59.95 Hbk.

Smith, Carl (1995) *Urban Disorder and the Shape of Belief: The Great Chicago Fire, the Haymarket Bomb, and the Model Town of Pullman*, Chicago, IL: University of Chicago Press, $35.00 Hbk.

Smith, Stephanie A. (1994) *Conceived by Liberty: Maternal Figures and Nineteenth-Century American Literature*, Ithaca and London: Cornell University Press, $15.95 Pbk, $39.95 Hbk.

Suleiman, Susan Rubin (1994) *Risking Who One Is: Encounters with Contemporary Art and Literature*, Cambridge, MA: Harvard University Press, $27.50 Hbk.

Tiefer, Leonore (1995) *Sex is Not a Natural Act and Other Essays*, Boulder, CO: Westview Press, $19.95 Pbk, $49.95 Hbk.

Wiener, Margaret J. (1995) *Visible and Invisible Realms: Power, Magic, and Colonial Conquest in Bali*, Chicago: University of Chicago, $29.95 Pbk, $69.95 Hbk.

Wiley, Norbert (1995) *The Semiotic Self*, Chicago, IL: University of Chicago Press, $19.95 Pbk, $39.95 Hbk.

Wright, Sue (1994) editor, *Ethnicity in Eastern Europe: Questions of Migration, Language Rights and Education*, $49.00 Hbk.

Zernicke, Paul Haskell (1994) *Pitching the Presidency: How Presidents Depict the Office*, Westport, CT: Praeger, $49.95 Hbk.

If you are interested in reviewing any of these (or other) books, contact Jennifer Daryl Slack, Department of Humanities, Michigan Technological University, 1400 Townsend Drive, Houghton, MI 49931-1295, USA.

Other journals in the field of cultural studies

There has been a rapid increase in the number of journals operating both in the field of cultural studies and in overlapping areas of interest. *Cultural Studies* wants to keep its readers informed of the work being done by these journals. After all, cultural studies is a collective project.

AMERICAN LITERARY HISTORY
(Oxford University Press, Journals Dept., 2001 Evans Road, Cary, NC 27513, USA)
Issue 6(3) Fall 1994
Contents: *Martin Bickman* From Emerson to Dewey: The Fate of Freedom in American Education; *Charles Vandersee* American Parapedagogy for 2000 and Beyond: Intertextual, International, Industrial Strength; *Gerald Graff and Christopher Looby* Gender and the Politics of Conflict-Pedagogy: A Dialogue; *Stephen Cox* The Two Liberalisms; *Carolyn Porter* What We Know That We Don't Know: Remapping American Literary Studies; *David Levin* American Historicism Old and New; *Eric Cheyfitz* The Irresistibleness of Great Literature: Reconstructing Hawthorne's Politics; *Sandra Adell* Writing about Race; *Laura Doan* What's In and Out, Out There? Disciplining the Lesbian; *Kenneth M. Roemer* Contemporary American Indian Literature: The Centrality of Canons on the Margins; *Judith Fetterley* Commentary: Nineteenth-Century American Women Writers and the Politics of Recovery.

ANGELAKI
(44 Abbey Road, Oxford OX2 0AE, UK)
Angelaki is a new triannual journal edited by researchers in philosophical, literary and social theory. The journal seeks to publish challenging work from contributors in different centres in the UK and overseas, and to foster a spirit of vigorous debate in and between disciplines.

Angelaki encourages a critical engagement with theory in terms of disciplinary development and intellectual and political usefulness; the inquiry into and articulation of culture, and the complex determination of change and its relation to history.

The journal especially strives to foster the theory of minor movements, recognizing their significant impact on and dynamic relation to the development of cultures, political spaces and academic disciplines, and emphasizing their formative power, rather than their oppositional entrenchment.

Angelaki provides a forum for the inquiry into questions of existential and political definition and agency, on the personal, collective, institutional and policy-oriented levels, and promotes the work of spirited and experimental theoretical writing in all areas of value-production.
Issue 1(1) September 1993
The Uses of Theory
Contents: *Pelagia Goulimari* On the Line of Flight: How to be a Realist?; *Barry Stocker* Crisis in Politics; *David Howarth* Reflections on the Politics of Time and Space; *Sarah Wood* Surprise in Literature; *Robert Smith* Title without Colon; *Mozaffar Qizilbash* Yuli's Birthday Party: A Philosophical Short Story; *Nick Groom* Never Mind the Ballads, Here's Thomas Percy; *Josep-Anton Fernández* Interview with Félix Guattari. Félix Guattari: Towards a Queer Chaosmosis; *Timothy S. Murphy* William Burroughs Between Indifference and Revalorisation: Notes Towards a Political Reading; *Charlie Blake* In the Shadow of Cybernetic Minorities: Life, Death and Delirium in the Capitalist Imaginary.

Issue 1(2) April 1994
Narratives of Forgery
Stories of literary forgery may inevitably be stories of disappointment, but they challenge definitions of mimesis and semiosis. By examining implications in the wider context of cultural expression **Narratives of Forgery** will redefine artistic deception as the reader's experience of a postmodern narrative. The issue, like the forgeries themselves, will appeal to readerly desires for tales of arcane scholarship and participation in the unravelling of literary-antiquarian mystique.
Contents: *Nick Groom* Introduction; *Daniel Carey* Henry Neville's 'The Isle of Pines' (1668): Travel, Forgery and the Problem of Genre; *Don Nichol* Rewriting Plagiarism; *Nick Groom* Forgery or Plagiarism? Unravelling Chatterton's Rowley; *Jonathan Barry* The 'History and Antiquities of the City of Bristol': Chatterton in Bristol; *Michael Suarez S. J.* What Thomas Knew: Chatterton and the Business of Getting Into Print', *Randall McGowen* The Forgery Trials of the 1770s and 1780s; *Paul Baines* The Macaroni Parson and the Marvellous Boy: Literature and Forgery in the Eighteenth Century; *John Goodridge* Identity, Authenticity and Class: John Clare and the Mask of Chatterton; *Inga Bryden* Arthur as Artefact: Concretizing the Fictions of the Past.

Issue 1(3) July 1994
Reconsidering the Political
This issue centres on a rethinking of the political in late modernity. It includes a series of articles designed to trace out the historical emergence, forms and contemporary debates surrounding the meaning and significance of politics in our present situation.
Contents: *B. Arditi* Tracing the Political; *M. J. Reid* Rorty's Pragmatism: Argument and Experience; *R. Visker* Fascination with Foucault: Object and Desire of an Archaeology of Knowledge; *M. Cholewa-Madsem* Enacting the Political; *S. and D. Bensusan* Civil Society: The Traumatic Patient; *D. Owen* Agonal Thought: Reading Nietzsche as Political Thinker; *S. Golding* Curiosity; *Antonio Negri and Michael Hardt* Interview with Ernesto Laclau. Excerpt from 'Labor of Dionysos'.

Issue 2 (1)
Home and Family
Theory can do more than simply extend the topography of the *oikia* (household) into unfamiliar spaces. The lexical itinerary of *oikia* incorporates interminable detours. How choose between one's literal and figurative home, one's romanticised families? How to move between establishments? Are big theories the place for these considerations? Marx established a new set of proprieties; but what has kept Marx in circulation is unfamiliar material practices (reading, substitution, exchange). Can household names take on the attributes of Kafka's 'assistants': 'neither members of, nor strangers to . . . but, rather, messengers from the one to the other'? (Benjamin). When psychoanalytic theory displaces topography with toponymy, the reassessment of establishments through cryptic disturbances and unplaced silences might occasion unprecedented articulations.

Issue 2(2)
Intellectuals and Global Culture
Whether the issue is institutionalization or degeneration (Jacoby, Bloom), genealogy or delegitimation (Turner, Baumann), specificity or universality (Spivak, Said), or redundancy (Johnson, Carey), the intellectual is now a species under anxious, largely

autolectic, scrutiny. This number will consider the broad issue of the intellectual as both regional and global phenomenon – as visualiser of the *world* as much as the *locality*, the *universal* as much as the *specific*. The issue will examine the mutable status of the intellectual in different periods and, importantly, in different parts of the world; in the corporation and the revolutionary cell; in the imagination of artists and dreamers.

Issue 2(3)
Authorizing Culture
For many, criticism is currently trapped in a struggle whereby the representation of popular culture is restricted to a choice between what appear to be two equally unacceptable positions: between, on the one hand, a traditional position of cultural critique and critical distance; and, on the other, a denial of distance and difference in favour of a simple celebration of cultural forms. It is this impasse, between the reactionary repudiation of popular culture, and its unequivocal and complacent celebration, that **Authorizing Culture** will explore. In what ways does this problem affect contemporary forms of cultural criticism (cultural studies, cultural materialism, new historicism, post-structuralism, psychoanalysis, post-colonial discourse, *et al.*)? Can cultural criticism really take no other form than an opposition between optimism and pessimism, inside and outside, critical objectivity and populist celebration? And is a change in attitude needed toward those commonly considered to be the modern masters?

Call for papers
The editors invite the submission of original and technically competent articles of 2–10,000 words, reviews and review articles, translations and interviews. Please send two copies of your manuscript, double-spaced, to *Angelaki* at the address above.

ARENA
Issue 3, 1994
Editorial: *Geoff Sharp* Civil War.
Commentaries: The World at Large: *Patricia Stamp* Foucault and The New Imperial Order; *David Bennett* Hollywood's Indeterminacy Machine: Virtual Reality and Total Recall; *Bruce Lindsay* GATT, Development and Intellectual Property; *Anthony Ashbolt* Falling Everywhere: Postmodern Politics and American Cultural Mythologies.
Media and Democracy: *Mark Poster* A Second Media Age?; *John Hartley* Citizens of Media, Technologies of Readership.
Indigenous Cultures and the Nation: *Nonie Sharp* Native Title in the Reshaping of Australian Identity; *Ricki Green* Lyotard and Mabo: An Unprecedented Liason; *Benno Wagner* We Know all about the Past.
Articles: *Sebastian Job* Russia: The Silence of the Lambs; *Fiona Mackie* Intersubjectivity: Extended Forms of Personness; *Mohammed Bamyeh* The City and the Country: Notes on Belonging and Self-Sufficiency.

BORDER/LINES
(The Orient Building, 183 Bathurst Street, Suite No. 301, Toronto, Ontario, Canada M5T 2R7. Tel: (416) 360–5249. Fax: (416) 360–0781)
Issue 34/35
Ten Years of B/L
Contents: *M. Nourbese Philip* Urban Confections From Robbery to racism: How

the media reported on a Toronto murder; *Carol Boyce Davies* Black Bodies, Carnivalized Bodies: Afro-American women's struggles with Carnival's meaning; *Patricia Pollock Brodsky* The Hanging Man: A Report on Homeless in Germany. Another wall, another social problem; *Joan Davies* A Reminiscence. A History; *Stan Fogel* Miscellany: A B/L Retrospective: 10 Progressive Years; Ten Years of Indexes to Border/Lines Your Resource Tool; *Joan Davies* Downsizing Culture Cutbacks to arts funding and what's to be done; *Alex Ferentzy* The International Urban Elite and the Culture of Instant Transmission: The implications of 'doing lunch'; *Gary Genosko* Red London: The Decline of the Left in Great Britain; *Philip Corrigan* What the 'Right' Fears Most! The Right's wrong for our correspondent from England; *Mike Gane and Nicholas Gane* Foucault, the Conference Subject: Foucault, the Conference Subject: regulated, defined and quartered. A Foucault conference evaluated; *Jose Arroyo* Knocking 'Em Dead At The Box Office: Natural Born Killers; *Steve Pereira* 'India Now!' at the Toronto International Film Festival.

Reviews: *Rinaldo Walcott* on Tricia Rose's *Black Noise: Rap Music and Black Culture in Contemporary America* and *Andrew Ross and Tricia Rose* (eds) *Microphone Fiends: Youth Music & Youth Culture*; *Bill Little* on Jean Baudrillard's *The Transparency of Evil: Essays on Extreme Phenomena*; *Nicole Shikun-Simpson* on Laura E. Donaldson's *Decolonizing Feminisms: Race, Gender, and Empire-Building*; *Gayle Irwin* on Sharon Butala's *The Perfection of the Morning: An Apprenticeship in Nature*; *Michael Hoechsmann* on Mexarcane . . . The Corporate Future of the Couple from Guatinaui; *Steve Reinke* on 'Dreaming of You': an exhibition featuring 75 artists who remember David Buchan, Robert Flack and Tim Jocelyn; *Ingrid Mayrhofer* 'Order helps keep a good house': a billboard project.

COLLEGE LITERATURE
(West Chester University, 554 New Main, West Chester PA 19383, USA. Tel: (215) 436-2901. Fax: (215) 436-3150)
Special Issue 22(1) February 1995
Third World Women's Inscriptions
Contents: *Geetha Ramanathan with Stacey Schlau* Introduction: Third World Women's Texts and the Politics of Feminist Criticisms; *Susan Lucas Dobrian* Writing in the Margin: Maternal and Indigenous Space in *Entrada libre*; *Jeanne Garane* A Politics of Location in Simone Schwarz-Bart's *Brigade of Beyond*; *Mildred Mortimer* The Female Quester in Myriam Warner-Vieyra's *Le Quimboiseur l'avait dit* and *Juletane*; *Mara L. Dukats* The Hybrid Terrain of Literary Imagination: Maryse Condé's Black Witch of Salem, Nathaniel Hawthorne's Hester Prynne, and Aimé Césaire's Heroic Poetic Voice; *Ketu H. Katrak* 'This Englishness Will Kill You': Colonial(ist) Education and Female Socialization in Merle Hodge's *Crick Crack, Monkey*, and Bessie Head's *Maru*; *Janice E. Hill* Purging A Plate Full of Colonial History: The *Nervous Conditions* of Silent Girls; *Keith E. Byerman* Anger in a Small Place: Jamaica Kincaid's Cultural Critique of Antigua; *Laura J. Beard* The Mirrored Self: Helena Parente Cunha's *Mulher no Espelho*; *Sandra Maria Boschetto-Sandoval* The Monsters of Her Mind: Reading(Wise) in Amanda Labarca Hubertson's 'Defenseless'; *Therese Saliba* On the Bodies of Third World Women: Cultural Impurity, Prostitution, and Other Nervous Conditions; *Mona Fayad* Reinscribing Identity: Nation and Community in Arab Women's Writing; *Judie Newman* 'He Neo-Tarzan, She Jane?': Buchi Emecheta's *The Rape of Shavi*.
Notes and Comments: *Evelyne Accad* Arab Women's Literary Inscriptions: A Note and Extended Bibliography; *F. Timothy Ruppel* 'Re-inventing Ourselves a Million

Times': Narrative, Desire, Identity, and Bharati Mukherjee's *Jasmine*; *Arun P. Mukherjee* Other Worlds, Other Texts: Teaching Anita Desai's *Clear Light of Day* to Canadian Students; *M. M. Adjarian* Between and Beyond Boundaries in *Wide Sargasso Sea*.

Review Essay: *Marc Bousquet The Work of Criticism*. Review of Jerome Loving, *Lost in the Customhouse: Authorship in the American Renaissance*; and Nicholas K. Bromwell, *By the Sweat of the Brow: Literature and Labor in Ante-Bellum America*.

Reviews: *Christopher Malone* Carol Jacobs, *Telling Time: Lévi-Strauss, Ford, Lessing, Benjamin, de Man, Wordsworth, Rilke*; *Alan W. France* Michael W. Apple, *Official Knowledge: Democratic Education in a Conservative Age*; *Matthew C. Stewart* Adrian Caesar, *Taking it Like a Man: Suffering, Sexuality and the War Poets: Brooke, Sassoon, Owen, Graves*.

COMUNICAÇÕES & ARTES
Ano 17 janeiro abril 1994

Artigos: *Júlio Plaza* Uma poética pós-fotográfica; *Eduardo Leone* A luze a mágica no país da informática; *Lúcia Santaella* A comunicação e a crise dos paradigmas; *Robert T. Craig* A comunicação na conversação de disciplinas; *Jeanne Marie Machado de Freitas* Chomsky: ecos de regiões silenciadas; *Ana Maria Amaral* O Boneco na mira do futuro; *Sherry B. Taylor* Dança em uma época de crise social; *A. M. M. Cintra, M. F. G. M. Tálamo, M. L. G. Lara e N. Y. Kobashi* Do termo ao descritor.

Ensaios: *Regina Silveira* A arte de desenhar; Gerald Thomas: fragmentos de conversa.

Fórum: *Paulo Pitombo* Ver ou não ver; *Roberto Duailibi* Uma questão de limites; *Milton Campos* TV cultura: caindo na rede; *Maria Ap. Baccega* Gestão de processos comunicacionais; *Ana Mae Barbon* O ensino da arte na América Latina.

CULTURAL CRITIQUE
(Oxford University Press, Journals Dept., 2001 Evans Road, Cary, NC 27513, USA)
Issue 28

Yvonne Yarbro-Bejarano Gloria Anzaldúa's *Borderlands/La frontera*: Cultural Studies, 'Difference', and the Non-Unitary Subject; *Christopher Lane* The Drama of the Impostor: Dandyism and Its Double; *Pamela Fox* De/Re-fusing the Reproduction-Resistance Circuit of Cultural Studies: A Methodology for Reading Working-Class Narrative; *David Palumbo-Liu* The Minority Self as Other: Problematics of Representation in Asian-American Literature; *Melba Cuddy-Keane* Conflicting Feminisms and the Problem of Male Space: Joyce Cary and the Fifties; *Michelle Kendrick* The Never Again Narratives: Political Promise and the Videos of Operation Desert Storm; *Luís Madureira* Tropical Sex Fantasies and the Ambassador's Other Death: The Difference in Portuguese Colonialism; *Kalpana Seshadri-Crooks* The Primitive as Analyst: Postcolonial Feminism's Access to Psychoanalysis.

CULTURE & POLICY
(Institute for Cultural Policy Studies, Faculty of Humanities, Griffith University, Queensland 4111, Australia)
Issue 6, 1994

Contents: *Tony Bennett, Graeme Turner and Michael Volkerling* Introduction: Post-Colonial Formations; *Michael Volkerling* Death or Transfiguration: The Future for Cultural Policy in New Zealand; *Martin Allor, Danielle Juteau & John Shepherd* Contingencies of Culture: The Space of

Culture in Canada and Québec; *Angela P. Cheater* Contextualising Cultural Policy in Post-Colonial States: Zimbabwe and New Zealand; *Allen Chun* The Culture Industry as National Enterprise: The Politics of Heritage in Contemporary Taiwan; *Nick Perry* Toyota Country and Toyota City: Urbanism and New Zealand Popular Culture; *Stan McMullin* A Matter of Attitude: The Subversive Margin in Canada; *Con Castan* Multiculturalism and Australia's National Literature; *Gill Bottomley* Post-Multiculturalism? The Theory and Practice of Heterogeneity; *Jennifer Craik* Peripheral Pleasures: The Peculiarities of Post-Colonial Tourism; *John Harp* Culture, the State, and Tourism: State Policy Initiatives in Canada, 1984–1992.

DISCOURSE

(Center for Twentieth Century Studies, University of Wisconsin-Milwaukee, PO Box 413, Milwaukee, Wisconsin 53201, USA. Tel: (414) 229-4141)

Issue 17(2) Winter 1994–5: **Insubordinate Bodies: Feminism, Spectacle, History**
Tania Modleski and Janet Lyon Introduction; *Janet Lyon* Women Demonstrating Modernism; *Margaret Russett* The 'Caraboo' Hoax: Romantic Woman as Mirror and Mirage; *Sonya Michel* Dorothea Dix; or, the Voice of the Maniac; *Barbara Green* From Visible *Flâneuse* to Spectacular Suffragette? The Prison, the Street, and the Sites of Suffrage; *Doris Witt* What (N)ever Happened to Aunt Jemima: Eating Disorders, Fetal Rights, and Black Female Appetite in Contemporary American Culture; *Rosaria Champagne* Oprah Winfrey's *Scared Silent* and the Spectatorship of Incest; *Alice Gambrell* You're Beautiful When You're Angry: Fashion Magazines and Recent Feminisms.

Reviews: *Susan Fraiman*: *Tainted Souls and Painted Faces: The Rhetoric of Fallenness in Victorian Culture* by Amanda Anderson; *Carol A. Stabile*: *Social Text 37* Special Issue on Sex Workers, ed. Anne McClintock; *Amelie Hastie*: *Window Shopping: Cinema and the Postmodern* by Anne Friedberg, and *Streetwalking on a Ruined Map: Cultural Theory and the City Films of Elvira Notari* by Giuliana Bruno.

JAVNOST/THE PUBLIC

(P.O. Box 11, 61109 Ljubljana, Slovenia. Tel: +386 61 168 14 61. Fax: +386 61 72 11 93. E-mail:slavko.splichal@uni-lj.si)

This is the first issue of the first volume of a new journal in the social sciences, *Javnost/The Public*. Problems of the public, the public sphere, public communication, public opinion, and public life in general, as well as contradictions between the public and the private, attract profound theoretical considerations everywhere, and Slovenia is not an exception. These clearly interdisciplinary problems draw the attention of political and communication sciences, psychology, sociology, linguistics, law, informatics, methodology, economics, statistics, and probably some other disciplines and professional interests. Thus the European Institute for Communication and Culture (Euricom), an interdisciplinary and international collective based in Ljubljana, decided to found a journal specifically devoted to these concerns. Although the journal is intended primarily, at least at the beginning, for readers in Slovenia and its immediate neighbourhood, it is at the same time conceived as a broader 'cosmopolitan' journal in a field that has recently become of fundamental political significance and scientific relevance, particularly in the former socialist countries. The journal is a result of the need to address problems of the public sphere on an international level, to stimulate the development of theory and research in the field, and to help understand and bridge the differences between different cultures.

The international nature of the journal is specifically asserted by the

international Editorial Advisory Board with prominent scholars from Europe and North America. All those invited to the Board kindly accepted the invitation. The international structure of the Board should guarantee international cooperation and quality, both of which are particularly important to the social sciences in Slovenia.

Javnost/The Public will be published quarterly, with six to eight articles in an issue, in both Slovene and English. The journal will regularly carry book reviews, review essays, and reports and commentaries. The major part of each issue will be devoted to specific themes, and we expect both the members of the Board and our readers to play a very active role in defining and elaborating the themes.

Some of the major themes in the journal are represented by the articles published in this first (double) issue. While miscellaneous topics are treated in the first issue, all these articles deal with what we expect to develop into continuous and systematic concerns of the journal. With the first (Spring/Summer) issue we wanted at one stroke to display the variety of fields of *The Public*. We look forward to your participation in this journal's future contributions to rigorous and lively efforts to understand and re-think different aspects of one of the most fundamental concepts in the social sciences – the idea of the public.

Issue 1(1–2), 1994, Razgrinjanje področja/Mapping the Field
Članki/Articles: *Slavko Splichal* Pomlad JAVNOSTI/The Spring of THE PUBLIC; *Jürgen Habermas* Predgovor k novi izdaji (1990) Strukturnih sprememb javnosti/ Foreword to the New Edition (1990) of the Strukturwandel der Öffentlichkeit; *Andrew Arato* The Rise, Decline and Reconstruction of the Concept of Civil Society, and Directions for Future Research/Vzpon, zaton in rekonstrukcija pojma civilna družba ter usmeritve za prihodnje raziskovanje; *Vlado Benko* Mednarodni odnosi in javnost/International Relations and the Public; *Majid Tehranian* World With/out Wars: Moral Spaces and the Ethics of Transnational Communication/Svet brez vojn: moralni prostori in etika transnacionalnega komuniciranja; *Jože Mencinger* Lastninske iluzije/Illusions of Ownership; *Ljubo Bavcon* Kratek oris prava človekovih pravic kot nove pravne discipline/An Outline of Human Rights Law as a New Legal Discipline; *Srdjan Vrcan* Seven Theses on Religion and War in the Former Yugoslavia/Sedem tez o religiji in vojni v nekdanji Jugoslaviji; *Darko Štrajn* Nove oblike družbenih odnosov in šola/New Forms of Social Relationship and Schooling; *Vid Pečjak* Osebnost političnega voditelja/The Personality of Political Leader.
Knjižne recenzije/Book review essays: *Marjan Brezovšek* Moderna obnova demokracije/Modern Reconstruction of Democracy; *Breda Luthar* Razredni boj za sredstva identitetne eksistence ali poljubnost življenjskih stilov/Class Struggle for the Means of Identity Existence or Variability of Life Styles;
Poročila in komentarji/Reports and commentaries: *Mojca Drčar-Murko* Etničnoverski nacionalistični konflikti in komuniciranje (7.kolokvij o komuniciranju in kulturi)/Ethno-religious Nationalistic Conflicts and Communication.

Issue 1(3), 1994, Ogroženost jezika/Endangered Languages
Tomo Korošec Ogroženost jezika.
Članki/Articles: *Alexandr Stich* Preživetje jezikovne dominacije: Primer češčine/ Surviving Domination: The Case of the Czech Language; *Monika Kalin Golob* Sodobni pogledi na ogroženost slovenščine/Contemporary Views on the Threats to the Slovene Language; *Magnús Pétursson* Jezikovna politika in skrb za jezik v Islandiji/Policies and Preservation of Language in Iceland; *Farrel Corcoran* Linguistic Colonialism and the Survival of Subaltern Languages: English and Irish/Jezikovni kolonializem in preživetje podrejenih jezikov: angleščina in irščina; *Stane Južnič* O

suverenosti slovenskega jezika/On the Sovereignty of the Slovene Language; *Katsuhiko Tanaka* Sedanjost poučevanja jezikov v zgodovinski perspektivi/The Contemporary Language Teaching from a Historical Perspective.

NEW LITERARY HISTORY
(Wilson Hall, University of Virginia, Charlottesville, Virginia 22903, USA)
Issue 25(4) Autumn 1994: 25th Anniversary Issue (this is the second of four issues to commemorate the twenty-fifth anniversary of *New Literary History*).
Contents: *Wolfgang Iser* Twenty-five Years *New Literary History*: A Tribute to Ralph Cohen; *Sanford Budick* The Experience of Literary History: Vulgar versus Not-Vulgar; *Michael Riffaterre* Intertextuality vs. Hypertextuality; *Robert Weimann* Textual Authority and Performative Agency: The Uses of Disguise in Shakespeare's Theater; *Paul Zumthor* The Medieval Travel Narrative; *Stephen Bann* Shrines, Gardens, Utopias; *Brian Stock* The Self and Literary Experience in Late Antiquity and the Middle Ages; *Karlheinz Stierle* Interpretations of Responsibility and Responsibilities of Interpretation; *John Culler* New Literary History and European Theory; *Murray Krieger* The School of Criticism and Theory: An Allegorical History; *Michał Głowiński* From a Different Perspective; *Marjorie Perloff* From Theory to Grammar: Wittgenstein and the Aesthetic of the Ordinary; *Martha Nussbaum* The Ascent of Love: Plato, Spinoza, Proust; *Stanley Cavell* What Is the Emersonian Event? A Comment on Kateb's Emerson;

Issue 26(1) Winter 1995
Narratives of Literature, the Arts, and Memory (this is the third of four issues to commemorate the twenty-fifth anniversary of *New Literary History*)
Disagreements: *Dorrit Cohn* Optics and Power in the Novel; *Mark Seltzer* The Graphic Unconscious: A Response; *John Bender* Making the World Safe for Narratology: A Reply to Dorrit Cohn; *Dorrit Cohn* Reply to John Bender and Mark Seltzer; *Deborah Knight* Women, Subjectivity, and the Rhetoric of Anti-Humanism in Feminist Film Theory; *Toril Moi* 'Am I That Name?' Reply to Deborah Knight; *Deborah Knight* The Rhetoric of Theory: Responses to Toril Moi.
Aesthetic narratives: *Douglas Dunn* Going Bird Meets Cougar-Asleep-on-Tree-Branch; *Dean Dass* Mineral Light, Journey to the Self; *Kate Nesbitt* The Sublime and Modern Architecture: Unmasking (an Aesthetics of) Abstraction; *D. N. Rodowick* Audiovisual Culture and Interdisciplinary Knowledge; *Vernon Gras* Dramatizing the Failure to Jump the Culture/Nature Gap: The Films of Peter Greenaway.
On memory: *R. S. Khare* The Body, Sensoria, and Self of the Powerless: Remembering/'Re-Membering' Indian Untouchable Women; *Roberta Culbertson* Embodied Memory, Transcendence, and Telling: Recounting Trauma, Re-establishing the Self; *Israel Rosenfield* Memory and Identity; *Jonathan Rée* Subjectivity in the Twentieth Century.

PUBLIC CULTURE
(Society for Transnational Cultural Studies, 1010 East 59th Street, Chicago, Illinois 60637, USA. Tel: (312) 702-0814. Fax: (312) 702-9861)
Issue 7(2) Winter 1995
Controversies: *Achille Mbembe and Janet Roitman* Figures of the subject in Times of Crisis; *Roger Rouse* Thinking through Transnationalism: Notes on the Cultural Politics of Class Relations in the Contemporary United States; *Eva Mackey* Postmodernism and Cultural Politics in a Multicultural Nation: Contents over Truth in the *Into the Heart of Africa Controversy*; *Motti Regev* Present Absentee: Arab Music in Israeli Culture.

Comment: *Karl Eysenbach* A Borderline Monument; *James Schwoch* Manaus: Television from the Borderless; *Chris Healy* AIDS and the Arts of Conversation.

RACE AND CLASS (Institute of Race Relations, 2–6 Leeke Street, London WC1X 9HS, UK)
Issue January–March 1995
This issue contains a major new article on postcoloniality: 'Politics, Literature and Postcoloniality' by Aijaz Ahmed. Also in this issue: Black dance in the US; Indian Science; Racism in Britain.

REPRESENTATIONS (University of California Press, Journals Division, 2120 Berkeley Way, Berkeley CA 94720, USA. Tel: (510) 642-4191. Fax: (510) 643-7127)
Issue 48, Fall 1994
Contents: *Steven Justice* Inquisition, Speech, and Writing: A Case from Late-Medieval Norwich; *Sarah Stanbury* The Body and the City in *Pearl*; *Charlotte Sussman* Women and the Politics of Sugar, 1792; *James Grantham Turner* Novel Panic: Picture and Performance in the Reception of Richardson's *Pamela*; *Stephen Greenblatt* The Eating of the Soul.

RETHINKING MARXISM
Issue 7(1) Spring 1994
(Guildford Publications, Inc., 72 Spring Street, New York, NY 10012, USA)
Contents: *Stephen Resnick & Richard Wolff* Between State and Private Capitalism: What Was Soviet 'Socialism'?; *Reinhold Wagnleitner* American Cultural Diplomacy, Hollywood, and the Cold War in Central Europe; *Carol A. Stabile* Feminism without Guarantees: The Misalliances and Missed Alliances of Postmodernist Social Theory; *Bruce Pietrykowski* Consuming Culture: Postmodernism, Post-Fordism, and Economics; *Susan Jahoda & May Stevens* 'This is my body: this is my blood', *Jay Stone* The Phenomenological Roots of the Radical Democracy/Marxism Debate.
Remarx: *Erwin Marquit* Ideological basis of the Organizational Crisis of Marxism-Leninism in the United States; *Benjamin B. Page* Tiger (Still) at the Gates, or The Cold War Is Not Yet Over.
Review: *Jonathan Diskin*: *New Reflections on the Revolution of Our Time*, by Ernesto Laclau.
(For orders from Europe, Middle East and Africa contact Guildford Press, c/o Turpin Transactions, Blackhorse Rd, Letchworth, Herts SG5 1HN, UK.)

TRANSITION (1430 Massachusetts Avenue, 4th floor, Cambridge, MA 02138, USA)
Issue 63
Contents: **Porn Free:** In Catharine MacKinnon's topsy-turvy feminism, freedom is a foe and the state is a bedfellow. *Ellen Willis* unravels the contradictions of the new anti-pornthink; **Alien Nation:** The race for space takes on a new meaning as contemporary UFO abduction stories seem to encode racial anxieties as extraterrestrial sex fantasies. *Luise White* ponders the parallels; **For Said:** Edward Said's celebrated work on culture and imperialism speaks to a larger critical predicament. *Bogumil Jewsiewicki and V. Y. Mudimbe* reflect on the dilemmas of the 'post-colonial' intellectual; **Disturbing the Peace:** Is the musical *Show Boat* irredeemably racist? Is Canada itself? For the answer to these and other questions, *Selwyn R. Cudjoe* lingers with a north-of-the-border firebrand; **Latin Lessons:** What is it that Latinos share, exactly: a world – or just a word? *Róman de la Campa* considers the vagaries of New World identity; **A Nice Place to Visit:** Reading America through the

travel accounts of foreign visitors can be a chagrining experience – also an illuminating one. *Philip Burnham* reports; **Mayhem as a Way of Life**: The art of low-intensity warfare has harrowed Mozambique and turned the promise of independence into a Hobbesian nightmare. *Andrew McCord* reviews the latest accounts of an African killing field; **The Same Difference**: Does 'diversity' make a difference? *Lucien Taylor* elucidates a Martinician master of obscurity; **Black Body Politic**: The Congressional Black Caucus has been hampered by parochial notions of race and representation, *Carol M. Swain* argues; and the problems just start there; **Pas as 'Dictator'**: *Eliot Weinberger*; **The Task of the Translator**: *Ilan Stavans*; **After Identity**: Poet and essayist *June Jordan* discusses identity, politics – and the fallacy of identity politics – with the critic *Peter Erickson*; **Toward an African Cinema**: Prolific Nigerian director *Chief Eddie Ugbomah* discusses film, finances, and the future of African film with critic *N. Frank Ukadike*; **Blood Brothers**: Hollywood's new 'gangsta' filmmakers, *Albert and Allen Hughes*, expand on the perils and promise of blaxploitation with *Henry Louis Gates, Jr.*

WOMEN'S EQUALITY
(Quarterly Bulletin of Aidwa, All India Democratic Women's Association, 23 Vithalbhai Patel House, Rafi Marg, New Delhi 110 001, India)
Issue: Winter 1994
Contents: 'We have learned how to fight': Profile of two Anganwadi workers; AIDWA Memorandum to the Chief Justice of India and his Reply; *Meera Velayudhan* On March 8: Remembering Clara Zetkin; *Rajni Palriwala* The Continuing Relevance of Anti-Dowry Struggles; *Rukhsana Chowdhury* 'Soft Justice': The Haryana Rape Case Judgement; An Interview with Godavari Parulekar; *Jayoti Gupta* Book Review: *Women in the Tebhaga Uprising*; *Nalini Taneja* Communalism Today; *Brinda Karat* The Gajraula Case; *Ahilya Rangnekar* Women's Representation in Elected Bodies; *Women in Action: State Reports*; *Atrocities on Women in Tripura: Report*; *Irfan Habib, K. P. Singh, Namita Singh* Report on the Aligarh Riots; *Kalindi Deshpande* Communal Violence in Agra.

UTS REVIEW (School of Humanities, PO Box 123, Broadway, NSW 2007, Australia)
Browsing through bookshops or reading about higher education in newspapers and magazines, it seems that cultural studies is expanding in Australian universities and creative writing is flourishing. The reality is that there are fewer places to publish now than there were ten years ago. It is hard even for established writers to publish serious work in this country. It is very hard for young academics to get a start, and almost impossible if their work takes formal or conceptual risks.

Australia is not the only country where writers working in English face these problems. Increasingly, publishers want cultural studies from all over the world to be written for an 'international market'. In practice, they mean 'British and American readers'. One result is a socially groundless, history-free genre of 'theory' that cannot engage with the cultural differences it endlessly invokes. Another is the global reproduction of US graduate school prose.

The UTS Review will offer an international space for new academic and creative writing on culture to receive careful consideration and critical discussion in Australia. Our main emphasis will be on work in cultural studies that engages with contemporary issues – but not only with recent texts or social experiences – relating communities within Australia and around the Pacific and Indian oceans.

Our outlook is regional rather than nationalist; we are interested in work shaping new relationships between social groups, cultural practices and forms of knowledge.

So we see the recent emergence of hybrid genres as an event in the field of new writing that is vitally connected to cultural studies. The UTS Review will offer space for creative writing that no longer construes 'the literary' as a site of withdrawal from contemporary culture and politics, from the worlds created by media, from new practices of history and from the social sciences.

The journal will be a 'review' in the fullest sense. We will encourage serious discussion of new publications in cultural studies, promoting critical reviews that are written in a spirit of care and responsibility, not malice or anxious self-censorhip. We will also seek reviews of work published in other countries that Australian readers might not easily encounter. Translations are welcomed.

The UTS Review will be a refereed journal alternating thematic and general issues. So that contributors may receive an informed and constructive reading of their work, we are assembling a large and diverse editorial board to advise us. By providing full professional credit for the work we publish, we hope to overcome one of the major disincentives to experiment that scholars and writers now face.

Forthcoming theme issues include: Intellectuals and Communities (July 1995); Is an experimental history possible? (1995–96).

The UTS Review is published three times over the financial year: July, October and April. Copy is due to the editors on the 15th of these months for possible inclusion in the following issue. A style sheet is available from the editors.

Conferences

Crossroads in Cultural Studies
An International Conference, July 1–4, 1996, Tampere, Finland
First Announcement and Call for Papers
Cultural studies is not a one-way street between the centre and peripheries. Rather, it is a crossroads, a meeting point in between different centres, disciplines and intellectual movements. People in many countries and with different backgrounds have worked their way to the crossroads independently. They have made contacts, exchanged views and gained inspiration from each other in pursuing their goals.

The vitality of cultural studies depends on a continuous traffic through this crossroads. Therefore the conference organizers invite people with different geographical, disciplinary and theoretical backgrounds together to share their ideas. We encourage international participation from a wide range of research areas.

The conference is organized by the Department of Sociology and Social Psychology, University of Tampere, and Network Cultural Studies. The organizing committee represents several universities and disciplines.
Organizing committee: Pertti Alasuutari (chair); Marko Valo (secretary); Pirkko-liisa Ahponen; Katarina Eskola; Pasi Falk; Marja-Liisa Honkasalo; Eeva Jokinen; Mikko Lehtonen; Kaisu Rattya; Matti Savolainen; Annika Suoninen; Soile Veijola
International advisory board: Ien Ang (Australia); Jostein Gripsrud (Norway); Lawrence Grossberg (USA); Kim Schroder (Denmark)
Speakers will include: Ien Ang * Pasi Falk * Paul Gilroy * Jostein Gripsrud * Jaber F. Gubrium * Lawrence Grossberg * Eeva Jokinen * Sonia Livingstone * Anssi Perakyla * Kim Schroder * Soile Veijola
Call for Papers and Coordinators
As you will see below, many people have already volunteered to organize sessions on a wide variety of topics, but there is still the opportunity to add to the list. So please complete the preliminary abstract form if you would like to give a paper or offer to organize a session. There will also be a book exhibition, and publishers are requested to contact the organizers.

The second announcement and invitation programme, including more information about the conference, its side-events, and a registration form will be available in September. At this stage we assume that the conference fee – including lunch and coffee – will be about 1000 FIM (£210) and hotel accommodation double $70 and single $60 (with breakfast included).

The Conference will be held in Tampere Hall that is the largest congress and concert centre in the Scandinavia. Opposite to the University of Tampere, Tampere Hall is within easy walking distance from the centre of the city and its many services. The unique architecture clearly reflects the activities for which the building was built: conferences, exhibitions, concerts and ballet.

List of Sessions: Anthropology and Cultural Studies: Influences and Differences; Body in Society; Cultural Studies and Space; Cultural Encounters in Mediterranean; Cultural Approaches to Education; Diaries and Everyday Life; Encountering with Otherness in Cultural Boarder-Crossings; Ethnography and Reception: Dilemmas in Qualitative Audience Studies; Feminist and Cultural Approaches to Tourism; History and Theory of Cultural Studies; (Inter)Net Cultures and New Information Technology; Life Stories in European Comparative Perspective; Media Culture in the Everyday Life of Children and Youth; New Genders: The Decay of Heterosexuality; Post-Socialism and Cultural Reorganization; Risk and Culture; Social Theory and Semiotics; Study of Institutional Discourse; The Culture of Cities; The Narrative Construction of Life Stories; Voluntary Associations as Cultures; Youth Culture

For further information contact: Crossroads in Cultural Studies, University of Tampere, Department of Sociology and Social Psychology, P.O. Box 607, FIN-33101 Tampere, FINLAND; tel: +358 31 2156949, +358 31 368 1848; fax: +358 31 2156 080; e-mail: iscsmail@uta.fi. Updated information about the conference is also available in gopher (vuokko.uta.fi 70) and WWW-systems (www.uta.fi).

CALL FOR PAPERS

'Irish Cultural Studies'
Special Issue of *Cultural Studies*
Dr Seamus Deane, Special Issue Editor

It is the aim of this Special Issue of *Cultural Studies* to investigate critically and theoretically the intersections of Irish Studies with other fields, including, but not limited to, gender studies, postcolonial theory and colonial discourse analysis, lesbian and gay studies, queer theory, African-American studies, film studies, critical theory, conflict studies, and cultural studies in general. Of particular interest are the charges each of these fields make to Irish Studies as a cultural practice. We would especially like to encourage articles that rigorously examine and/or critique the institution of Irish Studies as it exists outside of Ireland, particularly in the United States and the United Kingdom.

The deadline for articles is 30 November 1995. Articles should be sent to: The Irish Cultural Studies Collective, Department of English, University of Notre Dame, Notre Dame, IN 46556, USA.

For more information, please contact Skip Thompson in the Department of English at the University of Notre Dame.

Vol. 4 No. 1 Fall/Winter 1994 ISSN 1066-3452

The ALTERNATIVE ORANGE

Auburn University

Auburn University, Alabama 36849-5203

Grant Pheloung
Dept. of English
9030 Haley Center
Auburn University
Alabama 36849-5203

Dear

Thank you for your letter and your comments. Of course I am well aware of the "systematic repression of radical theory in the bourgeois academy" and in the interests of "Breaking the Silence" I will gladly contribute to your publication and offer any and all help that I can give. *The Alternative Orange* can publish my letter with my name and department attached because these reactionary practices should be made public as well as highlighted as global and not fetishized as the "political imaginary" of some local "trouble-makers"...

... As to the question of distribution of *The Alternative Orange* within the Auburn academic community I would be happy to try, but the reaction I received from attempting to distribute the extra copies of *The Alternative Orange* was not encouraging. Only two students wanted to read it and one of them claimed that the kind of critique that the publication undertook was as dangerous as any "right-wing" attacks on the academy. Ludic common sense demanding that "totality" be equated with "totalitarianism." This same attitude emerged when at a "Gender/Great Books/Feminism" reading group I encouraged the group to read Teresa L. Ebert's essay on "ludic feminism" in *Cultural Critique*. Realizing what was at stake the ludic theorists attempted an "immanent" critique of Ebert at the level of discourse and argued that she contradicted herself at the level of rhetoric. Also they questioned what was "postmodern" about her essay suggesting that "classical" marxist categories such as "class struggle" were no longer viable in a "postmodern" age. They also claimed that Ebert offered no "real" solutions and that her claims were "unrealistic", of course revolutionary critique is "unreal" to the bourgeois academy. Finally they tried to marginalize Ebert's materialism to a reading practice asking the question "How does one read as a materialist feminist?" As you can see my attempts at radical knowledge and critique(al) practice have met with opposition and censure. As I said, I would be happy to help the *A.O.* collective in any way but the students here, under the pressure of the "reality" of the market place are not interested in critique(al) knowledge.

Yours sincerely,

Grant Pheloung.

Articles

Reviews

Cultural Images

Images of Aging
Cultural Representations of Later Life

Edited by **Mike Featherstone,** *University of Teeside* and
Andrew Wernwick, *Trent University*

Original and compelling, this book sets out to explore images of aging
which have come to circulate in the advanced industrial societies of today. It
addresses such themes as gender images of aging and images of health,
illness and death.

August 1995: 234x156: 304pp Hb: 0-415-11258-3: **£45.00** Pb: 0-415-11259-1: **£13.99**

Space of Identity
Global Media, Electronic Landscapes and Cultural Boundaries

Edited by **David Morley,** *Goldsmiths College, London* and
Kevin Robins, *Newcastle University*

**'I have no doubt whatsoever that the book will become very quickly a major text in the field.
A fine collection which I hope will attract the kind of critical attention and respect it
deserves.'** – *Stuart Hall, The Open University*

In this stimulating study, the author examines how collective cultural identities are being reshaped
under conditions of a postmodern geography and a communications environment of cable and
satellite broadcasting.

July 1995: 234x156: 224pp: Hb: 0-415-09596-4: **£40.00** Pb: 0-415-09597-2: **£12.99**

The Photographic Image in Digital Culture

Martin Lister, *Newport School of Art and Design*

Exploring the technological transformation of the image and its implications
for photography, this book considers the importance of such issues as the new
discourse of 'techno-culture', medicine's new vision of the body and
interactive pornography.

Comedia

August 1995: 234x156: 256pp: illus. 36 b&w photos Hb: 0-415-12156-6: **£37.50** Pb: 0-415-12157-4: **£12.99**

An Introduction to Political Communication

Brian McNair, *University of Stirling*

A wide-ranging, critical introduction to the relationship between politics, the media and
democracy in the UK and other contemporary societies.

July 1995: 216x138: 224pp Hb: 0-415-10853-5: **£35.00** Pb: 0-415-10854-3: **£10.99**

For further information or a FREE Sociology catalogue, please
contact Liz Sproat, Routledge, 11 New Fetter Lane,
London EC4P 4EE Tel: 0171 842 2012 Fax: 0171 842 2303
Email: esproat@routledge.com

ROUTLEDGE

New from **Wesleyan University Press**

The Spivak Reader

Edited by **Donna Landry** and **Gerald Maclean,** *both at Wayne State University*

Among the foremost feminist critics to have emerged over the last fifteen years, Gayatri Spivak has relentlessly challenged established approaches to literary and cultural studies. This reader brings together the most salient readings of trends in Marxism, feminism and poststructuralism.

September 1995: 230x150: 320pp Hb: 0-415-91000-5: **£40.00** Pb: 0-415-91001-3: **£12.99**

The Postmodern Arts: An Introductory Reader

Edited by **Nigel Wheale,** *Anglia Polytechnic University*

This impressive volume provides essential material and invaluable guidance for students of culture and literature. Includes a thorough introduction by the editor and a collection of pertinent essays grouped into sections such as architecture, documentary film and the visual arts.

Critical Readers in Theory and Practice

July 1995: 234x156: 260pp: illus. 15 b&w photos Hb: 0-415-07776-1: **£45.00** Pb: 0-415-12611-8: **£13.99**

Solitary Pleasures

The Historical, Literary and Artistic Discourses of Autoeroticism

Edited by **Paula Bennett,** *Southern Illinois University*
and **Vernon Rosario II,** *Harvard University*

Analyzing representations of autoeroticism from the 16th century to the present, *Solitary Pleasures* establishes masturbation and related issues of sexual fantasy and sexual anatomy as subjects of importance for cultural history, gender studies and their history of literature and art.

September 1995: 230x150: 288pp: 15 illustrations Hb: 0-415-91173-7: **£40.00** Pb: 0-415-91174-5: **£12.99**

Writing Englishness: An Introductory Sourcebook

Edited by **Judy Giles,** and **Tim Middleton** *both at the University of Ripon* and *York St. John*

What did it mean in the first half of this century to say 'I am English'? Drawing on a wide range of sources including letters, diaries, journalism, fiction and poems, *Writing Englishness* addresses this question. It also contains a chronology, bibliography and suggestions for further reading.

November 1995: 216x138: 240pp: Hb: 0-415-11441-1: **£40.00** Pb: 0-415-11442-X: **£12.99**

Representing Black Men

Marcus Blount, *Columbia University,* and **George Cunningham,** *City University of New York*

Representing Black Men focuses on gender, race and representation in the literary and cultural work of black men. The book examines the ways in which black masculinities figure in African American and American cultures, exploring the constructions of African American masculinities as presences in theory, culture and literature.

August 1995: 234x156: 288pp: Hb: 0-415-90758-6: **£37.50** Pb: 0-415-90759-4: **£12.99**

For further information or a FREE Cultural Studies/Literature catalogue, please contact Ed Ripley, Routledge, 11 New Fetter Lane, London EC4P 4EE
Tel: 0171 842 2158 Fax: 0171 842 2306
Email: info.literature@routledge.com